The Leaders of
RHODE ISLAND'S
GOLDEN AGE

The Leaders of RHODE ISLAND'S GOLDEN AGE

DR. PATRICK T. CONLEY

WITH CONTRIBUTIONS BY
THE RHODE ISLAND HERITAGE HALL OF FAME

THE
History
PRESS

Published by The History Press
Charleston, SC
www.historypress.com

All images courtesy of the Rhode Island Heritage Hall of Fame collection unless otherwise noted.

Front cover, clockwise from top left: Sissieretta Jones, John Gorham, General Ambrose Burnside, Julia Ward Howe and the *Independent Man* statue. Back cover: The Corliss Engine, which powered the Philadelphia Centennial Exposition. From *Harper's Weekly*, May 27, 1876.

First published 2019

Manufactured in the United States

ISBN 9781467141482

Library of Congress Control Number: 2019932636

Notice: The information in this book is true and complete to the best of our knowledge. It is offered without guarantee on the part of the author or The History Press. The author and The History Press disclaim all liability in connection with the use of this book.

The statue of the Independent Man *that graces the cover of this book is Rhode Island's symbol of its individualism and pioneering role in establishing religious liberty and democratic self-government. It stands on top of the dome of a statehouse that was the crowning statement of Rhode Island's prosperity during its Golden Age. That building was designed by architectural firm McKim, Mead & White. Both McKim and White, the partners who did the actual design, are profiled in the book.*

The Independent Man *was designed by George T. Brewster and cast at the Gorham Foundry in 1899. John Gorham and his company are also profiled in my book.*

The statehouse was begun in September 16, 1895, with a groundbreaking. The cornerstone was laid on October 15, 1896, with Rowland Hazard (profiled herein) delivering the principal address. The secretary of state first occupied the building in late 1900, and the General Assembly followed, holding its first session in 1901.

The Independent Man *is the perfect capstone and cover for this book—he is even gilded in gold.*

CONTENTS

Contents

PREFACE

This book, sponsored by the Rhode Island Heritage Hall of Fame, is a continuation of the profiles of its inductees begun in *Rhode Island's Founders* (2010) and *The Makers of Modern Rhode Island* (2012). It covers (roughly) the period from 1861 to 1900, when Rhode Island played a leadership role in America's Industrial Revolution. The state's prosperity was revealed in the 1880 federal census when it ranked first in the nation in the valuation of its assessed real and personal property holdings, with a figure nearly triple the national average. For Rhode Island, this was truly its golden age!

Although the time span (forty years) is much shorter than the previous volumes, the number of people profiled (123) is more than double those listed in either of the earlier books. The two most obvious reasons for this increase are Rhode Island's burgeoning population and the increasing diversity and complexity of its modernizing industrial economy.

My intent in writing this book is to produce a reference work in the nature of an illustrated biographical dictionary. Neither format nor space constraints allow for rhetorical flourishes. The purpose of the profiles herein is to relate pertinent facts, generally in chronological order, concerning the inductee—date and place of birth, parents, ancestry (if significant), education and training, the achievements that merited Hall of Fame recognition (the bulk of the essay), other significant activities and personal data, including marriage, children, death and burial. As a postscript (and if applicable), I make mention of significant progeny, the enduring status of the inductee's achievements and biographical books or articles or large

manuscript collections that are particularly useful in providing greater depth and detail about the inductee.

As stated in the earlier volumes, there are some omissions in the Hall's roster of inductees, as those omitted individuals have not "brought honor to Rhode Island," a criterion for Hall of Fame induction. Notable in this respect are the wily Republican machine politician Charles R. "Boss" Brayton, who described an honest voter as "one who stays bought," and the arch-nativist U.S. senator and publisher of the *Providence Journal* Henry Bowen Anthony, who declared that the Irish Catholic "worshippers of the host…could not be assimilated." However, I have profiled these two in my anthology *Rhode Island in Rhetoric and Reflection* (2002).

Like the earlier vignettes, those contained therein are uneven in length, a difference based mainly on the influence the subject exerted on Rhode Island in this era. Politicians with longevity and industrial employers with wealth and power receive more coverage than people who are narrowly focused (such as artists or athletes). My emphasis in these brief essays is on the Rhode Island years of the inductee rather than on his or her exploits after departure from our microparadise.

As in *Makers*, I have used an appendix for the listing of some inductees because, despite their great lifetime achievements, their impact on Gilded Age Rhode Island was slight. These individuals were inducted either because of their Rhode Island birth (George Curtis and Dr. John Bates Clark) or because they studied or taught briefly at Brown University. Secretary of State John Hay, Dr. William W. Keen, Dr. Benjamin Ide Wheeler and Dr. J. Franklin Jameson are examples of this limited academic contact.

The parameters of this volume, like all historical compartmentalizations, are arbitrary because most inductees had careers, even those confined to Rhode Island, that went beyond the chronological boundaries of 1861 and 1900. Therefore, I have carried over some profiles from *Makers*, particularly those of a few industrialists and reformers. Conversely, I have omitted some notable inductees active in this era—such as Dr. and Governor Lucius Garvin, Bishop Matthew Harkins and Dr. Charles V. Chapin—because their major achievements came early in the twentieth century.

These profiles are admittedly sketchy. Some inductees covered in three pages are the subjects of three-hundred-page biographies, to which the reader is referred. The entries take the concise form of a *Dictionary of Rhode Island Biography* and are written as a prelude to such a reference work.

In arranging this volume for publication, I organized it by occupational categories into which I placed Hall of Fame inductees based on their

principal area of achievement. The entrepreneurs emerged as the largest chapter, composing a quarter of all the essays. Their prominence is not surprising because during the final third of the nineteenth century, they were among the leaders in America's Industrial Revolution and aided the rise of the United States to industrial preeminence among the nations of the world.

The second-largest chapter—architects and artists—is also unsurprising. Rhode Island, with its great natural beauty, has been an inspiration to them and a setting for their creations. Rhode Island's Golden Age was characterized by a dualism between the practical and the aesthetic. Unfortunately, Rhode Island long ago relinquished its industrial and technological supremacy, moving from the vanguard to the rear guard. Its beauty, however, has endured.

Unfortunately, important details of some persons profiled herein are lacking, or unascertainable, without the type of digging, travel and travail employed by some sleuth writing a book-length biography of that subject. Such inductees have at least been rescued from near oblivion and are no longer buried beneath the sands of time.

PATRICK T. CONLEY,
Historian Laureate of Rhode Island
President, Rhode Island Heritage Hall of Fame
February 12, 2018

ACKNOWLEDGEMENTS

A book, like the product of an assembly line, is the work of many hands. This book owes much to the efforts of the members of the Historians' Committee of the Rhode Island Heritage Hall of Fame who not only voted to approve my recommended inductees but also performed basic research on them and often presided over their Hall of Fame induction. Particularly notable in this respect were the late Al Klyberg, with his vast knowledge of Rhode Island's old-line families and their progeny; Glenn Laxton, historian and newscaster of "Not to Be Forgotten" fame; Paul Campbell, author, archivist and librarian; James Marusak, Esq., knowledgeable collector of Rhode Island memorabilia and a prominent attorney; General Richard Valente, an authority on the state's military history; Dr. Scott Molloy, labor historian, professor and Hall of Fame inductee; and Russell DeSimone, whose book *Remarkable Women of Rhode Island* introduced me to Sophia (Robbins) Little and Dr. Anita E. Tyng and gained for them belated Hall of Fame induction. Russell also proofread the final draft.

Caleb Horton, Providence city archivist and a director of the Rhode Island Publications Society, provided detailed online research downloading data, death records and photos. Hall of Fame photographer Richard McCaffrey not only did photo research but also interfaced with the publisher regarding the book's many illustrations. Newport art dealer and Hall of Fame inductee Bill Vareika provided information on our artists, as did Director David Shwaery. *Providence Journal* editor Ed Achorn, an authority on early baseball, reviewed the profiles of the four baseball inductees. Ron Gauthier performed

a difficult title examination on the evolution of Rocky Point, and Halsey Herreshoff provided information about his illustrious ancestors.

My legal secretaries Anna Loiselle, Doreen Schwartz, Linda Gallen and Jesse Washington performed the typing and transmission chores. Jeffrey Gantz, Edward Lengel and Caitlin Conley did stylistic editing and proofreading. The Rhode Island Heritage Hall of Fame and the Heritage Harbor Foundation provided funding for this book.

I extend my thanks to all for this team effort.

I
DEFENDERS OF THE UNION

U.S. SENATOR, GOVERNOR AND GENERAL AMBROSE E. BURNSIDE

Ambrose Everts (aka Everett) Burnside was born in Liberty, Indiana, on May 23, 1824, one of nine children of Irish and Scottish ancestry born to Edghill and Pamelia (Brown) Burnside. His father had been a South Carolina slaveholder who moved to Indiana after freeing his slaves. Edghill Burnside became a legislator in his adopted state—a position that enabled him to secure a West Point scholarship for his son Ambrose.

After graduation in 1847, young Lieutenant Burnside was assigned to an artillery unit but arrived in Mexico City too late to see actual combat in the short-lived Mexican-American War. In the spring of 1848, Burnside was given a post at Fort Adams in Newport, where he met and married Mary Richmond Bishop of Providence. This union was the start of his lifelong connection with Rhode Island.

In 1853, Burnside resigned his army commission to open a company in Bristol for the manufacture of carbines. Although the original company failed, it was reorganized in 1860 as the Burnside Arms Company and manufactured breech-loading carbines under patents Burnside supplied to his creditors. During the Civil War, the government bought more than fifty-five thousand of these Burnside carbines.

Although he resigned his commission, Burnside's military career was far from over. The legislature appointed him major general of the Rhode Island

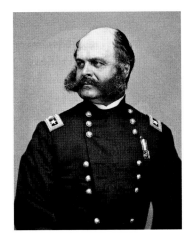

Militia in 1855, and upon the outbreak of Civil War, Burnside became colonel of the First Rhode Island Regiment and fought at the First Battle of Bull Run. In October 1861, after becoming friendly with President Lincoln, Burnside was given an independent command as brigadier general of volunteers. In early 1862, he conducted a successful amphibious campaign along the coast of North Carolina in conjunction with the U.S. Navy. His exploits earned him a commission as major general in March 1862, and he joined the Army of the Potomac under his old friend General George McClellan on the Virginia Peninsula.

In command of the right wing of McClellan's forces at the pivotal battle of Antietam, Burnside has been unfairly accused of delays on the offensive that might have transformed the military draw into a decisive victory. That such criticism was ill-founded became evident when Burnside (despite his reluctance) replaced McClellan as commander of the Army of the Potomac in November 1862.

When Burnside's plan to outflank Lee's army was foiled in the bloody Battle of Fredericksburg and in the infamous January 1863 "Mud March" that followed the Union defeat, Burnside was removed as army commander. Fredericksburg was his darkest hour.

Burnside was next assigned to head the Department of the Ohio, which comprised Ohio, Indiana, Illinois, Michigan and Kentucky. In this theater, he performed with considerable success, thwarting Confederate raids into Indiana and Ohio and liberating East Tennessee. At Knoxville, he repulsed the forces of General James Longstreet, and in January 1864, Congress cited him for bravery.

Burnside was recalled to command his old Ninth Corps in General Grant's 1864 Virginia Campaign, fighting at the Wilderness, Spotsylvania and Cold Harbor. At the Battle of the Crater, however, he drew criticism from his antagonistic immediate superior, George G. Meade, when the Ninth Corps failed in its assault on Petersburg. This July 1864 clash was Burnside's last battle.

Burnside's role in the Battle of the Crater has elicited the unwarranted disfavor of some historians. There, using Pennsylvania coal miners, Burnside promoted a plan to tunnel under the Confederate lines, detonate a massive

charge of explosives and exploit the resulting breach with rapid waves of ground troops. Burnside carefully appointed a trusted division of specially trained African American troops to the place of honor at the lead of the first wave of attacking Union troops.

Commanding General Meade did not share Burnside's confidence in the black regiment and directed Burnside to use ill-prepared alternates. The replacements, who were poorly led and untrained in entrenchment tactics, were slaughtered when they were unable to negotiate the crater created by the explosion. After the war, a Congressional investigative committee stated:

> [T]*he disastrous result of the assault…is mainly attributed to the fact that the plans and suggestions of…Burnside…who had so carefully selected and drilled his troops…*[were]…*entirely disregarded by a general who had evinced no faith in the successful prosecution of that work.*

Even General Grant remarked that "General Burnside wanted to put his colored division in front, and I believe if he had done so, it would have been a success." The misguided prejudices or paternalistic views of others who did not share Burnside's understanding of the maturity, bravery and skill of his chosen black troops deprived the Union of a brilliant victory.

Ambrose Burnside, despite some criticism of his military performance, had an impeccable record as an admirable person. The affection and respect shown to him after his passing is evident in such ways as Bristol's dedication of its town hall to his memory, the naming of City Hall Park in Providence as Burnside Park (in which an equestrian statue of the general is featured) and the naming of numerous Rhode Island streets in his honor. Civil War historian William Marvel's 1991 biography, simply titled *Burnside*, is a balanced yet favorable analysis of Burnside's diverse achievements, and Bruce Catton, a leading historian of the Civil War, described Burnside as "a simple, honest, loyal soldier doing his best even if the best was not very good, never scheming, conniving, or backbiting."

In postwar civilian life, Burnside became a resident of Providence, living at 314 Benefit Street, and he prospered as a railroad executive and engineer. Very engaging and popular, both with his soldiers and with his fellow citizens, Burnside was elected governor of Rhode Island three times (in 1866, 1867 and 1868) as a Republican, despite his unsuccessful prewar Democratic run for Congress in 1857. As chief executive, he unsuccessfully supported a state constitutional amendment that would have allowed Civil War soldiers who were naturalized citizens to vote without the requirement of owning real

estate. In 1874, General Burnside, whose unusual facial whiskers gave the word *sideburns* to the English language, became a U.S. senator, succeeding William Sprague IV. During his tenure, Burnside chaired the Committee on Education and Labor and served on the Committee on Foreign Relations. Prior to taking a seat in Congress, Burnside served briefly in 1870 as a volunteer mediator between France and Germany during the Franco-Prussian War. While a senator, he fought for a bill allowing black applicants special admission privileges at West Point.

While serving his second term, he was stricken with a heart attack and died at Edghill, his summer estate in Bristol near the present-day campus of Roger Williams University, on September 13, 1881. Burnside, succeeded in the U.S. Senate by Nelson Aldrich, was buried at Providence's Swan Point Cemetery next to his wife, Mary, who died in 1876.

COLONEL ELISHA HUNT RHODES

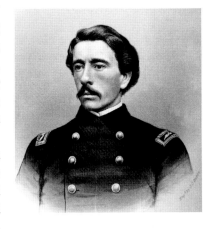

Elisha Hunt Rhodes, eldest son of ship captain Elisha Hunt Rhodes and Eliza Ann (Chace) Rhodes, was born in Pawtuxet Village on March 21, 1842. This lineal descendant of Roger Williams attended schools in Cranston and Providence, including Potter & Hammond's Commercial College.

His father's death at sea when Elisha was only sixteen left him the sole supporter of his family. He left school to work as a clerk in the office of a mill supplier. When the Civil War erupted, he promptly enlisted as a private in Company D, Second Rhode Island Volunteers. He remained in this unit from June 5, 1861, until it was disbanded on July 28, 1865, rising from the rank of private to that of colonel.

Rhodes participated in every campaign of the Army of the Potomac from Bull Run to Appomattox, keeping a detailed diary of his war experiences that writer and producer Ken Burns has described as "one of the most remarkable diaries I have ever read" and a diary that "came to represent, better than any other I found, the spirit of the Union soldier." Historian

David McCullough called the memoirs his "number-one favorite," and James McPherson, the premier living Civil War scholar, termed the journal "one of the best firsthand accounts I have read of campaigning and combat in the Civil War" by "one of the Civil War's most remarkable soldiers."

After the war, Rhodes engaged in marketing cottons and woolens throughout the country, but his truly significant efforts still pertained to the military. He headed veterans organizations, organized reunions at various battlefields and helped raise funds for monuments in battlefield parks. From 1879 to 1893, Rhodes was commander of the Rhode Island Militia with the rank of brigadier general. During his tenure, he helped transform the militia into a more professional organization and established its state training ground at Quonset Point in North Kingstown. He was a founder and first president of the Soldiers' and Sailors' Historical Society of Rhode Island, a position that enabled him to continue his Civil War writings.

Rhodes also engaged in political life, serving in such posts as a member of the Providence School Board, assessor of taxes in Providence and collector of internal revenue for the District of Rhode Island from 1875 to 1885.

Rhodes was an active Mason and a deacon and Sunday school superintendent at Providence's Central Baptist Church. He also was chairman of the Home for Aged Men and Couples.

Rhodes, who was only nineteen at the outset of the Civil War, married Caroline Pierce Hunt (1841–1930) after war's end. The couple had a son, Frederick Miller Rhodes, and a daughter, Alice Caroline Rhodes Chace. Elisha Rhodes died in Providence on January 14, 1917, at the age of seventy-five. He and his wife are buried in the Rhodes family plot at Swan Point Cemetery.

Thanks to his great-grandson Robert Hunt Rhodes, Elisha lives on in historical memory. In 1985, Robert edited and published Elisha's now famous letters and diary as *All for the Union*, a book used by Ken Burns as source material for his epic documentary film, *The Civil War*. Then, in 2002, Robert, a librarian by profession, presented his great-grandfather's collection of Civil War relics and memorabilia to the Rhode Island Historical Society.

Brigadier General Isaac Peace Rodman

Isaac Peace Rodman was born in South Kingstown on August 18, 1822, to Samuel Rodman, a woolen manufacturer, and Mary (Peckham) Rodman.

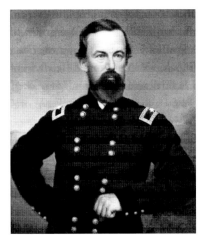

His ancestors included members of South Kingstown's most prominent clans, the Hazards and the Perrys.

After attending local public schools, Isaac entered his father's business, but his love of learning and avid reading habits gained him local renown as a scholar and literary critic. Engaging in public life, Rodman served as president of his town council and as a senator and a representative in the Rhode Island General Assembly. He was a devout Baptist who taught courses on the Bible at his local Sunday school. He also became director of the Wakefield Bank. In 1847, Rodman married Sally Arnold, the daughter of former Whig governor Lemuel Arnold. They became the parents of seven children.

When the Civil War began, the thirty-eight-year-old civic leader raised a military company composed of his fellow townsmen for the Second Rhode Island Regiment of Volunteers and was appointed as its captain by Governor William Sprague. For Rodman's valor at the First Battle of Bull Run, Sprague appointed him colonel of the Fourth Rhode Island Regiment when it was mustered into service in October 1861. That unit fought in the successful North Carolina Campaign as part of General Burnside's Ninth Corps. At the Battles of Roanoke and New Bern, Rodman won acclaim for his daring. One early Civil War historian stated that "the charge by Colonel Rodman, leading the Fourth Rhode Island Regiment, was one of the most heroic deeds" of the Battle of New Bern. Shortly thereafter, Rodman was breveted brigadier general. Governor Sprague, the martial man who mobilized Rhode Island troops at the outset of the war, wrote privately in early 1862 that "General Rodman is the bravest man I ever knew."

In April 1862, Rodman was felled by typhoid fever and came home to recuperate. Against the advice of his physician, he quickly returned to the battlefront.

Assuming command of the Third Division, Ninth Corps, Rodman led his troops at South Mountain and at the crucial Battle of Antietam, where he received a mortal wound. On the afternoon of September 17, 1862, Rodman tried to warn a brigade under his command of a Confederate ambush in the infamous Antietam cornfield. As Rodman daringly galloped

across an open meadow, a Rebel sharpshooter knocked him off his horse with a fatal shot to the chest. He succumbed to his wound thirteen days later in a field hospital at Sharpsburg, Maryland, becoming the highest-ranking Rhode Island soldier ever to die in battle.

Isaac Rodman is buried at the Rodman family cemetery located off Emmett Lane in the South Kingstown village of Peace Dale. His nearby home is listed in the National Register of Historic Places, and a section of Rhode Island's Route 4 in Washington County is named in his honor.

Brigadier General George Sears Greene

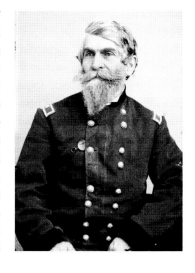

George Sears Greene, distinguished military leader and civil engineer, was born in Warwick's central village of Apponaug on May 6, 1801, the son of Sarah Robinson and Caleb Greene, a ship owner and relative of General Nathanael Greene. The family's military heritage influenced George to attend West Point, where his great skill in mathematics and engineering was discovered and developed. After graduation in 1823, Greene became a professor of mathematics and engineering at his alma mater, teaching, among others, Cadet Robert E. Lee. He then served in the artillery at several posts around New England.

In the summer of 1828, Greene married Mary Elizabeth Vinton, sister of his best friend at West Point, David Vinton. Elizabeth gave birth to three children over the next four years. While Greene was assigned to Fort Sullivan in Eastport, Maine, in 1833, tragedy struck his family: Elizabeth and all three of their children died within seven months, probably from tuberculosis. To ease the pain on his mind and escape the isolation and loneliness of peacetime army garrison duty, he immersed himself in the study of both law and medicine, coming close to professional certification in each by the time he resigned his commission in 1836 to become a civil engineer.

Greene took a second wife in February 1837, Martha Dana, daughter of Congressman Samuel Dana of Massachusetts, and by her had six children.

Two of his sons became distinguished civil engineers, like their father, after serving in the Civil War. A third, Samuel Dana Greene, served as executive officer of the ironclad *Monitor*.

In the quarter century after leaving the army, Greene became a noted and successful civil engineer. For the next two decades, he devoted most of his effort to the construction of railroads throughout New England. In 1856, Greene accepted a position with New York City's Croton Aqueduct Department, where he gained acclaim for designing the Central Park Reservoir, a pipeline on High Bridge over the Harlem River and other improvements to New York's water supply system. While in New York, he became one of the twelve founders of the American Society of Civil Engineers and Architects.

With the outbreak of Civil War, the sixty-year-old Greene rejoined the army, receiving a commission as colonel of the Sixtieth New York Regiment in January 1862. Within months, he was elevated to the rank of brigadier general of volunteers, and he fought in numerous Civil War engagements, most notably Antietam and Gettysburg. The leading scholarly history of the Battle of Antietam described Greene as "a tough old warhorse who believed in hard drill and discipline in camp and hard driving on the battlefield." Greene has been singled out by military historians as one of the three most effective Union generals at Antietam, the bloodiest day in American military history. In the following July at Gettysburg, Greene's troops bravely held off the Confederates at Culp's Hill and prevented them from turning the right flank of the Union army. In a reference to Colonel Joshua Chamberlain, commanding the Twentieth Maine Infantry, Greene has been called "Gettysburg's other second-day hero" by Civil War military historians. There is a monument to him on Culp's Hill at Gettysburg National Military Park.

In October 1863, Greene was shot through the face—a wound that kept him out of military action until he joined Sherman's army in its triumphal march through the Carolinas in the early months of 1865.

Lieutenant George K. Collins, who served under Greene during the Civil War, gave this revealing description of his commander:

> *He was a West Point graduate, about 60 years old, thick set, five feet ten inches high, dark complexioned, iron gray hair, full gray beard and mustache, gruff in manner and stern in appearance, but with all an excellent officer and under a rough exterior possessing a kind heart. In the end, the men learned to love and respect him as much as in the beginning they feared him, and this was saying a good deal on the subject. He knew*

how to drill, how to command, and in the hour of peril how to care for his command, and the men respected him accordingly.

Returning to civilian life in 1866, Greene embarked on the most significant years of his engineering career. From 1866 to 1871, he continued his expansion of the New York City water supply and then served as chief engineer for the District of Columbia. He was also employed as a consultant for the construction of water or sewer systems for such burgeoning cities as Yonkers and Troy (both in New York), Detroit and Providence, where he worked with J. Herbert Shedd during the administration of Mayor Thomas Doyle.

From 1875 to 1877, Greene served as president of the American Society of Civil Engineers and Architects, the organization that he had helped found in 1852. When he died at Morristown, New Jersey, on January 28, 1899, he was the oldest living graduate of West Point. His body was transported home for burial at Warwick's Greene Family Cemetery, with a two-ton boulder from Culp's Hill placed on his grave.

Major General Zenas Randall Bliss

Zenas Randall Bliss was born in the Johnston village of Simmonsville on April 17, 1835. He passed a comfortable youth in a middle-class family until he won a direct appointment to the United States Military Academy in 1850 at the age of fifteen. At West Point, Bliss graduated near the bottom of the class of 1854 and was immediately dispatched to Texas to serve with the Eighth United States Infantry.

Promotion to first lieutenant came in 1860, as Bliss continued with his peacetime duties of policing the frontier. In 1861, in the midst of the secession crisis, Brigadier General David Twiggs surrendered all Federal forces in Texas to Confederate authorities. Bliss, now a captain, found himself in captivity until April 1862, when he was exchanged. He immediately returned to Rhode Island and accepted command of the Tenth Rhode Island Volunteers for a three-month tour of duty in the defense of Washington.

In August 1862, Governor William Sprague appointed Bliss colonel of the Seventh Rhode Island Volunteers, and Bliss brought his regiment south, where he trained them in his own image. The result would be the finest combat regiment produced by Rhode Island during the Civil War. At the

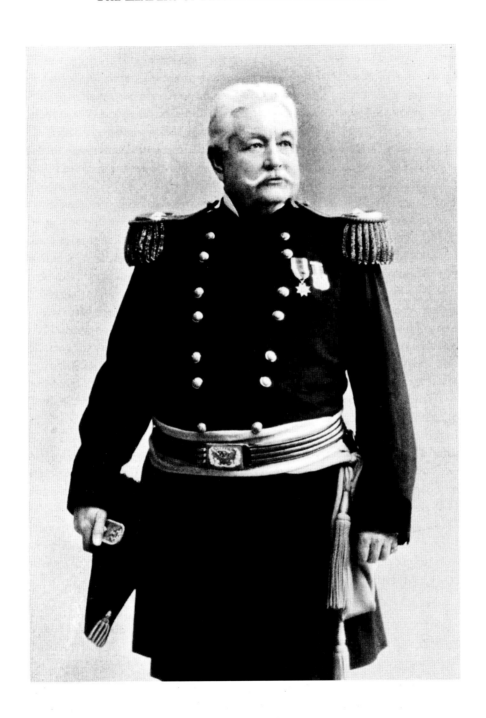

Battle of Fredericksburg on December 13, 1862, Colonel Bliss took the Seventh into action in a desperate assault against a fortified enemy position. Despite the fact that 40 percent of his regiment was either killed or wounded, Bliss, though slightly injured, personally led the Seventh to within fifty yards of its objective without the aid of any other staff officers. For his courageous actions, Bliss not only received universal praise from his commanders but also the rank of brevet major in the regular army, as well as nomination for promotion to brigadier general. His heroism at Fredericksburg earned him a belated Medal of Honor in 1898.

Colonel Bliss again led the Seventh with vigor during the Mississippi Campaign in the summer of 1863 and at the Wilderness in the spring of 1864, earning brevet promotions for each campaign. He was injured in a fall from his horse at the Battle of Spotsylvania Court House in May 1864 but was well enough to return to action later that summer.

After being mustered out of his volunteer rank in the summer of 1865, Bliss reverted to the rank of major in the regular army. After brief recruiting tours, he was sent west and assigned to command the so-called Buffalo Soldiers, with whom he spent twenty-one years on the frontier. His long tour of duty at numerous posts with these now legendary African American soldiers made him an early advocate for their widespread service in the army.

Bliss eventually rose to command the Department of Texas and gained promotion to brigadier and major general in 1892 and 1897, respectively. He officially retired on May 22, 1897, after nearly forty-seven years of active duty. General Bliss died on January 1, 1900, at age sixty-four and, fittingly, was laid to rest at Arlington National Cemetery, Section 1. A large collection of his papers is stored in the Briscoe Center for American History at the University of Texas–Austin.

On October 21, 1863, Bliss married Martha N. Work of Providence, who is buried with him. The couple had four children, two of whom lived to adulthood. Their son Zenas Work Bliss (1867–1957) was Republican lieutenant governor of Rhode Island from 1910 to 1913.

Major George Newman Bliss

George Newman Bliss was born in Tiverton, Rhode Island, on July 22, 1837, the son of James and Sarah (Stafford) Bliss. He attended Brown University, secured a bachelor's degree from Union College and earned a law degree from Albany Law School in 1861.

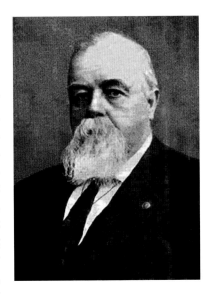

Enlisting in the Civil War as a private, he rose to the rank of major in the First Rhode Island Cavalry, serving with valor and resourcefulness in numerous engagements in the Virginia theater of war. At Waynesboro, Virginia, on September 18, 1864, he displayed such heroic action as to merit the Medal of Honor, an award conferred on him belatedly in 1897. According to the citation accompanying the award, Bliss, "while in command of the provost guard…saw the Union lines returning before the attack of a greatly superior force of the enemy, mustered his guard, and, without orders, joined in the defense and charged the enemy without support. He received three saber wounds, his horse was shot, and he was taken prisoner."

After the war, Bliss became a founder of the Soldiers' and Sailors' Historical Society of Rhode Island and wrote or edited many of the essays in the series *Personal Narratives of the Rebellion*. Bliss also became a prominent attorney, a state legislator serving in both the House and the Senate and town solicitor of East Providence. In 1872, he began fifty years of uninterrupted service as judge of the East Providence District Court. When he retired in 1922, Bliss had heard more than twenty-four thousand cases.

Besides his legal activities, Judge Bliss took an active part in veterans organizations and the Masonic Order. He was the civic leader of East Providence. In addition to writing a history of the town (which was acquired from Massachusetts by Rhode Island in 1862), Bliss was a member of the East Providence School Committee for twenty-five years and superintendent of schools for thirteen years. The Watchemoket Public Library owed its beginning to his efforts, as did the United Congregational Church of East Providence.

Bliss married Fannie Carpenter of Seekonk in 1850, and the couple had six children. One son, William C. Bliss, became chairman of the Rhode Island Public Utilities Commission. On August 29, 1928, Judge Bliss died at age ninety-one. His wife died in March 1930. They are buried at Lakeside Cemetery in Rumford. The George N. Bliss Papers detailing his varied career are stored at the Rhode Island Historical Society.

MAJOR GENERAL FRANK WHEATON

Frank Wheaton was born on May 8, 1833, in Providence, the son of Dr. Francis L. Wheaton and Amelia S. (Burrill) Wheaton. He attended public schools and studied engineering at Brown University for one year before leaving college to accept a position with the United States and Mexico Boundary Commission. This agency, headed by Rhode Islander John Russell Bartlett, set the boundary between the two recent combatants in the Mexican-American War. After five years of service with the commission, Wheaton accepted an appointment as a first lieutenant in the U.S. Cavalry. As a young officer, he engaged in several skirmishes with the Native Americans of the Southwest.

On March 1, 1861, preceding the outbreak of Civil War, Wheaton became a captain in the Fourth Cavalry and in July returned to Rhode Island to become the lieutenant colonel of the Second Rhode Island Infantry under Ambrose Burnside. Commended for "admirable conduct" at the First Battle of Bull Run, Wheaton fought with the Second Rhode Island in the Virginia Campaigns of the Army of the Potomac, rising to the rank of brigadier general and commanding a brigade in the Sixth Corps. He fought at Fredericksburg, Gettysburg, the Wilderness, Cedar Creek, Spotsylvania and Cold Harbor, as well as in the Petersburg Campaign.

In July 1864, Wheaton, now commanding a division, was rushed by water to Washington to repel a threatened attack on the national capital by Confederate general Jubal A. Early. His repulse of the attackers earned Wheaton a brevet as major general. His final battle was the successful final assault on Petersburg in April 1865.

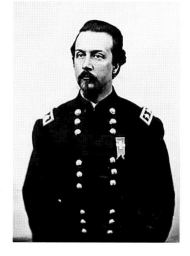

Wheaton's marital life was both sad and troubled. His first wife, Sarah Cooper, died in 1858 after less than two years of marriage. His second wife, Emma Mason, died in 1864 after slightly more than two years of marriage. Both ladies were descendants of Virginian statesman George Mason of Bill of Rights fame, and Sarah was the daughter of Confederate general Samuel Cooper.

At war's end, Wheaton was mustered out of the volunteer service and secured an appointment as lieutenant colonel of the Thirty-Ninth U.S. Infantry in the regular army. At this time, he received an honorary master's degree from Brown University and was presented with a sword of honor by the State of Rhode Island.

Returning to the West, Wheaton commanded the bloody 1872–73 expedition against the Modoc Indians in Oregon and northern California but met defeat. After continued western service, he was made a brigadier general in 1892 and assigned to command the military Department of Texas. In April 1897, Wheaton was promoted to his old volunteer rank of major general and retired. Thereafter, he made his home in Washington, the city he had defended so effectively in July 1864. General Wheaton died of a cerebral hemorrhage on June 18, 1903, and was survived by his third wife. That spouse, Maria Miller, had borne him five children, none of whom lived to adulthood.

Wheaton, Maryland, is named in his honor. He and Maria, who died in 1924, are buried together at Arlington National Cemetery.

CAPTAIN JAMES ALLEN

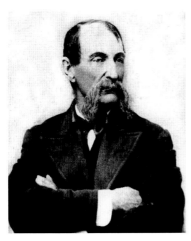

James Allen was born in Barrington on September 11, 1824, one of the ten children of Mary Luther, of that prominent East Bay family, and Sylvester Allen, a sea captain who died when James was eight of wounds sustained in a pirate raid.

Allen began his career as a pioneering balloonist when he made the first of several hundred ascensions in 1856. The *Zephyrus*, the first of his fifteen balloons, rose three and a quarter miles over Providence from a vacant lot at the present site of city hall.

When the Civil War began, Allen enlisted with the Union army as an observer, becoming the first American military balloonist. He was later joined by his younger brother Ezra, and the Allens provided intelligence to ground forces at such encounters as

Yorktown, Mechanicsville, Chancellorsville, Fair Oaks and Malvern Hill (for which James named his youngest son). Adolphus Greeley, chief signal officer of the Union army, later noted that "the Union Army was saved from destruction at the Battle of Fair Oaks…by the frequent and accurate reports" from Professor Thaddeus Low, chief Union aeronaut, and Captain James Allen.

While engaged in their duties with a balloon detachment in Virginia, James and Ezra met Count Zeppelin, then on duty at the Prussian embassy in Washington. The famed inventor of the lighter-than-air dirigible had his first ride in an aircraft with the Allens of Providence. Another noted Allen passenger over Yorktown was the daring George Armstrong Custer.

James Allen's well-known reconnaissance services in the Civil War attracted the attention of the government of Brazil, which recruited him in 1867 to assist in subduing the Paraguayan Rebellion. He and Ezra served Brazil with distinction for thirteen months and were handsomely rewarded by that victorious nation for their aerial efforts.

After the war, Allen was joined by his son James Kinnicutt Allen, and both became nationally recognized as experts in the science and practice of ballooning. They thrilled local audiences with their annual Fourth of July ascensions over Providence and Narragansett Bay. The exploits of James Allen and his family gained national attention, and they were invited to exhibit their talents as far west as San Francisco and as far north as the city of Quebec.

Allen was also aware of the scientific importance of ballooning, well beyond its entertainment value. From their earliest pre–Civil War flights together, Allen and his mentor, Samuel Archer King of Philadelphia, had been serious students of atmospheric science. Their observations of wind speeds and currents, clouds, temperature and pressure variations had formed the basis for valuable research. By the mid-1880s, King had convinced the U.S. Army Signal Corps of the usefulness of the balloon in gathering meteorological data. The Corps sent a data gatherer aloft with James and his son James K. on June 24, 1886.

By July 1891, James, James K. and Malvern Hill had made 481 ascensions. That September, the elder Allen garnered headlines across New England when he devised a way to transmit the score of the Harvard-Yale football game using specially designed blue pyrotechnic balloons. On two occasions, he stayed aloft for ten consecutive days.

Allen was a staunch Republican, a strong temperance advocate and an active member of St. Paul's Methodist Episcopal Church in Providence. He

married Agnes Jane Fields of Johnston on October 15, 1849. On occasion, even she took flight.

The patriarch of America's first family of aeronauts died peacefully on September 24, 1897, at age seventy-three of pneumonia and was buried at Swan Point Cemetery in Providence. He was survived by his wife and such distinguished flyers as his brother Ezra Allen; his cousin Samuel F. Allen; his sons James K. Allen, Ezra Stiles Allen and Malvern Hill Allen; and his daughter, Lizzie Allen.

II

THE ENTREPRENEURS

JOSEPH R. BROWN AND LUCIAN SHARPE

Joseph Brown and his protégé and successor, Lucian Sharpe, were the men who brought Rhode Island's machine tool industry into national prominence and leadership. Born a generation earlier than Lucian (1810 to Lucian's 1830), Joseph was the mechanical genius who founded the business, and Lucian expanded it, much like John Gorham did for his notable business enterprise as successor to his father, Jabez.

Joseph was born in Warren, Rhode Island, on January 26, 1810, the son of Patience Rogers of Newport and her husband, David Brown, a talented clock builder and dealer in clocks, watches, jewelry and silverware. Joseph attended school until the then-ripe age of seventeen, but he also spent considerable time in his father's shop learning and developing various mechanical skills. In 1827, after his family moved to Pawtucket, he secured a job in the machine shop of Wolcott and Harris in Valley Falls on the Blackstone River, two waterfalls above the Wilkinson Mill. Here Joseph engaged in the manufacture of cotton machinery and began to develop an interest in machine toolmaking.

After a brief debut in the machine-making business, he worked with his father in the construction of tower clocks for churches in the towns of Pawtucket, Taunton and New Bedford. When Joseph came of age in 1831, he opened his own small shop and began the manufacture of tools for the clock industry, precision measuring devices, lathes and a gauge for the brass

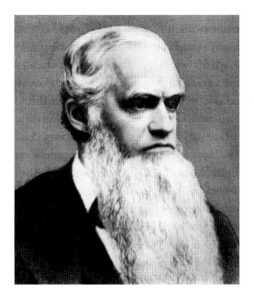

Joseph Brown.

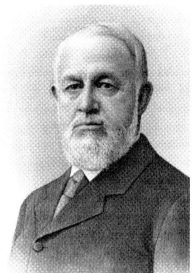

Lucian Sharpe.

industry. Then, in 1833, he was joined by his father in a new venture when they acquired facilities at 60 South Main Street in Providence. In 1837, after four years of growth, this shop and its contents were destroyed by fire. From this inauspicious beginning would evolve a mammoth enterprise. With insurance proceeds of $2,000, Joseph and David moved their business across the street to 69 South Main. After 1841, Joseph became the sole proprietor when his restless father traveled west to Illinois in search of new opportunities.

As his business continued to develop, Joseph moved it to larger quarters on 115 South Main Street. He received Lucian Sharpe as an apprentice at this location in 1848. This eighteen-year-old prospect, the son of stable owner Wilkes Sharpe and his wife, Sally Chaffee, was Providence-born with family antecedents in Pomfret, Connecticut. Sharpe, who possessed a high school education, impressed Brown not only with his mechanical aptitude but also with his drive, intelligence, literary proficiency and organizational skills. On March 1, 1853, he became Brown's partner under the firm name of J.R. Brown & Sharpe. This combination of technical and business talent united to make Brown & Sharpe a household name throughout Rhode Island and beyond.

When Sharpe became a partner, Brown's business had been established for twenty years, earning a local reputation for producing excellent and accurate work but earning only meager profits. Now Brown was free to give his undivided attention to his true genius, invention, while Sharpe

could focus on increasing business, most notably via an 1858 contract with the Wilcox & Gibbs Sewing Machine Company to manufacture its entire product. Giving Brown & Sharpe a prominence in mechanical work, this key account was primarily responsible for the firm's decision to focus on the precision machine tool business, in which Brown excelled.

The litany of Joseph Brown's mechanical inventions is amazing, especially to those, like historians, who generally possess little technical aptitude. Perhaps encouraged by his familiarity with clock mechanisms, Brown became interested in making precise measuring devices, the first of which was an automatic linear-dividing engine. By 1853, he had perfected the vernier caliper, the first practical tool for exact measurements that could be sold at a price affordable for the ordinary machinist. This technical breakthrough was followed by such patented inventions as a precision gear-cutting and dividing engine, a turret screw machine, the universal milling machine, the micrometer caliper, the universal grinding machine and a series of other gauges and machine tool innovations that revolutionized the industry and made Brown & Sharpe the national leader in the production of such items.

Brown was a simple, unostentatious man who was consumed by his work, which was his greatest pleasure. According to one who knew him, "He had no ambition to make a large amount of money or to establish a very large industry, but his inventions were of such a character that when made known they were at once appreciated and were of inestimable value to the business." Lucian Sharpe was the public relations and marketing genius who made them known internationally.

Brown married Caroline Niles in 1837, and the couple had two children before her death in 1851. The following year, he married Jane Mowry of Pawtucket. As his health began to fail, he devoted more time to leisure, and the pair toured Europe in 1866 and then made an extended stay in 1867. Brown died at his summer retreat at the Isles of Shoals, New Hampshire, on July 3, 1876.

During the years before and after Brown's death, Lucian Sharpe's marketing ability and managerial skill made the company one of the world's largest machine tool enterprises. In 1853, the floor space of its buildings covered 1,800 square feet; by 1899, the year of Sharpe's death, that space had increased to 293,760 square feet in seventeen interrelated buildings. During that same period, the Brown & Sharpe workforce expanded from fewer than twenty employees to two thousand craftsmen. Among those in that skilled workforce were Hall of Fame inductees Frederick Grinnell, fire sprinkler inventor; William Nicholson, the file king; and Henry Leland,

founder of the Cadillac and Lincoln Motor Companies. These and other craftsmen honed their skills at Brown & Sharpe.

Sharpe avoided active involvement in politics and took no part in the management of other manufacturing or commercial enterprises, except as director (from 1874) of the Wilcox & Gibbs Sewing Machine Company. However, he was a member of the board of directors of three Providence banks and the Providence Gas Company. Most important was his position as president of the Providence Journal Company from 1886 until his death.

Lucian Sharpe married Louisa Dexter on June 25, 1857, and the couple had four daughters and two sons. His daughters married into the Chafee and Metcalf families and were prominent in the development of the Rhode Island School of Design and the funding of many local charitable agencies.

Unlike many entrepreneurs, Sharpe never retired to rest on his laurels; he was intensely focused on his business and actively managed it until his death, which occurred on October 17, 1899, during his return voyage from Europe, where he had journeyed in hopes of regaining his health. He was sixty-nine years of age at his passing.

The business built by this duo continued through the twentieth century, at its peak operating eleven plants in four countries. In January 1965, it moved its main plant from Providence to a more modern facility in North Kingstown that it named Precision Park. Gradually, however, labor problems, money problems and the technological revolution debilitated the once mighty creation of Joseph Brown and Lucian Sharpe. The end came in April 2001, when Henry Sharpe Jr. yielded to the inevitable and sold its assets to Hexagon A.B., a metrology company based in Stockholm, Sweden.

Fortunately, this Rhode Island industrial giant has found an able chronicler. In 2017, historian Gerald M. Carbone, using the voluminous company papers carefully stored at the Rhode Island Historical Society, published *Brown & Sharpe and the Measure of American Industry*. As stated at the conclusion of my review of Carbone's book, "Providence's five industrial wonders have evaporated along with the status of Providence as one of America's manufacturing marvels. Progress often exacts a painful price. My wish is that the other four wonders obtain a writer with the talent and research skills of Carbone to preserve their memory for posterity."

George H. Corliss

Of all Rhode Island's successful entrepreneurs, manufacturers and inventors, none achieved more fame and notoriety in his or her lifetime than George H. Corliss, the man whose refinements to the steam engine earned him international acclaim. His ancestors were among the earliest settlers of the Massachusetts Bay Colony, where his family resided until moving to Easton, New York, a Hudson Valley village about forty miles northeast of Albany, shortly after the American Revolution. Here George was born on June 2, 1817, to the former Susan Sheldon and Dr. Hiram Corliss, a versatile man who farmed, taught school, ran a general store and practiced medicine.

The family, which eventually included nine children, moved to nearby Greenwich when George was eight. There he went to school and worked in the employ of a local factory store, where he inspected, measured and sold cotton goods. His first engineering venture, while he was still only seventeen, was the design of a temporary bridge over a small local river, which he constructed in ten days with volunteer help. Perhaps this feat prompted his father to support additional formal education for George, who selected Castleton Seminary in Vermont for further schooling. He graduated in 1838 but returned to Greenwich to partner with his father in operating a general store. While selling shoes at this establishment, he fielded complaints from customers that the leather shoes they purchased split along the seams. The mechanically inclined Corliss sought to address this concern by devising a stitching machine for work on such materials as leather and sail cloth that could sew at twenty stitches per minute. On December 23, 1843, he patented the invention and prepared to embark on a new career.

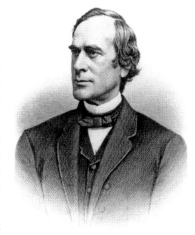

At that time, the Providence-Pawtucket area had a national reputation for the manufacture of innovative machinery, so Corliss came to Rhode Island to find a builder for his sewing machine. He got a job as a draftsman in the shop of Fairbanks, Bancroft & Company to raise funds to produce his invention and to gain machine shop experience. Corliss's ambition and talent, coupled with the retirement of Edward Bancroft, led to the firm's reorganization in 1847, when it

became Corliss, Nightingale & Company, with thirty-year-old George as its president. By 1856, it was simply the Corliss Steam Engine Company.

The upside of this business transformation was that Corliss and his company embarked on the manufacture of steam engines as the firm's principal product. The downside for Corliss was that he never put his sewing machine into production, so Elias Howe, originally of Spencer, Massachusetts, patented a slightly different version in 1846, manufactured it and received the popular acclaim for being the machine's inventor. To Howe's credit, he later acknowledged publicly that "I did not invent the sewing machine. That honor belongs to George H. Corliss of Providence, Rhode Island, the noted engine builder."

From 1847 onward, steam engine improvements and production became George's passion and his great achievement. Lacking higher education to refine his talent, Corliss sought out Alexis Caswell, a Brown professor of mathematics, to instruct him in the properties of confined steam and the force it could exert. Armed with both genius and knowledge, in 1849 Corliss patented a governor with an automatic variable cut-off that made it possible for a steam engine to use only that amount of steam necessary to produce the required power with no loss of speed. Preventing the waste of steam by rationing it meant that less fuel (coal) was burned and production costs were sharply reduced. This slide valve mechanism operated on the same principle as Zachariah Allen's 1834 cut-off valve, but it functioned differently. The similarities eventually led to a bitter legal and highly technical verbal battle between Allen and Corliss over their respective patents, with a court ruling in favor of Corliss.

Corliss also filed numerous complaints for patent infringement against others who copied him. In total, he reputedly spent more than $100,000 on such litigation, much of it paid to his principal attorney, William H. Seward of New York, who was Abraham Lincoln's secretary of state. He also retained local patent attorney Benjamin F. Thurston.

In his lifetime, Corliss was issued forty-eight patents, and twelve more, pending at his death, were issued later. Most involved improvements to what became known nationally as the "Corliss Engine," but others related to such diverse items as pumps, a boiler with condensing apparatus, gear cutters, machine tools and an elevator (which he installed in his mansion at 45 Prospect Street in Providence).

Immediately after creating his new firm, Corliss moved his operations from India Street to a much larger site on West River Street in Providence's north end. At the time of his death, in 1888, the company had grown to

encompass nine acres and employ one thousand people. It was the most famous engine works in America during the country's Age of Steam. Most of this vast plant has been destroyed, but the street on which Providence's mechanized main post office is located bears the Corliss name.

It was at the West River Street plant that refinements were made to the Union vessel *Monitor* in 1862 to prepare it for the first battle of ironclad ships. Built at the Brooklyn Navy Yard according to the designs of Swedish inventor John Ericson, the *Monitor* had a revolving gun turret, but no factory in New York was capable of machining the large bearing on which the turret's operation depended. Corliss had such equipment, so the *Monitor's* huge ring was rushed by train to Providence, worked on and returned to Brooklyn the same day to make the *Monitor* ready for its epoch-making duel with the Confederate *Merrimac* (renamed the *Virginia*).

In the ensuing years, the Corliss works produced thousands of steam engines for use throughout America and won numerous national and international awards for excellence in function and design, including coveted Rumford Medals from the American Academy of Arts and Sciences.

Corliss's crowning glory came in 1876 at the centennial celebration of the Declaration of Independence. He was invited to help plan a mammoth Philadelphia exhibition of American achievements. Its centerpiece was a 776-ton Corliss engine that was 40 feet high, had a flywheel 30 feet in diameter and weighed eleven tons. The wheel meshed with a pinion shaft that was 325 feet long and delivered power to the hundreds of machines that were on display in the exhibition's thirteen-acre main hall. The Centennial Engine, as it was called, was built in Providence and shipped by train on seventy-one flatcars to Philadelphia. Corliss, a devout Congregationalist, refused to place his engine in service on the scheduled Sabbath Day, so on Wednesday, May 10, 1876, as the spectators stood in awe, Corliss; his wife, Emily; President Ulysses S. Grant; and Brazilian emperor Dom Pedro II presided over the start-up ceremony, making the great wheel revolve to set in motion the intricate mechanisms that powered eight thousand machines throughout the vast hall. Nat Herreshoff assisted him in this process.

Corliss spent $100,000 on his prize creation, which ran flawlessly during the six-month festival. The engine was then bought for $62,000 by George Pullman, of railroad car fame, for his company town in Illinois. In 1905, as electricity replaced steam power, the famed machine was sold for scrap at a price of $7,892.50!

George Corliss did not have far-ranging interests other than his work, except for his skill as an architect. He dabbled a little in politics, serving

in the Rhode Island General Assembly from 1868 to 1870. He also was a Republican elector in the highly disputed Rutherford Hayes/Samuel Tilden presidential contest of 1876, which was decided in favor of the Republican Hayes by one electoral vote. Corliss was married twice, first in 1839 to Phoebe Frost, who died in 1859 after providing him with a son and a daughter, and then in 1866 to Emily Shaw, from his ancestral hometown of Newburyport.

For his second wife, who was considerably younger, Corliss built a splendidly designed mansion at 45 Prospect Street with a stunning interior, an advanced radiant heating system with thermostats and a hydraulic elevator from the basement to the third floor. He died in this mansion (which he called Emily's "Bermuda home") on February 21, 1888, and was buried at Swan Point Cemetery. Emily long survived him, living until 1910, but her husband's business did not—it failed in the disastrous national economic Panic of 1893.

JOHN GORHAM

John Gorham was the son and protégé of noted jeweler and silversmith Jabez Gorham, who, like John, is a Hall of Fame inductee. Jabez was an apprentice to silversmith Nehemiah Dodge, and with Dodge's guidance, the elder Gorham learned the trade but chose not to emulate his mentor by crafting costume jewelry when he concluded his apprenticeship in 1813. Not long thereafter, Jabez entered into a partnership (as was quite common in this business) with other craftsmen and began the manufacture of gold jewelry on the second floor of a building at 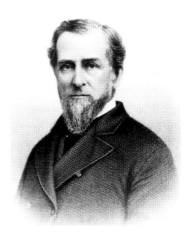 the corner of North Main and Steeple Streets in Providence's original jewelry district. In 1818, after five years of partnership operation, Gorham became the sole proprietor and soon won a regional reputation by making French filigree jewelry and a special kind of popular gold chain that became known as the "Gorham chain." From 1825 through 1840, Jabez took on a succession of three partners—Stanton Beebe,

Henry Lamson Webster and William Gladding Price—the last of whom married Jabez's daughter Amanda. The Webster partnership, which opened a shop at 12 Steeple Street in 1831, made the momentous shift to selling silver spoons as its leading product. From that point onward, silverware and Gorham became synonymous.

In 1837, Jabez took on an apprentice who would one day transform the Gorham Manufacturing Company into a world leader in the production of silverware, holloware and statuary. That protégé was his third child, John, whose birth on November 18, 1820, caused complications that led to the death of Gorham's first wife, Amey Thurber, eight days later at the age of twenty-five.

In 1839, Jabez withdrew from his partnership with Webster and Price but continued to manufacture his Gorham chain. Perhaps at the urging of his son John, he resumed the manufacture of spoons and silverware in 1841 at 12 Steeple Street by forming the firm of J. Gorham & Son.

Jabez retired permanently from the business in 1847, having achieved both fame and prosperity. In 1858, he and his second wife, the former Lydia Dexter, built an imposing brick house at the corner of Benefit and Bowen Streets, where Jabez continued to reside until his death on March 24, 1869, at the age of seventy-seven.

John Gorham proved to be a most worthy successor to Jabez. His father's business model relied on a small number of craftsmen producing a limited number of quality items, but John quickly began to recognize the advantages of mechanization to augment handcraftsmanship in the production of silverware. His research into manufacturing processes brought him to the Springfield Arsenal in Massachusetts and the U.S. Mint in Philadelphia, where he learned procedures for handling large quantities of coin silver.

His entry into silver manufacturing was blessed by good timing. In 1842, those engaged in the production of silverware successfully petitioned Congress to impose a 30 percent *ad valorem* tax on imported silver, a levy that gave American manufacturers a major impetus to increase production. After John bought out his father's interest in 1847, his incessant drive to learn more about his competitors and their business practices brought him to Europe in 1852, where he visited English factories in Birmingham and Sheffield, the London Mint and the Woolwich Arsenal, as well as silver shops in Brussels and Paris. Upon his return to Providence, Gorham quickly introduced factory methods to augment his handcraftsmanship, installed a steam engine to power his new machinery and even designed new machinery himself. By 1869, he had made four fact-finding trips to Europe.

In 1850, Gorham admitted his nephew Gorham Thurber as a partner, and another relative, Lewis Dexter, assumed a partnership position with the company in 1852. In addition to management adjustment, Gorham also realized that he could no longer rely on the traditional seven-year apprentice system to enlarge his skilled workforce, which numbered only 12 in 1850. During the 1850s, he set out to recruit more than 100 skilled craftsmen from overseas. By 1861, Gorham had increased his workforce to 150, and by the end of the Civil War, he had 312 employees. Contemporaries described him as a "practical mechanic of artistic taste, with an unusual ability to organize and construct."

In 1863, the Rhode Island legislature chartered John's firm as the Gorham Manufacturing Company, and he assumed its presidency, with Gorham Thurber designated the treasurer. Within a decade, Gorham was reputed to be the largest manufacturer of coin silverware in the world, with a workforce that had grown to 450 employees toiling in buildings that occupied an entire block around Steeple and North Main Streets.

John Gorham had taken many financial risks in expanding his father's company, so when the Panic of 1873 hit, he, like the Spragues, was forced into bankruptcy. The economic impact on John personally left him merely a Gorham Company employee when the firm recovered, so he resigned from the company in 1878. One contemporary observer noted that "he is in no business and has no means."

Sometime after 1881, John moved permanently to Chase City, Virginia, where he died on June 26, 1898. Despite this personal setback near the end of his career, his entrepreneurial spirit, his inventiveness and his management expertise had taken a small business founded by his father and grown it to be one of America's great industrial wonders. Although John Gorham himself had died, his creation thrived in its new and expansive complex at the end of Adelaide Avenue in the Elmwood section of Providence, to which it relocated in 1890.

Outside his business ventures, John's personal life was relatively uneventful. In the 1840s, he attained the rank of lieutenant colonel in a militia unit called the Providence Horse Guards, and he served one year as a Whig state legislator. In 1848, he married Amey Thurber, a woman with the same name as his mother. The couple had six children, three of whom died before their father's move to Virginia.

In 1967, Gorham became a division of the Rhode Island conglomerate Textron, which then sold it to Dansk in 1989. After two more flips, it now operates as a division of Lenox Corporation.

When the Elmwood plant closed in 1985, that event marked the removal from the city of the last of its "five industrial wonders of the world." A much smaller Gorham manufacturing plant was built in Smithfield in 1985, but that closed its doors in 2001.

In Rhode Island, however, the Gorham name lives on, and its most famous creation, the statue of the *Independent Man* atop Rhode Island's statehouse, crafted a year after John's death, will long be a visible reminder of the world-renowned business that Jabez and John Gorham began and nurtured. The voluminous records of their iconic company are now stored at Brown University's John Hay Library.

WILLIAM GORHAM ANGELL

William Gorham Angell was born in Providence on November 21, 1811. He was a descendant of Thomas Angell, one of Providence's first settlers. Despite his lineage, William's family was one of modest means: his father, Enos, was a carpenter, and his mother, Catherine Gorham, one of ten children, was the sister of the soon-to-be famous Rhode Island silversmith Jabez Gorham. Acquiring only a basic common-school education, William Angell took up his father's trade as a carpenter until he was about twenty years of age. Then he entered into a partnership with his uncle John Gorham, making reeds to allow looms to operate more efficiently. However, Angell possessed what his associates described as "an intuitive perception of the capabilities of a machine," and during these years, he experimented with machinery for making iron screws to be used in woodworking.

Angell devised several improvements in the screw-making machinery of his era, and when several Providence investors formed the Eagle Screw Company in 1838 to compete with the English manufacturers of these fasteners, Angell became its agent and manager. After more than twenty successful but challenging years in business, Eagle united with the New England Company in 1860 to form the American Screw Company, with Angell as its president.

Initially capitalized at $1 million, the firm soon ranked as the world's largest producer of wood and machine screws. It was regarded by century's end as one of Providence's five industrial wonders of the world.

By 1860, according to one source, Angell's "long experience and mechanical skill gave him an intimate and practical acquaintance and

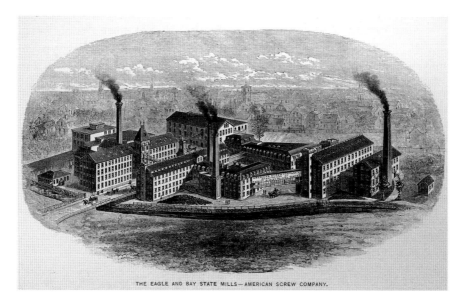

THE EAGLE AND BAY STATE MILLS—AMERICAN SCREW COMPANY.

The Eagle and Bay State Mills—American Screw Company.

familiarity with the entire history of the manufacture of screws and with the principle, construction, and operation of every machine used in this country or Europe for making screws." Along with his inventive ability, Angell had business sagacity and remarkable skill as an administrator. He knew intimately every aspect of his company, and he was, in addition, an excellent draftsman and a skilled architect and builder. These talents were used in the construction of factories that could stand the strain of the heavy machinery necessary in his manufacturing process. By 1900, American Screw was operating three major mill complexes within the city: the Bay State Mill and the Eagle Mill, on the north and south sides of Stevens Street near Randall (now Moshassuck) Square, and the New England Mill, on Eddy Street near the junction with Allens Avenue. The company remained one of Providence's leading employers until 1949, when it moved to Willimantic, Connecticut.

Angell concentrated on his business to the exclusion of most other pursuits, but he contributed liberally, though inconspicuously, toward the relief of the poor and unfortunate. Friends commented that "he was so much engrossed with his special business that he had little or no time for anything else," be it politics, social life or amusements. It was an axiom with Angell that "a man could do but one thing well."

Angell married Ann R. Stewart in January 1836 and became the father of two sons, Edwin Gorham and William Henry. The former succeeded him as president and executive manager of the American Screw Company after William Angell's death from consumption at his home on 30 Benefit Street, Providence, on May 13, 1870, at the age of fifty-eight. He is buried at Providence's North Burying Ground.

Edwin Angell presided over the business until his death on December 15, 1903. At that time, Samuel Mowry Nicholson, son of William, took over the presidency and management of the American Screw Company, thereby uniting two of Providence's industrial wonders of the late nineteenth century.

WILLIAM THOMAS NICHOLSON

William T. Nicholson was the founder of the Nicholson File Company of Providence, the originator of machine-made files and rasps in America, the largest company of its kind in the world and one of Providence's "five industrial wonders" of the nineteenth century.

Nicholson was born on March 22, 1834, in the village of Pawtucket, then in the town of North Providence, to Eliza Forrestell and William Nicholson. His father, a machinist, moved the family to Whitinsville, Massachusetts, where young William was raised and educated in the schools of that town and at the nearby Uxbridge Academy. At age fourteen, he became an apprentice machinist in Whitinsville but moved to Providence at seventeen to seek better job opportunities. He found them at Brown & Sharpe Manufacturing Company, where, rising to the position of shop manager by 1856, he supervised the production of that firm's precision instruments.

In 1857, Nicholson married Elizabeth Dexter Gardiner, who was descended from an old-line Rhode Island family. The couple had five children: Stephen, Samuel, William, Eva and Elizabeth.

In 1858, Nicholson had opened his own machine company in partnership with Isaac Brownell. By 1860, he had bought Brownell out and moved to a

larger facility. After the outbreak of the Civil War, he formed a partnership (Nicholson & Company) with Henry A. Monroe to supply the Union army with Springfield rifles. Then he turned his full attention to producing machine-cut files. In 1864, after patenting his invention, he formed the Nicholson File Company. Eventually, this enterprise became world-renowned for the quality of its specialized product and brought Nicholson and his family great wealth.

In his later years, Nicholson traveled widely and supported a number of civic projects, including the establishment of the Providence Public Library in 1877. He was for a time a member of the board of aldermen, the upper chamber of the Providence City Council.

William Nicholson died suddenly on October 17, 1893, and was succeeded by his son and protégé, Samuel Mowry Nicholson, who continued the firm's expansion and became a leading industrialist in his own right, as did his son and successor, Paul C. Nicholson Sr.

By 1900, the company's six plants—in Providence and Pawtucket, with four out-of-state—employed nearly 2,500 workers and produced more than ten thousand files and rasps a day, an output well beyond its founder's initial daily goal of three hundred. In 1903, Samuel Nicholson also acquired the huge American Screw Company after the death of Edwin Angell, son of its founder.

Nicholson File continued to operate under the direction of the Nicholson family until 1969. Its complex on Acorn Street in Providence consisting of twenty-four buildings occupying seven acres was listed in the National Register of Historic Places in 2005. The family's summer estate, Wind Hill, on Bristol Point was sold by Paul C. Nicholson Jr. to nearby Roger Williams University in late 2017 for nearly $7 million. The Rhode Island Historical Society maintains a collection of the company's records, including its patents.

Nicholson File began to phase out its Providence operations in 1952 and relocate to Anderson, Indiana, the site of a subsidiary plant that it had acquired early in the century. The company remained in Anderson until the late 1970s, when recurrent labor disputes prompted it to relocate to Cullman, Alabama. In 2011, it was acquired by Cooper Industries but remains in Cullman as the Nicholson Division of Cooper Industries.

SAMUEL POMEROY COLT

Samuel Pomeroy Colt, a brother of U.S. senator LeBaron Colt, shared his sibling's impressive lineage. His father, Christopher, was the brother of Hartford arms maker Samuel Colt, for whom he was named, and his mother, Theodora DeWolf, was a member of that notable Bristol clan.

Born in Paterson, New Jersey, on January 10, 1852, as the youngest of six children, Samuel received his early education in Hartford. He graduated from the Massachusetts Institute of Technology in 1873 and then from Columbia Law School in 1876. Samuel (or "Pom," as he was nicknamed) began the practice of law in 1877 with his brother, LeBaron, and Francis Colwell after an apprenticeship in the office of Benjamin Thurston.

Samuel soon revealed his passion for politics, becoming a military aide-de-camp on the staff of Republican governor Henry Lippitt from 1875 to 1877 with the rank of colonel, a title he proudly used for the duration of his career. He was Bristol's representative in the General Assembly from 1876 to 1879, an assistant attorney general from 1879 to 1881 and state attorney general from 1882 to 1885. These early political successes were his last. In 1903, he lost a race for governor to incumbent Democrat Lucius Garvin, and in 1905, he lost a bid for U.S. senator in a three-way contest with incumbent Republican George Peabody Wetmore and Democratic reformer Robert Hale Ives Goddard that required eighty-one legislative ballots.

As Samuel's luck in politics waned, his fortune in business waxed. In 1886, he founded the Industrial Trust Company and served as that bank's president until 1908 as it became the state's largest financial institution. Much later, it evolved into Fleet Bank and then merged with Bank of America.

Colt's entry into the rubber business was less than honorable; in fact, it was shameful. Were it not for his other substantial achievements, his benefactions and his legacy, Hall of Fame status would have been denied to him. The rubber factory in Colt's hometown of Bristol had been founded by Augustus O. Bourn in 1864 and built by him into Bristol's major industry. Perhaps resting on his laurels, Bourn and his family went to Europe in 1887 after his two terms as governor and his brief return to the state senate.

Bourn left his friend "Pom" Colt with a power of attorney over the business. Soon after Bourn's departure, his workers went on strike for back pay, thereby revealing the firm's shaky financial position because of Bourn's distraction with politics. To counter this threat, Colt petitioned the National Rubber Company into receivership and got his father-in-law, Judge Nathaniel Bullock, to appoint him as receiver. In the firm's reorganization, Bourn's stock was wiped out, and Colt emerged as the manager. The details of this maneuver, perhaps some that might have justified Colt's action, have been lost in time, but the end result is obvious. Of all the entrepreneurs profiled herein, Samuel Colt comes closest to fitting the stereotype of the so-called robber baron.

Colt's newly acquired rubber company merged with several similar firms during the early 1890s, including Joseph Banigan's enterprise, to form the United States Rubber Company. This "Rubber Trust"—the largest producer of rubber goods in the world—came under Banigan's leadership initially, but by 1901, Colt had assumed control. He served as the president of this monopoly from that date until 1918, when he became chairman of its board of trustees.

Samuel Colt amassed great wealth in business, but he shared some of it with his adopted town. He endowed Bristol's high school (Colt Memorial); granted public access to his large farm on the shore of Narragansett Bay (now Colt State Park), with signage reading, "Private property public welcome"; and financed other civic projects during his life and by his will.

Colt died on August 13, 1921, of complications from a stroke at his family home, Linden Place, at the age of sixty-nine. He was notorious for his flamboyant (some say licentious) lifestyle. He married Elizabeth Bullock of Bristol in 1881, and she bore him three sons, one of whom, Russell Griswold, married actress Ethel Barrymore. Samuel and Elizabeth separated in 1896. Neither remarried, but Samuel never lacked for female companionship. He is buried in the Colt family plot at Bristol's Juniper Hill Cemetery.

Samuel's brother, LeBaron, a distinguished federal judge, served as Rhode Island's U.S. senator from March 4, 1913, until his death in Bristol on August 18, 1924. LeBaron is also an inductee of the Rhode Island Heritage Hall of Fame.

JOSEPH DAVOL

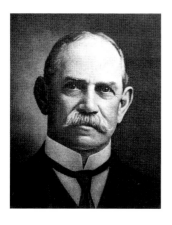

Joseph Davol, descendant of the William Davol who settled in the Massachusetts Bay Colony around 1640, was the son of Joseph Davol and Mary (Sanders) Davol. He was born in Warren in 1837, but the exact date of his birth is unknown. After early schooling in Warren, Joseph moved with his parents to Brooklyn, New York, where he attended secondary school. At the age of sixteen, he entered the employ of a wholesale dry goods business in New York City, where he received successive promotions by exhibiting a talent for business. In 1862, Davol married Mary E. Turner, a woman with deep Rhode Island roots. The couple raised two sons, George and Charles.

During the early 1870s, Davol returned to Rhode Island and turned his attention to the newly emergent rubber industry, foreseeing the great potential of this business. He devoted much of his time to product experimentation and patented several innovations. By 1874, the success of his research prompted him to open a small factory in Providence on the southerly side of Point Street in partnership with Emery Perkins. This firm, the Perkins Manufacturing Company, was taken over by Davol in 1878 and incorporated in 1882 as the Davol Manufacturing Company. In 1885, it became the Davol Rubber Company.

With Joseph Davol as president, treasurer and general manager, this firm filled an important niche in the rubber goods industry. The company produced an extensive and varied line of items, but it became especially renowned for the "fine" rubber goods it manufactured for the drug, surgical, dental and stationery trades both in this country and worldwide.

During Davol's tenure, his manufacturing enterprise expanded dramatically around the intersection of Point and Eddy Streets into a complex of several large brick buildings. The earliest surviving structure built by Davol is the Simmons Building (1880), at the southwest corner of Point and Eddy. It was named for Eban Simmons, Davol's grandfather-in-law, who had run a carpentry and planing company on that site.

The meteoric rise of Davol's business catapulted him into the ranks of Providence's captains of industry. He became a director of several banks and was active in numerous local commercial and civic enterprises until

his death on July 5, 1909, in his seventy-third year. He is buried at Swan Point Cemetery.

For the two decades following his death, his son Charles ran the continuously growing and expanding firm. Nearly a century and a half after its founding, Davol's company survives and thrives in Warwick. His renovated Providence manufacturing complex was placed in the National Register of Historic Places in 1980. A portion of that facility has been acquired for educational use by an ever-expanding Brown University, ensuring its continued prominence as a Providence landmark. The site is now known as Davol Square.

Benjamin B. Knight and Robert L. Knight

In American business history, some branded items are so successful that their name assumes the title of the generic product. Examples of this are Kleenex, Scotch Tape, Frigidaire and Xerox. Fruit of the Loom was a nineteenth-century forerunner of this phenomenon. It originated in the cotton mills of B.B. and R. Knight and thrives today thanks to Warren Buffett's Berkshire Hathaway conglomerate.

The Knights who harvested this "fruit of the loom" were Benjamin Brayton Knight and his younger brother Robert. They were two of the nine children of Stephen Knight and the prophetically named Wealtha (Brayton) Knight, a farming family who resided in western Cranston during the early nineteenth century.

Benjamin, the eldest sibling, was born on the farm on October 3, 1813, at the time of the fall harvest. His early life had a routine that was typically experienced by the children of rural families: farm work in season and attendance at the neighborhood school during winter. In 1831, at the age of eighteen, he began an apprenticeship at the Sprague Print Works, a factory on the Pocasset River, a small tributary of the Pawtuxet about three miles east of his farm. After two years of hard labor, he returned to his rural roots. Then, in 1835, showing unusual entrepreneurial spirit, he opened a grocery store in the print works village. After five years, he expanded and moved his business to Providence, eventually engaging in the flour and grain trade.

In 1849, Benjamin sold his grocery business to his brother Jeremiah, and in 1851, he sold half of his flour and grain business to his brother Robert, twelve and half years his junior. Simultaneously, he bought a half interest

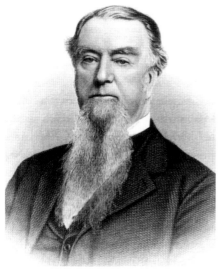

Benjamin Knight.

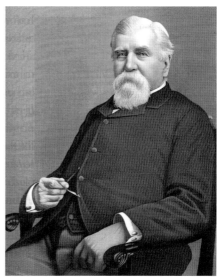

Robert Knight.

in Robert's Pontiac Mill and Bleachery, forming the firm of B.B. & Robert Knight. This venture was the start of the Knights' great textile empire.

Robert Knight pursued a different path to this momentous partnership. According to early accounts, he was born in "Old Warwick" on January 8, 1826. That location is probably a reference to the western area of the town, adjacent to western Cranston, that was set off from Warwick in 1913 to become West Warwick, the state's newest and final town. Robert also went to work at the Sprague (now Cranston) Print Works but did so at the age of eight. Later, he worked in the mill of future governor Elisha Harris until he was seventeen, toiling fourteen hours a day at the rate of $1.25 per week. In 1843, he began work for his brother Benjamin as a grocery store clerk. Two years later, with the help of friends, Robert studied for a year and a half at Pawcatuck Academy in Westerly, taking courses in business. He then taught briefly at a district school in the town of Exeter.

In 1846, Robert became a clerk in the factory store of John H. Clark at Arnold's Bridge (now Pontiac Village) for $8 per month plus board. When Clark was elected to the U.S. Senate in 1850, he sold his business interests, including a cotton mill and bleachery, to Robert and Zachariah Parker for $40,000. One year later, Robert purchased Parker's interest and then conveyed it to his brother Benjamin. That brotherly union endured from 1851 until severed by the death of Benjamin in 1898. According to Robert,

it was marked by "the closest and most friendly relations." Under the Knights' leadership, Pontiac expanded to thirty-seven structures, including mill housing, manufacturing buildings, a school, an Episcopal church and other public amenities, all built at the owners' expense.

Over the next five decades, with Pontiac as a base, the Knights marched up the Pawtuxet River, acquiring mills at Natick, Lippitt, Riverpoint, Fiskeville and Arctic and building the Royal Mill and the Valley Queen Mill in what is now West Warwick. They also took advantage of the collapse of the Sprague textile empire, picking up nine of Sprague's mills, including the Cranston Print Works, where both had begun their careers.

Their "fruit of the loom" empire did not end there. Elsewhere in Rhode Island, they built the White Rock Mill near Westerly and the Grant Mill in Providence. They acquired the Clinton Mill in Woonsocket and went out of state to Hebronville, Manchaug and Dodgeville in Massachusetts. They maintained twenty-four mills and seventeen manufacturing villages containing 12,000 looms with 500,000 spindles, and they employed more than seven thousand workers. According to one contemporary estimate, the company at its peak had an annual cloth product of 77.5 million yards—enough to circle the globe one and three-quarter times. The company also owned large farms near many of the villages to supply produce to the workers.

Although headquartered in Downtown Providence on Washington Row, the Knight brothers had business offices in New York, Boston, Hartford, Philadelphia and Baltimore. After Benjamin's death in 1898, the empire was run by Robert until his death on November 26, 1912, at the age of eighty-six and then by his two sons, C. Prescott Knight and Webster Knight. The business was sold by the sons in 1920 to New York interests.

Robert married Josephine Louisa Webster in 1849 and fathered nine children. Although engaging in some civic pursuits and serving as a director of several banking institutions, Robert devoted his time exclusively to business. He never held public office.

Conversely, Benjamin was elected as a Democratic representative to the General Assembly in 1852 and as a Republican in 1872, serving as chairman of the House Finance Committee. He also served as alderman on the Providence City Council from 1865 through 1867, as well as president of the Butchers and Rovers Bank from 1853 until his death on June 4, 1898, in his home at 159 Broad Street in South Providence at the age of eighty-four.

Benjamin had six children by two wives. He was married to Alice Westcott Collins from 1842 until her death in 1850. She gave him three children, none

of whom survived him. In 1851, Benjamin married Phebe Ann Slocum, who gave birth to three children. His second wife and two children survived him. Phoebe, who died in 1906, was noted for her humanitarian work. She was a founder of the Sophia Little Home and was long involved with the Society for the Prevention of Cruelty to Children.

The legacy of the Knight family includes the campus of the Community College of Rhode Island in Warwick and the Knight Memorial Library in the Elmwood section of Providence, where Robert had built his elegant home not far from the 159 Broad Street mansion of his brother Benjamin.

CHARLES FLETCHER

Charles Fletcher, like Samuel Slater before him, amassed years of experience in the English textile industry. He was born in Thornton, England, on November 25, 1839, the son of Richard and Ann (Drake) Fletcher. His father was the proprietor of a large variety store. Charles attended school in Thornton and then worked in a Thornton mill while going to night school. He finished his apprenticeship when he was seventeen and then moved to work in a mill in the larger town of Bradford until he was twenty-one.

Fletcher came to America in 1864 to work in a factory in Lawrence, Massachusetts. After returning briefly to England, he immigrated to Rhode Island in 1867. Once here, he soon built a regional empire for the production of woolen cloth and helped consolidate his holdings into an even larger national trust, the American Woolen Company.

Upon arrival, Fletcher took a job as night watchman at the Valley Worsted Mills on the Woonasquatucket River in Olneyville and quickly rose to the position of superintendent. He started his own worsted enterprise when he leased the nearby Rising Sun Mill in 1870. Then he purchased adjacent factories and built so many of his own that they were designated by number rather than name. By the early 1880s, he was employing three thousand workers in the nine mills of his National-Providence Worsted Company, providing the foundation for the rise of Providence as the greatest producer of woolen products in America by 1900. Labor problems at his establishments disrupted production throughout the Gilded Age, but Fletcher never experienced a significant financial setback.

After his Providence successes, Fletcher began new manufacturing endeavors in Johnston and named his mill village Thornton after the English town off

his birth. Here he re-created an English factory town complete with British machines, cottages and immigrants from Nottingham. He built here the Thornton Worsted Mill, the British Hosiery Mill, the Victoria Mill and the Pocasset Yarn Mill.

Although his entrepreneurial pace never slackened in textiles (he constructed plants in Massachusetts and New York as well), Fletcher engaged in other ventures. He owned the magnificent Narragansett Hotel in the capital city and helped initiate New England's only cable railway that ran over College Hill on Providence's East Side. He also became an accomplished yachtsman and a member of the Rhode Island, Bristol and New York Yacht Clubs.

Charles was a staunch Republican and a supporter of protective tariffs. Although he lacked political aspirations, he represented Rhode Island at the national convention that nominated Benjamin Harrison for president in 1888. He served on the executive committee of the National Association of Wool Manufacturers from 1886 until 1899, when he retired from active participation in the industry.

Near the end of his career, when his two sons, Frederick and Joseph, relieved him of some of his daily chores, he sold much of his empire, except for Thornton, to the American Woolen Company, a giant textile trust. He served this syndicate in several high-level capacities. By the time of his death, he had earned the sobriquet "Wool King of the United States." The woolen cartel that bought his holdings remained intact until purchased by the local conglomerate Textron in the 1950s. Some of Fletcher's original factory buildings now host high-tech start-up enterprises, while the structures on Valley Street in Providence have been transformed into luxury condominiums, known as the Rising Sun Mills, by Baltimore developers Struever Brothers, Eccles and Rouse.

Fletcher, who had become a resident of Jamestown, from where he commuted to Providence on his steam yacht, died suddenly in Boston on May 13, 1907, at the age of sixty-seven. He was survived by his wife, the former Harriet Beanland, as well as two sons and a daughter.

At his death, a contemporary account remarked about the meteoric rise of this English immigrant: "It would indeed be difficult to find a parallel case with his, wherein such large results in so short a time have been attained in manufacturing pursuits."

ROWLAND HAZARD

Rowland Hazard was born in Newport on August 16, 1829, the son of Hall of Fame member Rowland Gibson Hazard (1801–1888) and Caroline Newbold of Pennsylvania. He moved at the age of four to his family's mill village of Peace Dale, which remained his principal residence until his death, as well as a principal object of his benefactions and generosity.

After graduation from Brown University with distinction in 1849 (the same class as Benjamin Thurston), he lived a life filled with business success, travel, political involvement and civic activity. From 1864 until his death, he directed the Peace Dale Manufacturing Company, a large woolen textile firm. In addition, he acquired a huge lead mine in Missouri in 1875 called Mine La Motte, where he introduced improved methods of mining and smelting ore. This company's "Anchor Brand" of lead drew its name from the anchor on Rhode Island's state flag. In 1881, he organized the Solvay Process Company in Syracuse, New York, and introduced its product, called soda ash, to America.

In government, Rowland presided for many years as South Kingstown's town moderator. He also served as the town's state representative (1863–64) and state senator (1867–69). He received a plurality of votes for governor in 1875 while running as an independent and prohibitionist. At this time, however, a majority vote was required, and the General Assembly chose runner-up Henry Lippitt as the state's chief executive.

Among his many talents, Hazard was a skilled architect who designed several buildings and beautiful stone bridges in Peace Dale and chaired the building committee for the John Carter Brown Library at Brown University, where he was a longtime trustee, a fellow and a benefactor.

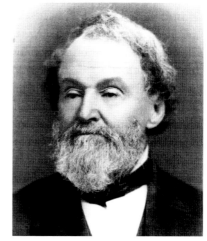

Devoutly religious, he organized the Second Congregational Church in Peace Dale and served for four decades as its deacon. In 1872, he designed and built a church for the congregation and added a chapel to it in 1895 dedicated to the memory of his wife, Margaret, who had died that August.

Rowland was a prolific writer on economic, philosophical and scientific

themes and a noted orator. He was for many years the president of the Washington County Agricultural Society and gave its annual address at the South County Fair. He also gave a memorable address on October 15, 1896, near the end of his life, at the laying of the cornerstone of the present statehouse in Providence.

As a wealthy and powerful industrialist during an era of corporate revolution, he became the antithesis of the so-called robber baron. He treated his mine and factory workers generously and with concern for their safety and comfort. At Peace Dale, he introduced a system of profit sharing for his employees. According to a contemporary assessment, "labor troubles were unknown" at his various business enterprises.

Rowland died on August 16, 1898, leaving two illustrious children: Hall of Fame educator and author Caroline Hazard and civic leader and humanitarian Rowland Gibson Hazard II, a man who maintained the traditions of his grandfather and namesake, as well as those of his illustrious father. Rowland Hazard was buried in the family plot at Peace Dale.

Darius Goff, Darius Lee Goff and Lyman B. Goff

The Goff family—like other Rhode Island business families such as the Browns, Sharpes, Spragues, Nicholsons, Gorhams, Hazards and Gilbanes—have produced two or more members of Hall of Fame caliber. Darius Goff and his sons Darius Lee Goff and Lyman B. Goff were major industrialists and civic leaders. Their combined endeavors in the development of the cotton textile industry spanned more than ninety years, and their contributions to Pawtucket were substantial

Because the Goffs, with the Sayles, might be called Pawtucket's first families of the late nineteenth century, a summary of what constituted their Pawtucket seems in order. The geographic entity known as "Pawtucket" is complex. West of the Blackstone River, the area around Pawtucket Falls where Samuel Slater built his mill in 1792, had become part of North Providence in 1765 when that town was taken from Providence and incorporated.

The east side of present-day Pawtucket has a more complicated history. It was part of Rehoboth, Massachusetts, home of the early Goffs, until 1812, when the town of Seekonk was created from its western portion. Then, in 1828, the Massachusetts town of Pawtucket was set off from Seekonk.

Finally, in 1862, via a land transfer, Rhode Island acquired the Massachusetts town of Pawtucket as well as the area that became East Providence. In 1874, the North Providence village of Pawtucket and its environs on the Blackstone's west bank were added to the former Massachusetts town to create the modern municipality of Pawtucket, with a total of 8.68 square miles. In 1885, Pawtucket was incorporated as Rhode Island's third city, with Frederic Sayles its first mayor.

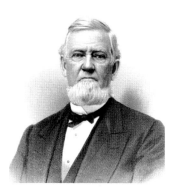

Darius Goff, whose father operated a small cotton mill in Rehoboth, Massachusetts, was born on May 10, 1809. After working at his father's mill until it closed in 1821, he suffered a serious accident. He then worked as a clerk for a Providence grocery business while recovering. In 1835, he bought the Union Cotton Mill in Rehoboth with his brother, Nelson, to produce batting, but the mill was soon destroyed by fire. Darius then turned his attention to the cotton waste business, contracting with local mills to take their refuse. In 1847, he started the Union Wadding Company with two Providence partners to process cotton waste into a wadded form that was usable by paper mills in the manufacture of paper products. Just as fortunes have been made in the recycling of scrap metal, so also did scrap cotton and remnants have value.

Unfortunately, this highly flammable product posed a danger to any building in which it was stored. That danger was realized in 1871 when Goff's wadding mill burned down. Fortunately, Darius had earned sufficient profits from this venture to diversify. In 1861, he had opened another mill with William and Fredric Sayles devoted to the manufacture of worsted braids under

Top to bottom: Darius, Darius Lee and Lyman.

57

the name American Worsted Company. In 1864, when the Sayles brothers departed, his son Darius Lee became his partner, followed in 1876 by his other son, Lyman. Their firm now became D. Goff and Sons Inc. and added such products as knitting yarn and silk fabrics, but their famous Alpaca braids, known in the marketplace as "Goff's Braids," were the mainstay of this business.

The Goffs were also determined to produce mohair plush for upholstery. In 1882, after several years of trial and error, they succeeded in becoming the first manufacturer of plush in America.

As the Goff Company prospered, Union Wadding recovered from its setback. By 1880, it had a capitalized value of more than $1 million and was reputedly the largest business of its kind in the world. The innovations in cotton recycling and wadding developed by Darius were adopted nationwide, and the Goffs opened other plants in Augusta, Georgia, and Montreal, Canada.

Darius Goff was married twice, first in 1836 to Sarah Lee, who soon died of childbirth complications along with her baby. He then married Sarah's sister, Harriet, in 1839. The couple had three children: a daughter and sons Darius Lee and Lyman. Darius was a director of several local businesses and also entered politics. As a Republican, he served several terms on the Pawtucket Town Council. He was elected Pawtucket's state senator in 1871.

The elder Goff established a model of humanitarianism for his sons. He gave money and land for the building of a school and for the construction of Goff Memorial Library in Rehoboth Village. He also provided generous support to the Pawtucket Congregational Church. When he died at the age of eighty-one on April 14, 1891, Pawtucket went into mourning.

Darius Lee Goff was born on March 20, 1840, and after a public school education in Pawtucket, he entered Brown University, graduating in 1862. He soon entered into his father's braid manufacturing business and assisted in its dramatic growth. "Goff's Braid" became not only a standard of quality but also a household name throughout the country.

Among the contributions of Darius Lee to Pawtucket were his role in the introduction of electric power to the city. He was a director of numerous local businesses and civic organizations, including the Pawtucket School Board. He was married in 1866 to Julia Pitcher, who died childless in 1869. His second wife, Annie Luther, whom he married in 1883, died in 1890 following childbirth, leaving him a daughter and a son.

Lyman Bullock Goff was born on October 19, 1841. After public school study, he entered Brown University and graduated with his elder brother,

Darius Lee, in 1862. In the fall of that year, he was on a western hunting trip when a war with the Sioux tribe erupted. He served during its continuance at Fort Abercrombie in Dakota Territory. Upon his return to Rhode Island, he was motivated to join the state militia, gaining the rank of lieutenant colonel in command of the Rhode Island Artillery. However, he did not see active service in the Civil War.

Following the war, he clerked for his father for several years until he was admitted to the Goff firm as an equal partner in 1876. Similar to his brother, he held numerous business and civic positions in Pawtucket. His interest in the city's youth prompted him to found and fund the Pawtucket Boys Club. The Lyman B. Goff School on Newport Avenue was dedicated in his honor.

Lyman, like his father and brother, was a lifelong Republican. In 1888, he represented Pawtucket in the General Assembly and served as a presidential elector for Benjamin Harrison. He declined nomination for the position of lieutenant governor in 1891 because his myriad local positions took precedence. In 1864, Lyman married Almira Wheaton. The couple had two children, but Lyman's son predeceased him, dying at age thirty-two. Lyman passed away on April 2, 1927. The Goff family are buried at Providence's Swan Point Cemetery.

William F. Sayles

William Francis Sayles was born in the mill village of Pawtucket, then a part of the town of North Providence, on September 2, 1824, the son of Clark and Mary Ann (Olney) Sayles, both of whom had deep and significant Rhode Island roots dating back to Providence's founding. His father—a coal and lumber merchant, banker and builder—gave William a good classical and business education locally and at Phillips Academy in Andover, Massachusetts.

In 1842, William entered the Providence commercial house of Shaw & Earle, serving first as bookkeeper, then as salesman and finally as financial manager. Not content with mere employment, however, he embarked on his own manufacturing venture late in 1847 by buying at auction a small textile print works in the area of Smithfield that became the town of Lincoln in 1871. Despite his lack of experience, he erected additional buildings and converted this plant on the Moshassuck River into a bleachery for cotton cloth. He steadily increased output until, by 1854, he had the largest operation

of its kind in Rhode Island. Then disaster struck, and his entire plant was destroyed by fire. Undaunted, Sayles rebuilt and modernized his factory over a period of several months and increased output by 50 percent. Eventually his operation, called the Moshassuck Bleachery, became the largest of its kind in America.

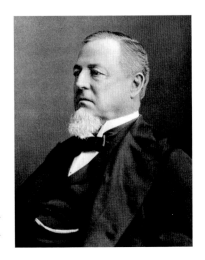

In 1863, Sayles partnered with his brother, Frederic, and the firm name became W.F. & F.C. Sayles. In 1877, the brothers built the two-mile-long Moshassuck Valley Railroad connecting with the Providence and Worcester line in the Woodlawn section of Pawtucket. The road was built to transport passengers and products not only to and from the bleachery but also to the Lorraine Woolen Mills on Mineral Spring Avenue in Pawtucket, an enterprise that was also a creation of the Sayles brothers. This factory produced ladies' dress goods and the finest-quality cashmeres. In 1886, Frederic became the first mayor of the newly incorporated city of Pawtucket.

William's interests were incredibly diverse. At the time of his death in 1894, his company, covering thirty acres, was reputedly the world's largest bleachery for cotton cloth; he was president of the Slater Cotton Company of Pawtucket, which he had founded; and he was a director or stockholder of various New England cotton mills. As a staunch Republican, William served two terms as a state senator representing Pawtucket in the General Assembly. During his career, William also was president of the Slater National Bank of Pawtucket, president of the Pawtucket Free Library and a member of the board of trustees of Brown University.

In 1878, William donated $50,000 to Brown and later an additional $50,000 for the erection of a building (Sayles Hall) as a memorial to his son William Clark Sayles, whose death occurred in 1876 during his sophomore year at Brown. William's wife, Mary Wilkinson (Fessenden) Sayles, predeceased him, but he was survived by two daughters, Mary and Martha, and another son, Frank, when he died on May 7, 1894, at the age of sixty-nine. He was buried at Pawtucket's Mineral Spring Cemetery. William left a huge sum of $200,000 for a memorial to his wife and deceased son, which was eventually used for the establishment of Pawtucket Memorial Hospital in 1907.

After William's death, his surviving son, Frank, expanded the business, the village's housing stock and other facilities until his death in 1920—a date that coincides with the start of the dramatic decline of Rhode Island's textile industry. Saylesville is now a historic district in the town of Lincoln that was added to the National Register of Historic Places in 1984 as a suitable memorial to the remarkable Sayles family. The family is memorialized in a beautifully crafted history and genealogy, *Sayles and Allied Families*, published in 1925 by Mary Dorr (Ames) Sayles. This work is also notable for its detail on the allied families of Ames and Dorr.

SIMON WILLARD WARDWELL JR.

Rhode Island inventor and entrepreneur Simon Willard Wardwell Jr. had a fascinating heritage. The first notable Wardwell, Samuel, was hanged during the Salem witchcraft craze in 1692. The first Simon Wardwell served in Rhode Island general James Mitchell Varnum's regiment of Continental infantry and then as a guard for George Washington's headquarters.

Simon, the inventor, was born on September 3, 1849, in Grantsville, Maryland, the third son and seventh child of Simon Willard Wardwell, a bookbinder, and Matilda Ann Ackland. When he was ten years old, his mother died, no doubt somewhat debilitated having given birth to thirteen children.

Details of Simon's youth and education are lacking, although the variety of his interests suggests some formal education. Sometime between the end of the Civil War and the early 1870s, he moved to St. Louis, Missouri, where he established his first Wardwell Manufacturing Company. It specialized in sewing machine technology. By 1871, Simon had been granted his first patent (no. 121,828) for an "improvement in table and treadle for sewing machines."

Until 1876, Simon worked on various devices to improve sewing machines. The effectiveness of his inventions was demonstrated by their reception at the United States Centennial Exposition in Philadelphia in 1876, where he won a centennial medal and his work was "commended for simplicity and ingenuity, and evincing progress in lock stitch machines." In 1878, he won another medal at the Paris International Exposition.

These honors came to the attention of the Hautin Sewing Machine Company of Woonsocket, and following his Paris triumph, he was hired

as its plant superintendent. He launched his productive Rhode Island industrial career by perfecting Hautin's leather machine. Shortly thereafter, in 1886, this constantly experimenting genius made a major invention: the Universal Winding Machine. This device simply and perfectly loaded thread on any kind of the many bobbin sizes used in assembly line sewing. With this breakthrough in design, the Hautin Sewing Machine Company was reorganized and incorporated in New York in 1886 as the Wardwell Sewing

Machine Company. The universal winder continued to be manufactured in Woonsocket until 1890, when Wardwell teamed up with Robert Leeson of Cranston to form the Universal Machine Company, which later became known as Leesona.

Over the course of an inventing career that included 170 patents, Simon produced new ideas for textile looms, stamped wrenches, rotary shuttles, a method of waxing thread for high-speed sewing, a collapsible canoe and a toy whistle. Among his well-known accomplishments is the Wardwell high-speed braider, which increased the production rate of braiding textiles and wire filaments. Among the better-known products made by Wardwell braiders are thread, shoelaces, candle wicks, surgical sutures, catheters, rope, tire cord, shielded and coaxial cable, telephone cables, elevator control cables, wiring harnesses and high-pressure hose.

Simon Wardwell's work as an inventor of national note was recognized by the Smithsonian Institution in Washington, which displayed the Wardwell high-speed braider from 1923 to the mid-1940s. A similar braider has been on display at Pawtucket's Old Slater Mill. Since 1902, Wardwell Braiding Company has operated in Central Falls, where today it is the leading braiding machine producer for the aerospace industry, with initiatives into the field of robotics as well.

One notable, but little-known, aspect of Wardwell's career is his literary creativity, as most of his writings were produced under various pseudonyms such as "Durst." He owned and operated a small firm he named the Woonsocket Publishing Company. It generated his poetry, the theme of which was the antipathy of industry and art. In a study of his mechanical and literary works, Michael Carlebach stated that they are evidence of Wardwell's "intellect, of the wide range of his interests, and of the depth of his feelings." Shortly after his death on February 19, 1921, his widow, the former Mary Ellen Shea, donated copies of these literary works to Brown University's John Hay Library. Simon was interred at Providence's North Burying Ground. He and Mary had no children.

Wardwell's gratitude to those who worked with him in perfecting and producing high-quality and precision machines was apparent in the directions he gave to his estate: upon his death, his assets were to be used, in part, to "take care of loyal and true employees."

Mayor Amos Chafee Barstow

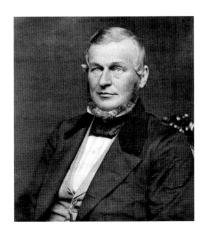

Amos Chafee Barstow, the son of Nathanael and Sophia (Chafee) Barstow, was born in Providence on April 30, 1813. He was educated in the public schools and for three terms in a private academy. In 1836, at the age of twenty-three, he put his mechanical and inventive skills to use when he became a partner in a small iron foundry in Norton, Massachusetts, that manufactured stoves. At that time, wood was the primary fuel used for heating, but anthracite coal was beginning to be used in factories and also found its way into homes for use in grates. Soft (bituminous) coal was imported from England and was also used as a heat source.

Stoves for cooking, however, were built to use wood only, and their variety and demand were limited. Barstow used his ingenuity to design quality stoves using this new fuel source. In 1836, Barstow developed his first stove and put it into production in 1837. Sales were brisk, so the company expanded and moved to Providence in 1844. There it continued to enlarge.

Barstow's success allowed him to build a large stone foundry on Point Street in 1849. Eventually, this facility employed two hundred workers and covered two and a half acres of the Point, Richmond and Chestnut Street block. His stove "Model Cook" won the Grand Medal at the 1873 Vienna World's Fair, and his products sold throughout the United States, in Northern Europe and even in China.

As remarkable as the corporate history of Barstow Stove is the career of its inventive founder. In addition to his business pursuits, which included management positions in banking, the litany of his achievements indicates his impact on the history of his native city. Among Barstow's most significant achievements was his term from 1852 to 1853 as mayor of Providence as a member of the Temperance Party. Also notable are his successful support of a short-lived state prohibition statute when he was a Democratic state representative in 1852; his term as Republican Speaker of the House in 1870; his longtime membership on the Providence Common Council; and his service as trustee of Providence's charitable Dexter Donation.

In addition to this varied governmental service, Barstow was the first president of the Providence YMCA, president of the Providence Gas Company, president of the influential Providence Association of Mechanics and Manufacturers, president of the board of Butler Hospital, builder of the Providence Music Hall and chairman of the committee that planned the construction of the present city hall. Barstow was a published poet and a prolific essayist who wrote about the Native American issue, Southern Reconstruction, travel, temperance and Congregationalism. He was also active in the campaign to abolish slavery. In addition to his writing, Barstow was called on to deliver major public addresses at commemorative events.

In 1875, his talent and prowess attracted the attention of President Ulysses Grant, who appointed Barstow to the chairmanship of the U.S. Board of Indian Commissioners. He held this post until 1880, serving the final two years as its chairman. In that capacity, he traveled throughout the Far West, visiting and inspecting government Indian agencies and, according to a contemporary account, "demonstrating a conscientious desire to improve the condition of the red man by carrying out a humane and Christian policy."

Barstow married Emeline Mumford Eames on May 28, 1834. The couple had seven children—five girls and two boys. His eldest son and namesake became president of Barstow Stove Company in 1895 upon the death of the founder. The company failed in 1930 during the Great Depression, and its main building is now occupied by Tops Electric Supply Company. His other son, George, moved to Texas and founded the small town of Barstow.

Amos died on September 5, 1894, at the age of eighty-one and was buried at Swan Point Cemetery.

WILLIAM HENRY LUTHER

William Henry Luther, son of Edward and Hannah (Sprague) Luther, was born in Dover, New Hampshire, on April 24, 1844. The Luther family, originally from Cranston, moved to Providence four years later, where young Henry attended public school with some additional instruction at a local private school.

As a young man, Luther, along with his brother, Edward, and his cousin John, became interested in the lapidary trade, and after learning the essentials of the industry in Attleboro, Massachusetts, they established their business

in 1864 on 79 Pine Street in Providence. Success was almost immediate. In 1877, after several moves to larger quarters, J.W. & W.H. Luther acquired a spacious building (still standing) on the corner of Oxford and Harriet Streets in South Providence that had been known as Temperance Hall when it was constructed by the St. Michael's Abstinence Society.

The company gained an international reputation for the production of high-grade electroplated jewelry that included cuff links, brooches, rings, necklaces and earrings. Luther's relatives withdrew from the firm in 1884, and shortly thereafter, William brought his son, Frederick, into the new firm, now called William H. Luther & Son. By 1890, twenty-six years after its founding, the company was the largest manufacturer of electroplated jewelry in America. In 1900, the expanded company was said to have "one of the most up-to-date jewelry manufacturing establishments in the state of Rhode Island."

In 1865, Henry married Mary Blanding of Norton, Massachusetts, by whom he had one son, Frederick, who assumed control of the business from the mid-1890s onward.

Luther's generosity was well known to the local citizenry, especially those in South Providence. He developed a strong interest in public safety and raised funds to support the purchase of a hook-and-ladder truck for his Southside neighborhood. Locals there expressed their appreciation by naming Ladder Company No. 5 at the corner of Public and Ocean Streets in his honor when it was built in 1885.

Between 1895 and 1901, Luther served as a member of the first city board of fire commissioners and then became Providence's first police commissioner, receiving his appointment from Republican governor William Gregory in 1901. In these capacities, he distinguished himself for his leadership roles, removing political influence from both departments and establishing professional standards of conduct.

In May 1913, twelve years after being named chairman of the police commission board, Luther made an offer to resign to the newly elected mayor of Providence Joseph Gainer, but the Democratic mayor declined to accept his letter. By that time, however, Luther's health was failing, and on March 15, 1914, he died of pneumonia at the age of sixty-nine. Former mayor Henry Fletcher, paying tribute to Luther's twenty-nine years of public service, called him "fearless and determined" in his public responsibilities, while Mayor Gainer praised Luther for being "a man who had the courage to do what he thought was right, even when such a course of action was not in accord with popular feeling."

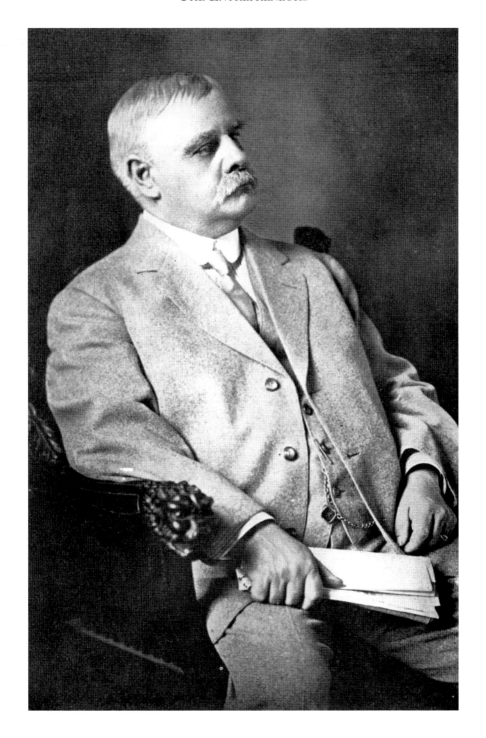

Luther was a member of several prominent businesses and social clubs, and for several years, he was president of the board of trustees of the Woodbury Memorial Unitarian Church. Although his business and residence at 163 Niagara Street were in Providence, Luther was buried in Norton, Massachusetts.

GEORGE BYRON CHAMPLIN

In 1838, eleven-year-old Stanton Browning Champlin left his old-line family's farm in South Kingstown and headed to Providence. What motivated his youthful departure is unknown. Fortunately for him, a grocer on Dorrance Street gave young Stanton shelter and a job. Eventually, he became a jeweler's apprentice and married Waity Ann Dyer.

On September 11, 1851, Stanton and Waity had a son, whom they named George Byron Champlin. In 1872, when George was nearing his majority, his father established Stanton B. Champlin & Son in a building on the corner of Eddy and Elm Streets in what is today known as the Providence Jewelry District. There the duo began the manufacture of gold rings and gold-filled chain.

The combined entrepreneurial skills of father and son produced immediate results. In 1885, the Champlins acquired the Campbell Machine Company in Pawtucket. Three years later, having outgrown their Eddy Street plant, they constructed a six-story brick building (now condominiums) on a triangular parcel at the corner of Chestnut, Ship and Clifford Streets, also in the Jewelry District, to accommodate their growing workforce. In 1894, they acquired E.M. Dart, a small local manufacturer of pumps, valves and pipe fittings, and patented many of the former owner's inventions. The expansion continued after Stanton's death from cancer on November 16, 1895. George moved the enlarged E.M. Dart to new headquarters at 134 Thurbers Avenue (at the corner of Eddy Street) and also pursued real estate development, most notably by constructing the four-story Champlin Block just across from the Beneficient Church on Weybosset Street. Just after 1900, he purchased two Providence-based manufacturing businesses and merged them to form United Wire and Supply Corporation. Clearly, George B. Champlin and his wife, the former Carrie Emma Pabodie, whom he married in 1879, laid the financial foundation for the charitable foundation that bears the Champlin name.

George B. Champlin's son, George Stanton Champlin, also a member of the Hall of Fame, inherited the family talent for business development, but by the early 1930s, with the nation firmly in the grip of the Great Depression, George B. and George S. redirected their collective energy toward supporting worthy initiatives within their community. In 1932, George Stanton Champlin and his two sisters, Florence and Hope, established the first Champlin Foundation with their father's encouragement. Shortly after the death of ninety-five-year-old George Byron on

October 15, 1946, his son established a second Champlin Foundation, and in 1975, he added a third, the largest of the three. Together the combined Champlin charities provide major support for a diverse array of Rhode Island nonprofit organizations.

By 2017, the Champlin Foundations had distributed more than $550 million to fund capital projects for Rhode Island nonprofit organizations. The fund also underwrites the Champlin Scholars Program, which guarantees that any graduate of a Rhode Island public high school who is accepted at Brown University as an undergraduate or a medical student will get the necessary financial aid to attend. The university has recognized the generosity of this industrialist and corporate citizen by naming the George B. Champlin Residence Hall on the Brown campus in his honor. The Champlins are buried at Swan Point Cemetery, but their legacy lives on.

FREDERICK GRINNELL

Frederick Grinnell, industrialist, engineer and inventor, was born in New Bedford, Massachusetts, on August 14, 1836, the son of Lawrence and Rebecca Smith (Williams) Grinnell. Both his parents were of colonial stock. Grinnell's elementary education was obtained at the Friends' School in New Bedford. At the age of sixteen, he entered Rensselaer Polytechnic Institute in Troy, New York, where he completed the four-year course in three years, graduating as a civil and mechanical engineer in 1855 at the head of his

class of sixty. In the fall of that year, when he was nineteen, he entered the Jersey City Locomotive Works as a draftsman. Three years later, he became an assistant engineer of construction on the Burlington & Missouri River Railroad. Upon the completion of this road, he returned to the locomotive works, where he remained until 1860.

Grinnell came to Providence in 1860 to assume the positions of treasurer and superintendent of the Corliss Steam Engine Works. He continued with Corliss throughout the Civil War, working especially on the installation of steam engines designed by Corliss for naval vessels. However, at war's end in 1865, he returned to the Jersey City Locomotive Works as general manager. This factory was under lease by the Atlantic & Great Western Railroad. During his association with it from 1865 to 1869, Grinnell, as superintendent of motive power and machinery, designed and built more than one hundred locomotives.

In 1869, Grinnell purchased a controlling interest in the Providence Steam & Gas Pipe Company, a firm that had been in existence for some twenty years and was engaged in the manufacture of fire-extinguishing apparatus and the installation of these devices in factories, particularly textile mills. Fire-extinguishing apparatus at that time consisted mainly of perforated pipe installed along the ceilings of factory rooms and connected with a manually operated water supply system. Many attempts had been made in vain to devise automatic sprinklers to be used in these factory water pipe lines. Finally, in 1874, Henry S. Parmelee of New Haven patented such a device, and the Providence Steam & Gas Pipe Company secured a license to manufacture it. With great energy, Grinnell worked thereafter to improve the Parmelee invention, and in 1881, he patented the heat-sensitive automatic sprinkler that today bears his name. Basically, this Grinnell invention is a valve sprinkler with deflectors set in operation by the melting of solder. According to one source, this innovation "completely revolutionized the system of fire protection in manufacturing establishments throughout the world."

Besides attending to the business of introducing the sprinkler to the world market, Grinnell devoted much time to its improvement. Between 1882 and 1888,

he perfected four types of metal-disc sprinklers, and in 1890, he invented the glass-disc sprinkler, which is essentially the same as that still in use. Grinnell secured some forty distinct patents for improvements on his sprinklers. In addition, he invented a dry pipe valve and an automatic fire alarm system. An 1895 meeting between Grinnell and fire representatives of the insurance industry led to the creation of the National Fire Protection Association in the following year.

In 1893, Grinnell brought about the combination of a number of the more important competing sprinkler manufacturers and organized the General Fire Extinguisher Company, with offices and plants in Providence; Warren, Ohio; and Charlotte, North Carolina. This company, under his active leadership, became the foremost organization in its field of manufacture. Grinnell retained the management of the whole business until his retirement shortly before his death.

Grinnell was director of banks in New Bedford and Providence and of several textile manufacturing companies. He was a member of the American Society of Mechanical Engineers and belonged to a number of yachting clubs. He was an enthusiastic yachtsman, and what little time Grinnell took from his business ventures for leisure activity he spent racing his beloved schooner *Quicktime* and winning a number of celebrated races thereon.

Possessor of a genial and kindly nature, Grinnell maintained a high reputation for honor and upright dealings. It is written that all who knew him cherished his memory.

In October 1865, Frederick married Alice Brayton Almy of New Bedford, who died in 1871, leaving two daughters. Three years later, he married Mary Brayton Page of Boston, by whom he had five children. When Grinnell died in New Bedford on October 21, 1905, at the age of sixty-nine, he was survived by Mary, their five children and two daughters by his first wife.

Today, the Grinnell name survives with prominence. In 1919, General Fire Extinguisher was renamed the Grinnell Company in his honor. Over the last four decades, his profitable creation has experienced a bewildering number of acquisitions and mergers involving Tyco International, Johnson Controls and Simplex-Grinnell, which claims to be the largest fire protection company in the world.

In 1985, in recognition of its Providence origins, the Grinnell Company sponsored the publication of *Firefighters and Fires in Providence: A Pictorial History of the Providence Fire Department, 1754–1984*, by Patrick T. Conley and Paul Campbell, to acknowledge "Grinnell's long and continuing relationship with the Providence Fire Department."

WILLIAM BINNEY

William Binney Sr. was the son of Elizabeth (Coxe) Binney and Horace Binney, a trial lawyer of national acclaim who twice declined a seat on the United States Supreme Court. His grandfather Barnabas Binney was a renowned surgeon who served with distinction in the American Revolution. William Binney was born in Philadelphia on April 14, 1825, and obtained honorary bachelor's (1849) and master's (1866) degrees from Yale University after illness cut short his undergraduate career. He also earned a master's degree from Brown University in 1856, and that launched his storied connection with Rhode Island.

Binney came to Providence as a young lawyer in 1853 and quickly rose to prominence in the profession. He practiced successfully until 1867, when he organized and founded the Rhode Island Hospital Trust Company. He became a lifelong member of that bank's board of directors and was the first president of that important institution, serving from 1867 to 1881. The bank, the first trust company in New England, was initially created to fund the nascent Rhode Island Hospital, which opened on October 1, 1868. Its charter was unique in that Hospital Trust was the first local bank to be granted immunity from state taxation, provided it devoted a certain portion of its profits to charitable purposes—specifically, for a time the company was required to pay one-third of its net income over 6 percent to Rhode Island Hospital.

In addition to his charitable and banking endeavors, Binney served on the Providence Common Council from 1857 to 1874—eight years as its president. During his tenure, he became the principal draftsman of a new city charter. Binney, who also served with distinction in the Rhode Island General Assembly, has been described as a man who exemplified the "ancient ideals of scholarship, of gentle dignity, of reverence and sincerity, of honor and integrity, of sanity and good taste." He died on April 20, 1909, at the age of eighty-four and was buried at Swan Point Cemetery.

Binney's first wife, Charlotte Hope Goddard, whom he married in January 1848, bore him six children before her death in 1866. She was

the sister of Hall of Fame inductee Colonel Robert Hale Ives Goddard. He married his second wife, Josephine Angier, in April 1871. She had no children by Binney and survived him.

WALTER SCOTT

The steps leading to the invention of an American cultural original, the diner eatery, began in Providence through the initiative of Walter Scott.

Scott was born on November 28, 1841, in Cumberland, the son of lawyer Joseph A. Scott and Juliet Howland Scott. By age eleven, he was peddling candy, fruit and newspapers on the streets of Providence to supplement his widowed mother's small income. In 1858, at age seventeen, Scott started an after-hours business selling sandwiches and coffee to denizens of men's clubs and to night workers in Providence.

Following his rejection to serve in the military during the Civil War due to defective eyesight, Scott moved to Vineland, New Jersey, and tried his hand at farming. Unsuccessful, he soon returned to Providence and found work as a pressman for the *Providence Evening Press* and, later, the *Morning Star*. Between editions, Scott resumed his youthful entrepreneurial ways and began to provide fellow workers with light snacks and coffee. Sometime in 1872, he gave up his newspaper job and used his savings to open a full-time mobile food business selling his sandwiches and coffee from a horse-drawn freight wagon that he located in front of the Barton Block at the corner of Westminster and Weybosset Streets in Downtown Providence.

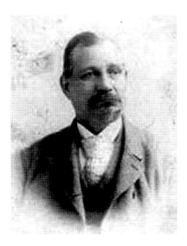

Although the custom of street peddlers hawking pastries and other consumables was well established in Providence at the beginning of the nineteenth century, Walter Scott was nearly alone in selling his victuals to night shift workers. Most of the other street vendors worked out of stalls in the first floor of the Market House. These stands were run by small operators who styled themselves as "caterers." Scott took this marketing method to a new level by offering his wares from the back of a wagon, which carried more and moved from workplace to workplace. Scott called himself a "caterer."

His innovation marked the birth of the lunch cart, the forerunner of the classic American diner.

In 1887, the lunch cart concept went from Providence to Worcester, where Thomas Buckley became the first of many who organized companies to build lunch wagons and eventually stationary dining cars. The stationary diner came about because American cities experienced traffic congestions caused by the mobile wagons, known as "Night Owls." The eatery's classic chrome interiors—featuring neon signs and hearty, inexpensive, quick-stop late-night dining—were the result of the entrepreneurial innovation of Providence's Walter Scott.

Scott retired from the lunch wagon business in 1917, having made a living but not a fortune for himself and his wife, Ida Marietta Lawrence, whom he had married in 1880. He died on October 26, 1924, and is buried at Swan Point Cemetery. Today, the American Diner Museum honors his memory. It is appropriately located on the Harborside campus of Johnson & Wales University and is run by the university's culinary school. Although the museum was initially opened to the public, its use is now restricted to students of Johnson & Wales.

JOSEPH BANIGAN

Joseph Banigan and his family were part of a wave of Irish Catholic refugees who fled the Great Famine in Ireland in the late 1840s. Arriving in Rhode Island in 1847 from County Monaghan via Scotland with his parents, Bernard and Alice Banigan, Joseph attended school for one year before becoming a full-time child laborer at age nine at the New England Screw Company, a firm managed by William Angell. Over the next fifty years, Banigan employed the "pluck and luck" characteristic of Yankee entrepreneurs to build a local footwear empire before assuming the presidency of the United States Rubber Company in 1893.

Banigan was a youthful apprentice in the jewelry industry before tinkering with rubber products. At the age of twenty-one, he discovered a way to bypass the vulcanization patent of Charles Goodyear. By 1867, he had used his skill and charisma to raise $100,000 in capital to put his innovation to the test at his newly formed Woonsocket Rubber Company.

Banigan employed a progressive agenda, ranging from labor relations to the latest production methods, to build his Woonsocket venture into the

premier establishment of its kind in the United States. When he sold the company in 1893 for an incredible $9 million, he was already Rhode Island's first Irish Catholic millionaire. In 1896, he built Providence's first "skyscraper," the ten-story steel-framed Banigan Building at 10 Weybosset Street.

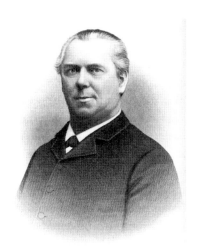

Banigan's wealth fueled his penchant for philanthropy, especially for Irish and Catholic causes. He often challenged his fellow Irish parishioners at St. Joseph's Church on Hope Street in Providence to contribute more.

Banigan helped to establish the Home for the Aged Poor, St. Vincent De Paul Infant Asylum, St. Joseph's Hospital and St. Maria's Home for Working Girls. He endowed an academic chair at Catholic University and provided scholarships for the first Catholic students at Brown University. In 1885, Pope Leo XIII recognized his generosity and made Banigan a Knight of St. Gregory, only the second American so honored.

Banigan displayed his ecumenism by making generous contributions to the Church of Latter-day Saints. In addition, Irish patriots, who crisscrossed New England during the Gilded Age, always stopped for a conference with Joseph Banigan and usually left with a handsome check.

As an Irishman, Banigan hired hundreds of his countrymen to work in his mills, where they became skilled rubber workers and homeowners at a time when the warning "No Irish Need Apply" ruled in Yankee Rhode Island. Yet in 1885, the same year Banigan became a Knight of St. Gregory, an ill-advised wage reduction herded his workers into the Knights of Labor in a series of strikes that ended in a compromise.

After selling his rubber footwear facility to the United States Rubber Company, Banigan became president of the emerging cartel. He left in 1896 after the board of directors refused to implement his modernization plans. He returned to Providence to start a new footwear company on Valley Street in a mill sold to him by Charles Fletcher, but he died of a diseased gall bladder on July 28, 1898, at his 510 Angell Street mansion near Wayland Square. At the time of his death, he was serving on the board of directors of more than a dozen major companies. He was only fifty-eight years old according to his death record. His exact date of birth in 1839 is unknown.

Banigan took great pride in erecting the beautiful St. Bernard Mortuary Chapel in Pawtucket's St. Francis Cemetery, which he designed not only as the final resting place for himself and his family but also as a place of prayer and recollection for those who visited the cemetery. He named the chapel for his father and his mammoth Alice Mill in Woonsocket for his mother. It was destroyed by fire in June 2011.

Banigan's family included his first wife, Margaret (Holt) Banigan of Woonsocket, whom he married in 1860. She bore him four children prior to her death in 1871. His second wife, whom he married in 1873, was Maria T. Conway.

Banigan is most fortunate that his memory has been perpetuated in a fine 2008 scholarly biography by Professor D. Scott Molloy entitled *Irish Titan, Irish Toilers: Joseph Banigan and 19th Century New England Labor*.

James Hanley

James Hanley was born in Roscommon, Ireland, on September 7, 1841, and came to America with his parents, Patrick and Bridget (Farrell) Hanley, as a child in 1846 during the Great Famine migration. He rose from poverty to prominence as Rhode Island's leading brewer. Hanley's first important step into the world of business came in January 1862, at the age of twenty, when he opened an inn and liquor store in Downtown Providence. In 1876, he began his career as a brewer in partnership with fellow Irishman John P. Cooney. Although this partnership lasted for only two years, Hanley's career continued until his death. His major enterprise on Jackson Street became known as the James Hanley Brewing Company in 1891, but he also established the Providence Brewing Company and the Hanley-Hoye Company, a wholesale liquor dealership. In addition, Hanley became a director of the National Exchange Bank and several other large financial corporations.

Hanley loved the sport of harness racing and became nationally prominent as the trainer and owner of fine and successful racehorses, one of which, a pacer named Prince Alert, established a world record for the mile in September 1903. In his business, he used the best draft animals available, and his prize teams of six, nine and twelve horses won many national and international competitions, bringing wide attention to his fine ale.

Hanley's teams (foreshadowing those of Budweiser's August Busch) were known as the "World's Best," and Providence residents thrilled at the appearance of these handsome deep-chested animals in parades and other public celebrations. His most famous group was "the Big Nine," a synchronized team of roan Belgian horses ranging in height from seventeen to nineteen hands and in weight from 2,200 to 2,500 pounds. The entire entourage, weighing more than ten tons, hauled a twenty-foot show wagon and was regarded as one of the world's finest teams of draft horses.

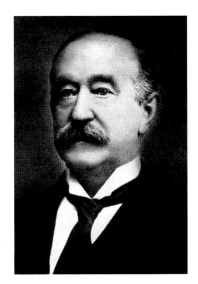

At the time of his unexpected death of a cerebral hemorrhage on August 31, 1912, just prior to his seventy-first birthday, Hanley had acquired a reputation not only as a businessman and a horseman but also as a civic leader and a benefactor of numerous charitable causes, especially those affiliated with the Catholic Church. He was buried at St. Francis Cemetery, Pawtucket.

James was predeceased by his wife, Martha (Cummings), who died in 1910. The couple had six children—four daughters and two sons, Walter and Gerald, who ran the brewery after their father's demise. Gerald (1884–1959) gained distinction in his own right and is regarded as the founder of the Rhode Island Air National Guard, an achievement that earned his induction into the Rhode Island Aviation Hall of Fame.

WILLIAM GILBANE AND THOMAS GILBANE

The Gilbane family, like the Banigans and the Hanleys, were driven from Ireland to America by the potato blight that caused Ireland's Great Famine. William Gilbane, who, was born in 1842, arrived in America from County Leitrim with his parents, Thomas and Bridget (O'Brien) Gilbane, in 1845, settling originally at Lime Rock in the Blackstone Valley. On September 5, 1854, William's brother Thomas was born there.

As a young boy, William left the Valley for Providence to learn the carpenter's trade. He soon met and apprenticed himself to George A. Brown, a city carpenter who maintained a shop at 25 South Court Street, but William also continued his educational training. Working under the tutelage of carpenter Brown by day, young Gilbane attended night classes at the Providence Evening School and a mechanical drawing school on Fountain Street. Anticipating his entry into the business world, he later undertook coursework at Bryant & Stratton Business College and the Rhode Island School of Design.

Just before 1870, the Gilbane family moved to Providence. At that time, the city was entering its golden age. Nearly 69,000 inhabitants lived within its limits. Ten years later, that number would reach 105,000 as a result of annexations from surrounding towns and the steady influx of immigrants seeking a better life.

This swelling immigrant population provided a vast pool of unskilled labor that fed the city's rapidly expanding industrial base. The city's burgeoning population, coupled with economic growth, stimulated residential construction and a pressing need for religious and service-oriented institutions. Providence offered almost unlimited opportunity for ambitious, skilled craftsmen such as William Gilbane.

William Gilbane practiced the carpentry trade in Providence under George Brown until June 18, 1873, the date on which Brown succumbed to illness. It was perhaps this tragic incident that prompted the thirty-one-year-old carpenter to establish his own business. His younger brother, Thomas, now nineteen years of age, had also moved to Providence and was listed in the city directory as a carpenter. He had, in fact, apprenticed himself to his brother.

William advertised in the 1875 directory as "William Gilbane, Contractor and Builder." Several years earlier, he had moved to a wood-frame building at 64 Lippitt Street and made this small house his office. Unfortunately, his carpentry shop opened in the midst of a severe economic recession called the Panic of 1873 that precipitated large business failures and created massive unemployment.

The brothers, working together with the return of better economic times, developed a family-based team spirit that soon became an unmistakable trademark of the company. Thomas proved equally ambitious in his drive to succeed. He attended both day and evening classes at Bryant & Stratton Business College, studied at the Fountain Street drawing school and for six winters took courses at the Rhode Island School of Design.

In 1883, the two brothers formalized their partnership by establishing William Gilbane and Brother. Following that merger, continued industrial

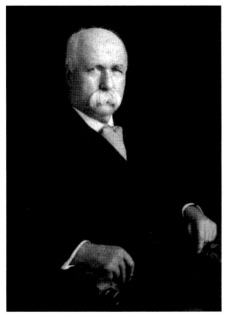

William Gilbane.

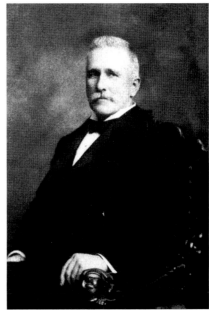

Thomas Gilbane.

expansion locally generated increased activity in the building trades. The Gilbanes and their crews worked dawn to dusk, six days a week. They built homes so well that the owners boasted (and still do) "Built by Gilbane" at resale. Before long, Gilbane craftsmen were building the hospitals, churches, schools, public buildings and private homes needed for the city's expansion. Intricate brickwork, gingerbread cornices and carved black walnut interiors challenged the ingenuity and abilities of Gilbane's craftsmen.

Boss William Gilbane, a tough-minded, hard-driving man, wore out two saddle horses a day traveling from job to job inspecting the work and giving encouragement to his men. His brother, Thomas, now company president and the man who estimated most of the jobs, kept the office intact and handled the finances.

Both were devoted family men. William married Annie Francis Martin in 1870 and by 1890 had fathered five daughters and one son, William, who was born on October 21, 1875. Thomas wed the former Mary Josephine McGuinnes on January 27, 1886. Their marriage produced two daughters.

The Gilbane brothers were devout members of the Catholic Church and participated in a wide range of community activities. For these family men, employees were regarded as family too.

In 1887, the Gilbanes opened an office on 9 Custom House Street in the heart of the downtown. Two years later, the firm moved again, this time to a spacious new ten-thousand-square-foot facility on Senter Street.

On April 22, 1897, while the company was busily engaged in the construction of such projects as the new Hope and Technical High Schools, Roger Williams Park Casino, its Museum of Natural History and the new addition to the Butler Hospital, a crushing setback occurred. Fire destroyed its headquarters. Machinery, workmen's tools and much of the lumber being used in jobs under contract were gone. The company emerged from the disaster and immediately began plans for a larger, more modern complex on nearby Harris Avenue. Within a year, the new office was in operation and quickly became a success.

Business was thriving for William Gilbane and Brother at the turn of the century. It was during this time that the company began its long association with Brown University. In 1900, the Gilbanes were contracted to build a Colonial Revival brick-and-marble residence for Brown's president, William Faunce. A short time later, Gilbane workers were on the campus again, constructing an administration building and a dormitory, Brunonia Hall (renamed Richardson Hall). In 1902, the company won a major contract to build Providence's new Central Fire Station, the largest public project at the time. As the business grew, so did the company's workforce. By 1900, more than two hundred men worked for the firm.

Gilbane workers became more than employees. Everyone knew one another by first name and attended one another's weddings and funerals, as well as celebrated births and special occasions together.

William Gilbane retired in 1902 shortly after his sixtieth birthday and brought in his son, William H., as a partner of the firm. In September 1908, the three men officially incorporated the Gilbane Building Company.

The Gilbane family continued to run the growing business throughout the twentieth century and to the present day. It is one of the largest privately held, family-owned construction and real estate development firms in the nation. Of all the great local business enterprises of Providence's golden age, only the Gilbane Corporation has survived intact and is still family run.

Tom and Bill Gilbane, grandsons of William, the founder, became not only business and civic leaders but also great collegiate athletes at Brown University. That earned them induction to the Rhode Island Heritage Hall of Fame in 1977, forty years before the founders received a similar honor. Sports are always the key to fame. The founders were belatedly inducted in

December 2017, giving the Gilbanes four Hall of Fame members. Only the Brown family has more.

Even in retirement, the founders kept a watchful eye on their creation while William's son, William H., ran the firm. In October 1927, William contracted pneumonia and died after a week's struggle on November 3 at the age of eighty-five. Thomas succumbed to the same illness three months later on February 20, 1928, at age seventy-three. They were buried at St. Francis Cemetery, Pawtucket.

CHARLES H. DOW AND EDWARD D. JONES

Charles H. Dow and Edward D. Jones were local reporters. Both wrote for the *Providence Morning Star and Evening Press.* Then Dow joined the *Providence Journal.* The names of these former Rhode Island journalists have become synonymous with money and finance.

Charles Henry Dow was born on his family's farm in Sterling, Connecticut, not far from the Rhode Island border, on November 6, 1851. He began his career in journalism as a reporter in Springfield, Massachusetts. In 1875, he joined the *Providence Morning Star and Evening Press*, where he met and worked with Edward Jones, a Brown University dropout who had also entered the world of reporting.

Dow was first exposed to financial reporting when he got a job at the larger *Providence Journal.* The paper sent him westward to cover the mining frontier. During his travels in 1879, he filed nine reports detailing gold and silver discoveries in Colorado. These informative missives were known as his "Leadville Letters." Dow also wrote a twenty-nine-page pamphlet on the history of steam navigation between Providence and New York in 1877, as well as a sprightly history of Newport titled *Newport, The City by the Sea: Four Epochs in Her History* (1880).

In late 1879, upon his return from the West, he moved to New York City and began working at the Kiernan News Agency, a firm that delivered handwritten news to banks and brokerage houses. Once established, he recruited Jones, his former colleague, to join him.

Edward Davis Jones was born in Worcester, Massachusetts, on October 7, 1856, the son of Reverend John Jones and Clarissa (Day) Jones. From a young age, he was known as someone who could read and understand complicated financial reports.

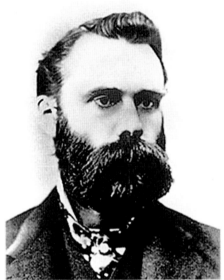

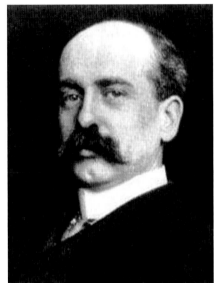

Charles Dow. Edward Jones.

Dow and Jones worked just long enough at Kiernan to learn the ropes, know the town and see opportunity. In 1882, they bolted to establish their own financial news operation that they called the Dow Jones Company. This new firm published a daily two-page financial news bulletin, and when the editors expanded their creation, it became known as the *Wall Street Journal*. Their first index—a transportation average—appeared on February 16, 1885. The first edition of their innovative paper was published on July 8, 1889.

Other than the *Wall Street Journal*, the principal legacy of these one-time Rhode Island entrepreneurs is the Dow Jones Industrial Average, a stock market index. It is the most prominent of several indices created by Charles Dow and was first calculated on May 26, 1896, for twelve "smokestack companies." Their averages create an index that presently shows how thirty large, publicly owned companies based in the United States have traded during a standard session in the New York stock market. The "industrial" portion of the name is mainly traditional, as now many of the thirty traded companies have little or nothing to do with the heavy manufacturing (or "smokestack") industry.

The rules established by Dow and Jones were for their employees to exude integrity, accuracy and trust—to be a reporter who "gets it right." Their *Wall Street Journal* has become the world's most vital newspaper for business and financial news and information.

Dow died in Brooklyn, New York, on December 4, 1902, after selling his shares of the company to Clarence Barron. He was fifty-one. Survivors included his wife, Lucy, whom he married in 1881, and a stepdaughter.

Jones, described as a hot-tempered, red-mustachioed six-footer, dealt with the messengers and wrote and edited the bulletins. A growing incompatibility with Dow prompted him to leave the firm in 1899. He then worked on Wall Street in the brokerage business until his death at sixty-five on February 16, 1920. He was survived by his wife, Janet (Conkling), and one son. He is buried at Hope Cemetery in his native town of Worcester.

DANIEL F. LONGSTREET

Daniel Francis Longstreet was a Gilded Age pioneer in labor-management-passenger relations on the Providence street railway system. He later invented improvements for streetcars and their electrification and helped to establish some of the national managerial organizations in the public transit industry.

Daniel was born into a farm family in Thompson, Connecticut, on July 9, 1846, the son of Richard Longstreet and Jane Ann Roberts. Little is known of his youth, but he moved with his family to Providence and attended Providence schools. He participated in the Civil War by joining the Fourth Rhode Island Infantry at age sixteen (more than one hundred of his wartime letters are catalogued at Brown University's John Hay Library).

After the conflict, Longstreet worked as a conductor for the Union Horse Railroad Company in Providence. In less than a decade, he rose through the managerial ranks to become superintendent of operations. Despite tension with the Sprague family, owners of the horsecar system, Longstreet insisted on paying the highest wages in the country to attract an honest and intelligent workforce while implementing a system of organizational accountability. He also instituted one of the first ten-hour workdays in the nation.

During the Panic of 1873, a particularly severe blow to the state's economy that bankrupted the Sprague business empire, Longstreet continued to pay premium wages. Furthermore, he took the opportunity in tough economic times to actually increase the state's urban track mileage by 50 percent. He also provided the latest amenities for vehicles and waiting stations to win the hearts and minds of grateful passengers.

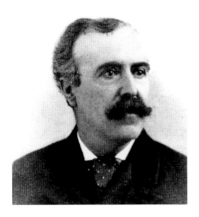

Longstreet invented improvements to railway operations, including snowplows, brakes, fortified wheels and even the "Longstreet Rail," a widely admired steel track. He conducted some of the earliest national experiments employing petroleum fuels and storage batteries. Organizationally, he was a founder and president of the American Street Railway Association, where he endorsed progressive personnel policies.

In conjunction with the Sprague family, Longstreet was instrumental in founding the American Thoroughbred Association, an organization that exercised jurisdiction over horseracing in the United States and helped to eliminate cheating and fraud in that sport.

In 1888, after more than twenty years at the helm in Providence, Longstreet took a similar job at one of the country's largest operations, the West End Street Railway in Boston. In 1890, as a pioneer in the electrification of the trolley business, he was hired to supervise the building of an electrified streetcar system in Denver, Colorado. He returned to Rhode Island after 1900 and spent much of his retirement participating in Civil War veterans' activities under the auspices of the Grand Army of the Republic (GAR). When he died at his daughter Elizabeth's home in Brighton, Massachusetts, on January 19, 1937, at age ninety, he was the last surviving member of the Isaac Rodman Post of the GAR. Longstreet was buried at Swan Point Cemetery.

In the age of the robber barons, Longstreet practiced labor-management-customer relations that presaged the reforms of the New Deal. His Rhode Island career is traced in detail by Professor D. Scott Molloy, himself once a bus driver, in *Trolley Wars: Streetcar Workers on the Line*, published in 1996 by the Smithsonian Institution Press.

William R. Tripp

William Rodman Tripp of Little Compton was the man most responsible for the development of a breed of chickens known as the "Rhode Island Red," a fowl that has been designated the state bird. Unfortunately, details concerning

the life of this farmer are scant. Like the humble rustic in Thomas Gray's immortal "Elegy," Tripp was a man "to Fortune and to Fame unknown," at least until his 2004 induction into the Rhode Island Heritage Hall of Fame. No photo of him survives.

Tripp was born in Westport, Massachusetts, on February 24, 1812, the son of farmers Job and Patricia Tripp. In 1850, he married Betsey G. Wood, by whom he had seven children. It appears that Betsey died in 1865 while delivering her final child. He apparently remarried.

In 1854, Tripp, who operated a farm on Long Highway in Little Compton, began an important development in the American poultry industry. He marketed much of his produce in New Bedford, a major port that carried on trade with Southeast Asia. From a sailor returning from an Asian voyage, Tripp obtained a red cock that was said to be a Malay or a Chittagong. When he took the fowl home and let it run with his scrub hens, he observed that the new chicks grew into a stock that improved on his nondescript natives: the hybrids were meatier and laid more and bigger eggs.

Rhode Island Red monument in the Little Compton village of Adamsville.

Another farmer, John Macomber of nearby Westport, Massachusetts, became interested in Tripp's experiments, so the two men collaborated in further crossbreeding efforts. Isaac C. Wilbour of Little Compton then joined in. He crossed the resulting breed, called "Tripp fowls," with Light Brahmas, Plymouth Rocks and Brown Leghorns, the final product being a breed with both a high egg yield and more flesh for consumption.

Two professors at the agricultural experiment station in Kingston (the forerunner of the University of Rhode Island), Samuel Cushman and A.A. Brigham, also contributed to the development of this new super chicken that Wilbour named the "Rhode Island Red." In the early twentieth century, this fowl became a mainstay of the American poultry industry. Now Tripp himself is recognized for his exemplary work as a poultry breeder.

William Tripp died on May 16, 1891, at the age of seventy-nine. He is buried at Beech Grove Cemetery in Westport, Massachusetts.

Two memorials to Tripp's famous bird can be found in Little Compton— one on Long Highway across from the Tripp farmhouse and a second mounted on a large boulder on Main Street in Adamsville. The latter is allegedly the world's only memorial to a chicken.

III

POLITICIANS
AND POLITICAL REFORMERS

U.S. Senator and Governor William Sprague IV

A brief profile such as this is totally inadequate to capture the tragedy and complexity of William Sprague IV. When he was only thirteen, his father, Amasa Sprague, was brutally murdered, a death compounded by the execution of an innocent man, John Gordon, for the crime. His marriage to Kate Chase, the belle of Washington society, produced a mentally challenged daughter and ended in a humiliating divorce caused in part by Kate's adultery. His mammoth textile empire collapsed in the Panic of 1873, and a relentless receiver, Zechariah Chafee, prevented Sprague from recovering. His only son, William V, committed suicide in 1890 at the age of twenty-five. Canonchet, his magnificent oceanfront mansion in Narragansett, was destroyed by fire, and he lived his final years in self-imposed exile in Paris in the midst of World War I.

William Sprague, the fourth prominent member of the legendary family to bear that name, was born in Cranston on September 12, 1830, in a mansion near the family's print works that is now home to the Cranston Historical Society. His parents were Amasa and Fanny Morgan Sprague. As the youngest of four children, he was named for his father's brother, William, an industrialist who would become both governor and U.S. senator. He was educated with his brother, Amasa, at Irving Institute in Tarrytown, New York, but his schooling was terminated by the murder of his father.

The Sprague business enterprises, already far-flung, were directed by William's uncle, William III, until his death in 1856. Thereafter Amasa, William IV and their cousin Byron (who owned Rocky Point Amusement Park briefly in the late 1860s) ran the business in conjunction with the widows of William III and Amasa Sr. As partners, they reincorporated the A&W Sprague Company in June 1859. Their Cranston facility quickly became the largest calico printing textile mill in the world, and five other weaving mills owned by the Spragues also prospered. Before his death, William III had purchased controlling interest in the new Hartford, Providence and Fiskhill (on the Hudson) Railroad. It connected the five mills with the Cranston plant to which the woven cloth from those mills were shipped for printing.

The coming and the outbreak of the Civil War created a major alteration in the life of William IV. In 1860, at the age of twenty-nine, he ran for governor of Rhode Island on a Democrat-Conservative ticket, and his Unionist position allowed him to prevail over the more extreme Seth Padeford, a Republican, by a vote of 12,278 to 10,750. In 1861, he headed the Union ticket defeating future Republican governor James Y. Smith 12,005 to 10,326. That April victory coincided with the outbreak of war.

After Lincoln's call for troops, the dashing young governor traveled with a brigade of volunteers under the command of Colonel (later Major General) Ambrose Burnside to defend Washington, D.C. At the First Battle of Bull Run on July 21, 1861, the governor acted as an aide-de-camp to Burnside and saw action in the Union defeat. His horse was shot, but he escaped injury. After the battle, Sprague was offered a commission as a brigadier general of volunteers, but he wisely declined.

Back in Rhode Island, he secured reelection in April 1862, running unopposed. He then attended the war governors' conference in Altoona, Pennsylvania, that endorsed Lincoln's Emancipation Proclamation. In May 1862, the General Assembly elected Governor Sprague to the U.S. Senate for a term beginning on March 3, 1863, as his gubernatorial term neared its end. He received 92 of the 103 votes cast.

The very popular Sprague served two six-year terms in the United States Senate. When the General Assembly voted for his continuance in office on June 9, 1868, he garnered all ninety-eight votes that were cast. During his two terms, he served as chairman of the Committee on Manufactures and the Committee on Public Lands and as a member of the Committees on Commerce and Military Affairs. He voted with the so-called Radicals to impose strict surveillance on the reconstructed Confederate states to protect the civil rights of the freed blacks. In 1874, in the midst of a financial crisis, he relinquished his U.S. Senate seat in favor of his wartime associate Ambrose Burnside.

Sprague's Senate career was unremarkable, except for his marriage to Kate Chase, the beautiful belle of Washington society, on November 12, 1863. As a wedding present, he gave his bride, the daughter of Salmon P. Chase, Lincoln's secretary of the treasury and the future chief justice of the U.S. Supreme Court, a tiara of matched pearls and diamonds that cost more than $50,000. In turn, Kate gave William prestige and four children—William, Ethel, Catherine and Portia—between 1865 and 1873. The marriage, at first blissful, grew increasingly stormy. The final squall came in 1879, when William returned to their Narragansett mansion to discover Kate in a compromising position with Senator Roscoe Conkling of New York. The marriage ended with a bitter divorce in 1882.

The couple's relationship was damaged by the huge financial setback suffered by Sprague in the great economic Panic of 1873. His vast textile empire went into receivership, and the receiver, Zechariah Chafee, diligently set about recovering the company's estimated $14 million debt. According to one historian of the bankruptcy, "no man in the history of Rhode Island business ever had such dictatorial powers over such a large corporation" as Chafee exercised. Despite Sprague's best efforts, his factories were sold by Chafee, and the company was liquidated in the mid-1880s. The major recipient of the Sprague Mills was the emerging partnership of Benjamin and Robert Knight.

Politics was in Sprague's blood. Soon after his divorce and the loss of his textile empire, he became involved in the Equal Rights constitutional reform movement of the 1880s led by Charles E. Gorman. The Democratic reformers backed Sprague in a gubernatorial run in 1883, but he lost to Augustus O. Bourn by a margin of 13,068 to 10,201. Sprague's shifting political positions are enigmatic.

In 1900, Sprague was again back in the political ring, but decidedly on the undercard. As a resident of the newly created town of Narragansett, a

resort for the wealthy just set off from South Kingstown, he won election to the council and became its first president.

After his divorce, William engaged in some unusual pursuits, devising a few mechanical inventions and writing some essays on economic philosophy. In 1883, he also remarried. His second wife was Dora Inez Clavert of West Virginia. The couple resided at beautiful Canonchet, the oceanfront estate that Sprague had managed to keep from Chafee's grasp. On October 11, 1909, a fire destroyed this splendid home along with Sprague's diaries, personal papers and valuable artifacts. Discouraged, the couple moved to Paris, where they were soon confronted by World War I. In a final magnanimous gesture, they opened their Paris apartment on the Île-de-France as a convalescent hospital for the wounded.

On September 11, 1915, the day before his eighty-fifth birthday, Sprague died of meningitis. His wife arranged his return to Rhode Island so that he could be buried in the family tomb at Swan Point Cemetery. His epitaph might well have been "What Price Glory."

Governor Elisha Dyer II and Governor Elisha Dyer III

The Roman numerals after the names of Governor Elisha Dyer suggest a family first name scenario similar to that of the Spragues. William III (1799–1856) and William IV (1830–1915) were governors of Rhode Island, as were Elisha II (1811–1890) and Elisha III (1839–1906). One wishes that these prominent families could be more creative with their nomenclature.

Elisha I, the father of the first governor Dyer, had an illustrious Rhode Island ancestry dating back to the coming of William and Mary Dyer to Portsmouth in 1638 as exiled disciples of Anne Hutchinson. Mary later espoused Quaker beliefs, and because she defiantly and repeatedly returned to Boston to preach her doctrines, she was executed by order of the Massachusetts Bay Colony's magistrates in 1660.

Elisha Dyer I, born in Glocester on January 5, 1772, became a very successful Providence commission merchant and textile manufacturer. He established two mills along the Woonasquatucket River—the Providence, Bleaching, Dyeing and Calendering Company on Valley Street in Olneyville and the Dyerville Mill on Manton Avenue in what was then the town of

Elisha Dyer II.

Elisha Dyer III.

North Providence. He also operated a general commission business on South Water Street in Providence.

His son, Elisha Dyer II, was a man of diverse talents and interests. After an early education at private schools, he entered Brown in 1825 and graduated in 1829. Two years later, he became his father's junior partner in the commission merchant business, and in 1835, this father-and-son team established the Dyerville Mill to produce cotton cloth. They ran this business jointly until the death of Elisha I in 1854.

In the year the Dyers founded their mill, Elisha II began a lifetime association with the Rhode Island Society for the Encouragement of Domestic Industry, eventually serving as its president from 1859 to 1878. In the late 1830s, he became very active in the affairs of the Whig Party. When the Whigs gained firm control of state government in 1840, Elisha II was elected adjutant general of Rhode Island, a post to which he was reelected for five successive one-year terms. In this position, Dyer played a major role in directing the military maneuvers of the Law and Order government during the Dorr Rebellion.

During the 1840s and 1850s, Dyer held leadership positions in an array of civic agencies, both private and public. These included membership on the Providence School Committee, the presidency of the Fire Wards in the city of Providence, membership on the Butler Hospital Corporation, the presidency of the Providence YMCA, the vice-presidency of the Providence

Art Association and the presidency of the Exchange Bank. In 1851, he was the unsuccessful Temperance Party candidate for mayor of Providence. During this time, he remained a dedicated official of the Whig Party organization, but as that party disintegrated during the sectional crises of the 1850s, he moved into a leadership position in the newly emergent Republican Party.

In 1857, Dyer became Rhode Island's first Republican governor, defeating Democrat Americus V. Potter by a decisive margin of 9,581 to 5,323. After outpolling well-respected Democrat Elisha R. Potter Jr. by a vote of 7,934 to 3,572 in 1858, Dyer declined to run in 1859. As he left office, the *Providence Post*, a leading Democratic newspaper, offered an admission: "We have from the first looked upon him [Dyer] as an honorable, high-minded opponent and a straightforward, conscientious man; and candor compels us to say that he has never failed to reach the standard set up for him."

Elisha Dyer II lived for more than three decades following his governorship through most of the Gilded Age. An 1881 biographical profile states that "Governor Dyer has been an invalid for the last thirty years, and very much of his work has been done under the burden of infirmity and suffering." Perhaps the condition that afflicted him was rheumatoid arthritis, but surviving accounts do not identify his malady. One thing is certain: it did not detract from his drive, nor did it prevent his additional accomplishments. Dyer volunteered for service in the Civil War, serving three months as captain of the Tenth Ward Drill Company of Providence; he invested in several local railroad ventures; and he continued to make numerous public addresses as an elder statesman on such diverse topics as politics, business, education and music. In the last-mentioned field, he was elected president of the first National Music Congress, a gathering held in Boston's Music Hall in 1869. In addition, Dyer was a Rhode Island commissioner to the London International Exhibition in 1871 and an honorary national commissioner to the Vienna Exposition in 1873. He crossed the Atlantic eighteen times during his career and took extensive notes on his travels to Europe.

On October 8, 1833, Elisha II married Anna (Jones) Hoppin. One of their seven children, Elisha Dyer III, would also become governor of Rhode Island.

On May 17, 1890, Elisha Dyer II died at the age of seventy-eight. A devout Episcopalian, he remained a strong advocate of temperance throughout his remarkable life. He is buried at Swan Point Cemetery.

Elisha Dyer III, son of the governor, was born in Providence on November 29, 1839. After attending the public schools of Providence, Elisha III graduated from the University Grammar School and the Lyon & Frieze School. In 1856 and 1857, he was enrolled at Brown University as a

special student. While attending Brown, he launched his military career. In October 1856, he joined the First Light Infantry Company as a private and served with that rank until April 6, 1858. In that year, he took leave from his courses at Brown and went to Germany to study at the University of Gissen, graduating with his PhD in chemistry on August 10, 1860.

The same year that he left town he was commissioned a colonel and aide-de-camp on the staff of his father, who was then the governor. On April 17, 1861, he enrolled as a sergeant in the First Light Battery, Rhode Island Detached Militia. He was injured in the line of duty and, on a surgeon's certificate, was discharged on April 27, 1861. He returned to Rhode Island, where he married Nancy (Anthony) Viall of Providence on November 26, 1861. They became the parents of three children, Elisha IV, George and Hezekiah Anthony, who became a Hall of Fame inductee as an artist.

Elisha III was a martial man, holding numerous state militia offices from 1861 through 1878, when he retired from the First Battalion Light Infantry, Second Brigade, Rhode Island Marines. However, he maintained membership in several military organizations, and on February 7, 1882, he was elected adjutant general of the state with the rank of brigadier general. He was reelected at the expiration of each term until he voluntarily retired on October 31, 1895. During his tenure, he thoroughly organized the military records of the state, especially those pertaining to the Civil War, and he secured additional state assistance for needy or disabled veterans of that war.

Dyer was by profession a chemist, and he devoted at least twenty years of his working life as a manufacturing chemist. In addition to his military and professional involvement, he was a member of several civic and cultural organizations, including the Rhode Island Society of the Sons of the American Revolution and the Rhode Island Historical Society.

In 1877, Dyer was elected as a Republican to the state Senate from North Kingstown. He later changed his residence to Providence and, in 1881, was elected to the Rhode Island House of Representatives from the city's Fourth District. He was also a member of the Providence School Committee from 1888 until 1897. Dyer ran for the city council in 1890 and was elected an alderman. He served from June 7, 1890, until January 1892.

On April 7, 1897, Elisha III was elected governor as a Republican by a wide margin (24,309 to 13,675) over Democrat Daniel T. Church and held the position of chief executive for three consecutive one-year terms. While he was governor, the United States fought a brief and victorious war with Spain, and Dyer, as commander-in-chief, put his military experience to work by mobilizing the state militia. At war's end, he orchestrated the

publication of a book recounting Rhode Island's role in that conflict titled *Rhode Island in the War with Spain.*

After completing his gubernatorial tenure, Dyer was again elected to the state Senate, where he served during 1904 and 1905. Then he made a bid for mayor of Providence and secured election to that post on November 7, 1905. Unfortunately, his term was cut short by his unexpected death on November 29, 1906, at his Power Street home.

Dyer was buried in the family plot at Swan Point Cemetery. His passing came on his sixty-seventh birthday.

Congressman Thomas Allen Jenckes

Congressman Thomas Allen Jenckes is regarded nationally as the "Father of Civil Service Reform." He was born in Cumberland on November 2, 1818, the son of Thomas and Abigail (Allen) Jenckes. He was educated in the public schools of that town under the tutelage of Reverend Adin Ballou, and in 1838, he graduated from Brown University, where he had distinguished himself in mathematics and the physical sciences.

Jenckes studied law under Samuel Y. Atwell, an ardent ally of Thomas Wilson Dorr, and was admitted to the bar in 1840. Surprisingly, however, he became a supporter of the Law and Order Party, which put down Dorr's reform movement, and served as secretary of its Landholders' Convention and of the conservative convention that drafted the state constitution of 1843.

In 1845, Jenckes became state adjutant general, a post he held for a decade, and also served as a state representative from 1854 to 1857. He employed his legal skills as chief counsel for Rhode Island in its boundary dispute with Massachusetts and argued for Rhode Island's claim in the U.S. Supreme Court. Jenckes's ability and interest in science and mechanics led him to specialize in patent law, a field in which he gained prominence and from which he gained business opportunities both in Rhode Island and New York.

Jenckes was brilliant and read widely on a variety of subjects. As a colleague said of him, "He was equally familiar with the last novel of Dickens, or the last work on astronomy, and he could repeat from memory long passages from a new poem by Tennyson before most people knew it had been published."

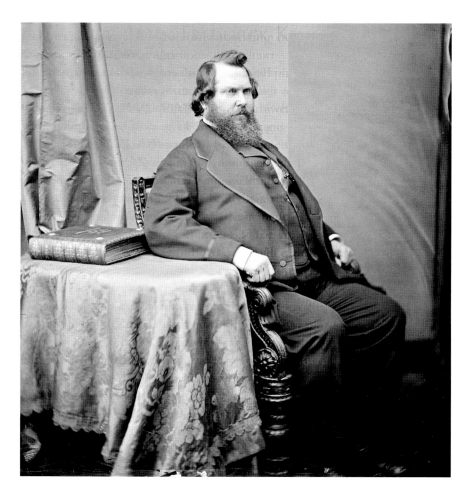

Jenckes represented Rhode Island's Eastern District in the U.S. House of Representatives from 1863 to 1871 as a Radical Republican. While a congressman, he wrote an article of President Andrew Johnson's impeachment and sponsored the federal Bankruptcy Act of 1867. He served as chairman of the Committee on Patents and wrote several laws pertaining to that subject. He was also a major sponsor of the act creating the U.S. Department of Justice and the post of solicitor general of the United States. As an attorney, Jenckes saw the need for a federal justice department headed by the attorney general because of the great increase in the amount of litigation involving the U.S. government.

However, Jenckes is remembered best as a leader in the movement to reform the federal civil service from a system based on patronage to one founded on "merit." He patterned his reform bill on the British system of

open, competitive examinations for government jobs. In its general outline, the original Jenckes Bill (which did not pass) furnished a model for the famous Pendleton Civil Service Reform Act of 1883.

Ironically, Jenckes's support for a merit-based civil service system cost him his seat in Congress, as that reform ran counter to the position of his local Republican Party organization. In the Congressional election of 1868, incumbent Jenckes beat his Democratic opponent in a head-to-head race 7,964 to 3,898, a margin of 4,066 votes. After spearheading the drive for a merit system in defiance of Senator Henry Bowen Anthony, the corrupt boss of the state's Republican Party, Jenckes was defeated for reelection in 1870. In the era before primaries, Anthony ran a machine-backed Republican against Jenckes in the general election. That candidate, Benjamin T. Eames, outpolled Jenckes 4,962 to 1,965. In short, Jenckes sacrificed his seat in defense of principle.

After leaving office, Jenckes resumed his busy law practice, representing local industrialists such as George Corliss in defense of their patents. Then he received another setback, financial rather than political, during the economic depression known as the Panic of 1873, when a corporation failed in which he was a major shareholder.

Compounding these losses was the death of his wife, Mary Jane Fuller, in 1872. She was the mother of his seven children. These reverses took their toll on Jenckes. He died in Cumberland on November 4, 1875, at the age of fifty-seven. He was buried next to Mary Jane at Swan Point Cemetery. The Library of Congress and the Rhode Island Historical Society maintain large collections of his papers.

Mayor Thomas A. Doyle

Arguably Providence's most beloved and accomplished mayor, Thomas A. Doyle presided over his city's golden age. He was born in Providence on March 15, 1827, to Martha Jones and bookbinder Thomas Doyle, a man of Irish Protestant heritage. The great popularity gained by young Thomas during his career was proof that in nineteenth-century Rhode Island, the only thing objectionable about the Irish was the suffix "Catholic."

Thomas was one of seven Doyle children, whose father died when they were young. His most notable sibling was his sister Sarah, an educator and reformer, who has also earned induction into the Rhode Island Heritage Hall of Fame.

Doyle attended local schools, and during his teenage years he worked as a clerk for lawyer Benjamin Cozzens and later for Jacob Dunnell & Company, calico printers. Early accounts describe Doyle as "remarkably quick and self-reliant." These traits, no doubt, were imposed on the young man by the premature death of his father.

Doyle developed an early interest in politics, and in 1848, the twenty-one-year-old was elected clerk of the Sixth Ward Whig Committee. Four years later, he was elected to the Common Council from the Fifth Ward, and in 1854, he was chosen council president. Doyle left the city council in 1857 and worked variously as a stockbroker, an auctioneer and in the real estate business, but his ongoing interest in politics led him to enter the Providence mayoral race in 1864. Described as a "maverick" Republican, Doyle won more than 55 percent of the vote in a three-man race.

On October 21, 1869, Doyle married Almira Sprague, sister of U.S. Senator (and former governor) William Sprague IV, but the marriage was childless. Doyle's annual election wins between 1864 and 1880 were interrupted only once, in 1869, and then primarily because of charges that he had doubled city taxes and had conflicts of interest with the Sprague family. During this period, Doyle established the Providence Police Department, built new fire stations, acquired Roger Williams Park via a gift from Betsy Williams and constructed two reservoirs to bring fresh water to city residents.

In 1874, Doyle's administration began work on a new sewer system, and during that decade, four large brick grammar schools, eleven primary schools and a new high school were built. Responding to the economic depression or Panic of 1873, Doyle launched a massive urban renewal effort, hiring one thousand workers to clear nearly four hundred acres in the Fox Point district for redevelopment. His crowning achievement was the construction of the impressive five-story city hall, which was completed in 1878 and is still in use.

Behind the tall, bland exterior, Doyle possessed unbounded energy. He was forceful, blunt and persistent to a fault, and his combative style won both friends and enemies. Doyle left the mayoralty in 1880 and for three years thereafter served in the state Senate. In 1884, however, he was again elected mayor. His death in office on June 9, 1886, at the age of fifty-nine shocked

the citizenry of the city. Shortly after 9:26 p.m., bells around the city began ringing as a signal of his passing. Thousands came to city hall several days later to view his body and pay their respects. On June 14, a seven-division procession accompanied Doyle's remains, initially to the First Unitarian Church for services and then to Swan Point Cemetery. During his time in office, Providence more than doubled in population and geographic size and was transformed from a large town to a thriving industrial city.

Mayor Doyle is well remembered in Providence. Doyle Avenue, a major thoroughfare in the city's Mount Hope section, is named in his honor, and a life-size bronze statue of him stands at the intersection of Broad and Chestnut Streets on the western edge of Downtown near his home. That impressive memorial was sculpted in 1889 by Henry Hudson Kitson, who is best known for crafting the statue of the *Minute Man* on Lexington Green.

GOVERNOR HENRY LIPPITT

Henry Lippitt is one of those Gilded Age leaders who is difficult to categorize. His two one-year terms as governor, at a time when the General Assembly was by far the ascendant branch of government, were marked by divisions within the dominant Republican Party. His business interests were far more significant. However, he began a political dynasty unequaled in Rhode Island history that places him squarely in the political category.

Henry Lippitt was born in Providence on October 9, 1818, the son of Warren and Eliza (Seamans) Lippitt. He was descended from John Lippitt, one of the founders of Providence. His father, Warren, was a pioneer textile manufacturer, an industry that would become the basis for the family's wealth. Their first venture was the Lippitt Mill in present-day West Warwick, which opened in 1809.

Henry was educated at Kingston Academy and as a young man held jobs as a clerk and a bookkeeper in the textile industry. His big business move came in 1848, when Henry joined his father and his brother, Robert,

in the purchase of the large Tiffany Mill in Danielson, Connecticut, and reorganized it as the Quinebaug Manufacturing Company.

From 1850 to 1853, Henry and Robert also manufactured cotton goods in Newport at the Coddington Mill. Then they purchased an interest in the Social and Harrison Mills in Woonsocket with the profits from the sale of their stock in the Quinebaug Company. After Robert's death in 1858, Henry continued to expand, acquiring control of the Manville Mill in Lincoln, the Globe and Nourse Mills in Woonsocket and the Silver Spring Bleaching and Dyeing Company in Providence.

In addition to his impressive business acquisitions, Henry was interested in military affairs. He helped to reorganize the Providence Marine Corps of Artillery and, as a lieutenant colonel, commanded a portion of the unit in the suppression of the Dorr Rebellion in 1842. During the Civil War, he was draft commissioner for Providence County.

Henry held leadership positions in numerous banking and business organizations, owned a hotel and an opera house and helped to establish the Providence Board of Trade, a group over which he presided for three years as president. Because of his business and civic leadership, he was nominated by the Republican Party for governor in 1875, but GOP reformers advanced Roland Hazard to run against him. With the Republican vote divided, no candidate received a majority, so under the Rhode Island law of that era, the General Assembly made the selection. Lippitt was its choice for the one-year term, even though Hazard had registered a slight lead in the popular vote. In 1876, the Prohibition Party created a similar situation, and again the legislature selected Lippitt. The highlight of his tenure was his enthusiastic involvement in the Philadelphia Centennial Exposition, an event in which industrial Rhode Island starred.

In 1845, Henry married Mary Ann Balch, a physician's daughter. The couple had eleven children—eight sons and three daughters. One son, Charles Warren Lippitt, was his gubernatorial chief-of-staff and became governor in his own right from 1895 to 1897, but his was just the start of the incredible Lippitt political dynasty. Henry's younger son Henry Frederick Lippitt became a U.S. senator from 1911 to 1917; his grandson Representative Frederick Lippitt was longtime House minority leader; his great-grandson John H. Chafee was Warwick mayor, governor, secretary of the navy and U.S. senator; and his great-great grandson, Lincoln Chafee, became mayor of Warwick, U.S. senator and Rhode Island's ninetieth governor.

Governor Henry Lippitt died in Providence on June 5, 1891, at the age of seventy-two and is buried at Swan Point Cemetery. His Italianate

mansion, built in 1865 at 199 Hope Street on Providence's East Side, has been designated a National Historic Landmark. In 1981, it was donated by the Lippitt family to Preserve Rhode Island and is presently a house museum open to the public

GOVERNOR AUGUSTUS O. BOURN

Governor Augustus Osborn Bourn was born in Providence on October 1, 1834. His mother was Huldah Eddy, and his father, George, was a descendant of a distinguished old-line Rhode Island family whose earliest recorded ancestor, Jared Bourn, served as a Portsmouth representative to the colonial assembly in 1654–55. After graduation from Providence High School and Brown University (class of 1855), Bourn joined his father in the business of manufacturing India rubber goods.

After his father's death from respiratory disease in 1859, Augustus continued to run the business in Providence. During the Civil War, it furnished vulcanized rubber tents to the Union army. In 1864, he founded the National Rubber Company in Bristol and brought the Providence operation to Bristol four years later. His firm developed a workforce of more than 1,200 within twenty years of its establishment and became, by far, Bristol's largest industry. Bourn's economic influence in Bristol translated into political and civic leadership as well. In 1876, he was elected to the first of several terms as state senator from Bristol. In the legislature, Bourn formed a close association with Republican boss Charles R. Brayton, who secured for him the Republican nomination for governor.

Bourn was elected Rhode Island's chief executive in 1883 and secured reelection in 1884. Then he returned briefly to the state Senate, where he became principal sponsor of the Brayton-backed Bourn Amendment to the Rhode Island Constitution. This measure (Article of Amendment VII) was an ostensible reform, as it removed the real estate requirement for voting in state elections imposed in 1843 against naturalized citizens. In reality, however, it was a political masterstroke because it immediately enfranchised newer immigrants like the Franco-Americans, Swedes, Germans and British-Americans who were politically estranged from the increasingly influential Irish Catholic Democrats. The amendment won the electoral allegiance of these newly arriving immigrant groups. It has been persuasively argued that the Bourn Amendment (which also imposed a property taxpaying

requirement for voting in city council elections) kept the state Republican Party in power through the first three decades of the twentieth century.

Bourn's work on behalf of his party was rewarded in 1889, when President Benjamin Harrison appointed the Bristol industrialist as United States consul general to Italy, a position he held until 1893.

In the following year, Bourn reestablished his rubber business in Providence and incorporated that operation in 1901 as the Bourn Rubber Company. This move was necessary because attorney Samuel P. Colt had wrested control from Bourn of his Bristol-based National India Rubber Company in 1888.

According to noted Bristol historian George Howe, Colt, a friend and neighbor of Bourn's, was given power of attorney over the business when the Bourn family first departed for Italy in 1887. When the workers at the plant went on strike for back pay soon thereafter, Colt petitioned the company into receivership. The judge presiding over the insolvency, Russell Bullock, was Colt's father-in-law, and he appointed Colt as the receiver. In the reorganization that followed, Governor Bourn's stock was wiped out and Samuel Colt became the new manager and the future "rubber king."

In 1873, Bourn built one of Bristol's most stately homes on Hope Street overlooking Bristol's harbor. He named this Gothic Revival mansion Sevenoaks. It was designed by famed architect James Renwick, who listed St. Patrick's Cathedral in New York City and two buildings at the Smithsonian Institution in Washington, D.C., among his credits.

Until his death in Bristol on January 28, 1925, at the age of ninety, Bourn continued his civic leadership. He remained active in the militia (in 1878 he had become lieutenant colonel of the First Battalion, Rhode Island Calvary), and he repeatedly used his renowned oratorical skills to stimulate audiences at public observances. He was also a staunch and active Freemason.

Bourn and his wife, Elizabeth Morrill, whom he married in 1863, had four children. Augustus and Elizabeth are buried at Swan Point Cemetery.

U.S. Senator Nelson W. Aldrich

U.S. Senator Nelson Wilmarth Aldrich became the acknowledged leader of the conservative, business-oriented wing of the national Republican Party during the administrations of William McKinley, Theodore Roosevelt and William Howard Taft.

Aldrich was born in rural Foster on November 6, 1841, the son of Anan E. Aldrich, a mill hand and farmer, and Abby (Burgess) Aldrich. He attended public schools in nearby East Killingly, Connecticut, and then enrolled at East Greenwich Academy. After graduating from this secondary boarding school, he went to work for a grocer in Providence with whom he eventually became a partner. In 1866, after a brief, non-combatant service in the Civil War, he married Abigail Chapman, a well-to-do woman with impressive antecedents. Together they had eleven children.

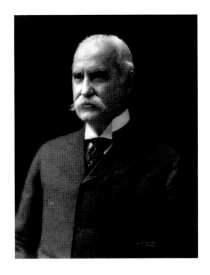

In 1869, Aldrich won a seat on the Providence City Council and served there until 1874, the final two years as its president. In 1875, he advanced to the state legislature, and by 1876, he was Speaker of the House. He demonstrated a definitely prophetic pattern of advancement.

In 1878, Republican U.S. Senator Henry Anthony and "Boss" Charles Brayton endorsed Aldrich for Congress. He won easily. After one term, the GOP-dominated General Assembly chose him to be the U.S. Senate successor to Ambrose Burnside, who had died in office. On October 5, 1881, he began a Senate career that spanned nearly thirty years. In 1911, he stepped aside in favor of Henry F. Lippitt.

A protégé of Henry Bowen Anthony and a partner of Rhode Island Republican boss Charles R. Brayton, Aldrich owed his political longevity to a rural-based Republican machine that relied on malapportionment and purchased votes to maintain dominance. In 1905, muckraker Lincoln Steffens examined the grassroots of Aldrich's power in an exposé titled "Rhode Island: A State for Sale."

Had Aldrich been content merely to hold national office rather than wield national power, his association with Brayton would have been sufficient. However, Aldrich was ambitious, relentless and resourceful in his pursuit of success, both political and financial. He cultivated friendships and business relationships with the great captains of industry and supported their demands for sound money (i.e., the gold standard), high protective tariffs and minimal governmental interference with private enterprise. They, in turn, provided Aldrich with stock participations, loans

and other business opportunities that enabled the man many called the "General Manager of the United States" to achieve great personal wealth despite his humble beginnings as a grocery clerk in Providence.

Aldrich's most notable alliance was the one forged with the Rockefellers when his daughter Abby married John D. Rockefeller Jr. That union produced several prominent children, the foremost of whom, Nelson Aldrich Rockefeller, became governor of New York and vice president of the United States from 1974 to 1977.

The respect that Aldrich commanded from his contemporaries is epitomized by the frank admission of Theodore Roosevelt, leader of the Progressive Republicans. "Aldrich is a great man to me," Roosevelt once confided to Lincoln Steffens, "not personally, but as the leader of the Senate. He is the kingpin in my game. Sure, I bow to Aldrich; I talk to Aldrich; I respect him, as he does not respect me. I'm just a president, and he has seen lots of presidents."

Unfortunately for Aldrich, the progressive tide eroded his influence during his last term. As chairman of the Senate Finance Committee, he failed in his efforts to create a central bank controlled by private banking interests, and his reversal of the downward trend of the Payne Tariff in 1909 helped to set off a wave of insurgent protest that eventually split the Republican Party. However, he did back and introduce (without enthusiasm) a resolution proposing the Sixteenth Amendment, which allowed the federal government to impose a tax on incomes. This measure, initiated by Senator Norris Brown of Nebraska, passed Congress in July 1909 and was ratified by three-fourths of the states by February 1913.

Although Congress would not accept Aldrich's original plan for a central banking system under private banker auspices, it did approve other banking proposals he developed in concert with key American financiers when he chaired the National Monetary Commission. In 1913, two years after Aldrich retired, President Woodrow Wilson signed the Federal Reserve Act, a law containing many elements derived from the Aldrich plan, thereby creating the modern Federal Reserve System. Despite his acknowledged contribution to this new financial system, Aldrich spoke out against it, as it gave the president power to appoint the board of governors and permitted the fifteen reserve banks to issue notes in a manner that he regarded as inflationary.

Aldrich spent his final years in his magnificent mansion on Warwick Neck overlooking Narragansett Bay, directly across the water from Samuel Colt's spacious Bristol estate. One wonders how each felt while gazing at the other's success. The Aldrich property is now owned by the Diocese of

Providence and once served as Our Lady of Providence Seminary, and the Colt property is presently a beautiful state park. Aldrich's Providence mansion on Benevolent Street is now the headquarters of the Rhode Island Historical Society.

Perhaps the best assessment of the controversial senator from Rhode Island has been provided by historian Jerome Sternstein: "In reality he was the incarnation of triumphant capitalism. Convinced that unfettered business enterprise had infinite capacity to produce the good life, at minimal cost, and therefore persuaded that in providing a hospitable legislative environment for business, he was doing an invaluable service for the country, he was the practicing political equivalent of the great captains of industry."

Senator Aldrich died in New York City on April 16, 1915, and is buried at Swan Point Cemetery. The most incisive analysis of Aldrich and his career can be found in the writings of Jerome L. Sternstein. The book *Old Money* (New York, 1988) by Aldrich's great-grandson and namesake offers an intimate, candid and interesting picture of the senator and his distinguished descendants, including his daughter Abby (Aldrich) Rockefeller and her husband and Brown University alumnus and library donor, John D. Rockefeller Jr., both of whom are Rhode Island Heritage Hall of Fame inductees.

SPEAKER CHARLES E. GORMAN

Charles Edmund Gorman was Rhode Island's foremost constitutional reformer of the late nineteenth century. He was born in Boston on July 26, 1844, to an Irish immigrant father for whom he was named and a Yankee mother, Sarah Woodbury, who traced her Massachusetts ancestry to the Cape Ann colony of the early 1620s.

Gorman was three years old when his parents came to Providence. Despite a maternal lineage that later gave him the right of membership in the Sons of the American Revolution, his circumstances were such that he left school at age eleven to become a newsboy. Being of keen intellect, he fulfilled his ambition to study law and even secured a clerkship with former chief justice Richard W. Greene.

Gorman earned admission to the Rhode Island Bar on December 12, 1865, at the age of twenty-one, thus becoming the first Irish Catholic

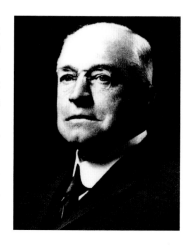

lawyer to achieve that status. From that time onward, he became the Irish Catholic pathbreaker—first state legislator (1870), first Providence city councilman (1875), first Speaker of the House of Representatives (1887) and first U.S. district attorney (1893). He ran as a Democrat for many other elective offices but was unsuccessful.

Throughout his legal career, Charles Gorman led the movement for constitutional change based on the principle of equal rights. He was instrumental in the legislative passage of the Bourn Amendment, despite the fact that it would work to the immediate political detriment of the Democratic Party, and he served on the three blue-ribbon commissions (1898, 1899 and 1912) that crafted reform constitutions that failed of adoption. In 1896, the legal lion whose formal education stopped at age eleven received an honorary Doctor of Laws degree from Georgetown University. In 1905, he was one of the principal draftsmen of the Court and Practice Act of 1905, which established the present Superior Court System and made the Supreme Court a predominantly appellate tribunal.

Gorman's most important legal foray was the publication of a learned treatise titled *An Historical Statement of the Elective Franchise in Rhode Island* (1879), a work that he effectively presented to the Congress of the United States to demonstrate that the prevailing Rhode Island suffrage system was at variance with the newly enacted Fifteenth Amendment to the U.S. Constitution. His invocation of that amendment foreshadowed twentieth-century U.S. Supreme Court interpretations of the provision as it relates to state suffrage laws.

Gorman was very active in various fraternal and cultural organizations. He was president of the Orestes Brownson Lyceum and a member of the Catholic Club, the University Club and the Sons of the American Revolution by virtue of his mother's ancestry.

In 1874, Gorman married Josephine Dietrich, with whom he had five children. Sadly, only one son was still living when Gorman died at his Providence home on February 16, 1917, at the age of seventy-two. He maintained a vigorous legal practice until his death and was referred to as Providence's oldest practicing attorney. Gorman is buried at St. Francis Cemetery in Pawtucket.

MAYOR EDWIN D. MCGUINNESS

Edwin Daniel McGuinness, the son of Irish immigrants Bernard and Mary (Gormley) McGuinness, was born in Providence on May 17, 1856. The family lived at 17 Walling Street, just off Charles Street in the city's north end. Edwin attended local public schools and graduated from high school in 1873. His father's success as a real estate broker combined with Edwin's talent for learning led to his acceptance at Brown University, where he earned his bachelor's degree with honors in 1877. McGuinness pursued his interest in law under the tutelage of Charles P. Robinson, Esq., and soon enrolled at Boston University Law School, graduating at the top of his class in 1879. Admitted to the Rhode Island Bar in July of that year, he established the partnership of McGuinness and Doran. These aspiring Irish American attorneys set up their office on 29 Weybosset Street.

The twenty-five-year-old McGuinness married Ellen T. Noonan on November 22, 1881, and settled into a home at 19 Pettis Street. They became the parents of one daughter, Mary Francis, who was born in Providence on October 15, 1882. Early on, McGuinness developed a keen interest in politics, and in 1885, at the age of twenty-nine, he was elected chairman of the Providence Democratic Committee. He was intelligent, personable and over six feet tall; therefore many, including Irish reform leader Charles E. Gorman, soon recognized Edwin's political potential. In 1887, McGuinness became the first Irish Catholic nominated for statewide office by receiving the endorsement for secretary of state. Running as part of a reform slate headed by "Honest" John Davis, the Democrats, including McGuinness, gained a surprising victory. He

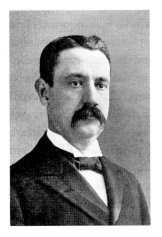

declined reelection in 1889 in order to enter the race for alderman from Providence's Third Ward. Successful once again, he served the citizens of this ward until January 1893.

His first attempt at the mayoralty in 1893 failed when he lost to Republican Frank F. Olney. In the following year, he lost once again to Olney, but this time by fewer than four hundred votes. The Irish Democrat was persistent, and on November 29, 1895, he defeated his Republican opponent, becoming the city's first Irish Catholic mayor. The following year, McGuinness gained reelection by a landslide, winning every election

district in the city, despite the fact that in the presidential race, Republican William McKinley carried the city by seven thousand votes in his contest with Democrat and Populist William Jennings Bryan.

Compared by some to his beloved predecessor, Mayor Thomas Doyle, McGuinness's popularity soared when he announced that he would administer the city in a nonpartisan manner. A tenacious reformer, McGuinness fought abusive practices by utility companies, particularly railroads. During his tenure, the 1848 Thomas Tefft–designed Passenger Depot (now the site of Burnside Park) was demolished after a fire and replaced with a five-building complex that included elevated railroad tracks.

McGuinness's community involvement included service as an adjutant and later as major of the Fifth Battalion of the Rhode Island Militia from 1879 until 1887. He was also a trustee of the Catholic Knights of America, president of the Orestes Brownson Lyceum for two years and a member of the Rhode Island Historical Society, the Providence Athletic Club, the Press Club and the Reform Club of New York.

Despite his robust appearance, the responsibilities of holding executive office took its toll. Late in his second term, McGuinness suffered a nervous breakdown and declined renomination in 1898. His health, however, continued to deteriorate, despite a trip to the South to assist in recovery, and on April 21, 1901, he succumbed to heart disease just before his forty-fifth birthday. He was buried at St. Francis Cemetery in Providence and was survived by his wife and his daughter. His obituary in the Republican-oriented *Providence Journal* called his tenure as mayor "the first great triumph here for independence in politics" and one that was "particularly commendable."

Colonel Robert Hale Ives Goddard

This book has been divided into chapters in which Hall of Fame inductees have been compartmentalized according to their major area of activity. Robert Hale Ives Goddard has been the most difficult to place. He had a distinguished Civil War military record; he ably administered a mammoth textile empire; and he used his economic power not for political aggrandizement but for political reform, working in concert with Irish American Democrats against a corrupt and discriminatory political system. No inductee profiled herein exceeded him in altruism and nobility of character.

Colonel Goddard was born in Providence on September 21, 1837, the son of Professor William G. Goddard, a newspaperman and first chancellor of Brown University, and Charlotte Rhoda (Ives) Goddard. Through his mother's line of descent, Goddard was related to the Ives family, who partnered with the Brown family in shipping, manufacturing, real estate and banking through the Providence firm of Brown and Ives. He was a Brown University graduate in the class of 1858.

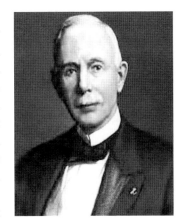

When the Civil War broke out, Robert volunteered, enlisted as a private and fought in the First Battle of Bull Run. Then he was mustered out of service but volunteered again a year later, this time serving as an aide on the staff of General Ambrose Burnside. He fought at the Battles of Fredericksburg, Cumberland Gap, Blue Springs and Campbell Station and at the Sieges of Knoxville and Petersburg, and he was present for Lee's surrender at Appomattox. While many of his generation and comparable station in life sought commissions as officers with slight military burdens, Robert Goddard worked his way up through the ranks and participated in some of the most dangerous battles of the war. His war record was a true military record.

Had he wished, Goddard could have hired a substitute, but he chose to shoulder his responsibility himself. His actions are all the more remarkable because his personal self-interest and that of his family were directly affected by the Southern cotton economy, which was decimated by the Civil War. Nonetheless, he defied the conventional wisdom of his textile business interests in the Lonsdale Company by going to war against the very cotton plantation economy so vital to his economic well-being.

Reentering private life, Robert became president of Goddard Brothers, the managing agents of the firm of Brown and Ives, with mills in Blackstone, Massachusetts, and in Smithfield and Warwick, Rhode Island. The deaths of his cousins, the Ives brothers, left the Goddards in charge of the vast family business enterprises.

Following the Civil War, the giant Lonsdale Company expanded its textile operations to the Cumberland villages of Ashton (1867) and Berkeley (1872) and at Lonsdale's Ann & Hope Mill (1886). In addition to these manufacturing ventures, Colonel Goddard was a prominent member of the board of the Rhode Island Hospital Trust Company and held controlling

shares in the Providence and Worcester Railroad, the line that served his Blackstone Valley mills.

Goddard returned to active service in 1874 as a military aide to Governor Burnside, retiring with the rank of colonel in 1883. Like many local Civil War veterans, Goddard engaged in several civic activities. Unlike many other business leaders with Civil War experience, however, he refused to accept the political bossism of Charles Brayton, dominating chairman of the Republican State Committee.

Goddard became a leader in the Progressive movement in Rhode Island at the turn of the twentieth century. Despite his Republican roots, he joined with Democrats Theodore Francis Green and Amasa Eaton in the short-lived Lincoln Party of 1906. Colonel Goddard served in the state Senate as an independent in 1907 and 1908, was a staunch supporter of Democrat Governor James H. Higgins and ran unsuccessfully as a Democrat for a U.S. Senate seat in 1907 in a three-way race against Samuel Pomeroy Colt and George P. Wetmore.

Those of his descendants who bear his exact name have, to this day, also distinguished themselves, both as prominent Rhode Island businessmen and public-spirited humanitarians.

Colonel Goddard died in Providence on April 23, 1916, and is buried at Swan Point Cemetery. In 1927, his son and daughter made one of the largest donations of parkland in the history of the state of Rhode Island—the nearly 490 acres of the Goddard Memorial State Park in the Potowomut section of Warwick—to honor their father's memory and accomplishments.

THE LAW MEN

CHIEF JUSTICE CHARLES S. BRADLEY

Charles Smith Bradley was born in Newburyport, Massachusetts, on July 19, 1819, the son of Charles and Sarah (Smith) Bradley. After attending Boston Latin School, he graduated first in his class at Brown University in 1838. He then obtained a master's degree from Brown and, eventually, a law degree from Harvard. He commenced the practice of law in Providence in 1841 in partnership with Charles F. Tillinghast Sr. and became known as an eloquent, persuasive and powerful advocate.

Bradley was elected to the Rhode Island Senate from North Providence in 1854, and he promoted, among other causes, an act providing amnesty to the participants in the Dorr Rebellion of 1842, even though he had supported the Charter government. Bradley routinely represented Rhode Island at the national conventions of the Democratic Party.

As a testament to his universally admired reputation, he was elected chief justice of the Supreme Court of Rhode Island in 1866 by a Republican majority, succeeding the famous Judge Samuel Ames. He filled this office with distinction for two years before resigning to devote more time to scholarship and his private business matters.

Bradley was a devout Episcopalian and a generous philanthropist. He helped to endow Rhode Island Hospital at its inception and delivered an address at its opening.

In the 1880s, Justice Bradley became a leading supporter of constitutional reform and a member of the equal rights movement of that era. In 1885, he wrote an impressive legal treatise titled *The Methods of Changing the Constitution of the States, Especially that of Rhode Island*, a work that rebutted the 1883 advisory opinion of the Rhode Island Supreme Court stating that the General Assembly had no power to call a constitutional convention. The essay prompted a rebuttal by Chief Justice Thomas Durfee. A 1935 advisory opinion of the Rhode Island Supreme Court in the aftermath of the Bloodless Revolution vindicated Bradley's position.

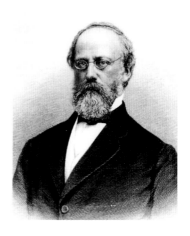

Justice Bradley's public life and its successes (apart from defeats as a Democratic candidate for Congress) contrasted sharply with his personal life. He was married three times, and all three wives predeceased him, as did several infant daughters. Two sons, who had grown to manhood, also predeceased him. When he died in New York City on April 29, 1888, at the age of sixty-eight, two of his sons, Charles and George, survived him. He was buried at Swan Point Cemetery.

Justice Bradley served as a lecturer and as Busey Professor of Law at Harvard Law School from 1876 to 1879. He became a nationally renowned public speaker whose oratorical talents were legendary. Bradley traveled widely and collected notable works of art.

Greatly loved and admired by the Rhode Island community, Justice Bradley was described by a friend and colleague as "[t]all, erect, manly and of commanding presence and figure. He was always dignified and commanded the respect of others wherever he moved."

Chief Justice Thomas Durfee

Thomas Durfee was born in Tiverton on February 6, 1826, the eldest son of Job Durfee, draconian chief justice of Rhode Island from 1835 to 1849. His father's influence marked Thomas from the outset for a career in law. His mother was Judith Borden, member of a prominent Fall River family.

Thomas completed his preparatory education at the East Greenwich Academy and graduated with honors from Brown University in 1846.

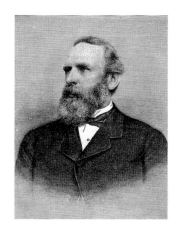

After studying law under the tutelage of Charles Tillinghast Sr. and future chief justice Charles S. Bradley, Durfee was admitted to the bar in 1848. He became the reporter of the Rhode Island Supreme Court from 1849 to 1853, succeeding James K. Angell, with whom he wrote a treatise on the *Laws of Highways* in 1857. In that year, Thomas married Sarah Jane Slater of Providence, a descendant of the noted textile manufacturer. The couple had only one child, Samuel Slater Durfee. Thomas served on the Providence Court of Magistrates from 1854 to 1860, the last five years of that tenure as chief magistrate.

Following the path of his famous father, he became Speaker of the Rhode Island House of Representatives in 1864. He moved to the state Senate in the following year, and within weeks, the legislature elected him an associate justice of the Rhode Island Supreme Court. He replaced George Brayton as chief justice in 1875. Both Brayton and Job Durfee had sat on the infamous trials of Thomas Wilson Dorr and John Gordon during the 1840s.

Thomas Durfee had a talent for writing and for oratory. According to one authority, "The state reports [of Supreme Court decisions] abound in examples of his powers as a writer of judicial opinions, and his contributions to the reports exceed those of any other judge in the history of the court" to that time. He was a staunch Republican and a defender of the political and constitutional status quo, as evidenced by his opposition to the equal rights movement of the 1880s.

Durfee had a strong interest in Rhode Island history and gained local fame as a writer and lecturer on such topics. One of his most notable efforts was the delivery of the major oration at the 1886 observance of the 250th anniversary of the founding of Providence. He also wrote and published poetry.

Durfee published several highly acclaimed articles and a volume of the works of his father. He was president of the Providence Public Library from 1891 until his death and an active member of the Rhode Island Historical Society. He maintained strong connections with Brown University, which conferred an honorary doctorate on him in 1875. Durfee was chancellor

of Brown from 1879 to 1888 and a fellow of the university until his death from heart failure on June 6, 1901, at the age of seventy-five. His Providence home at 49 Benefit Street, where he died, was ideally located to facilitate his continual involvement with Brown, the historical society and the court. Durfee is buried with his wife at Swan Point Cemetery.

CHIEF JUSTICE JOHN HENRY STINESS

John Henry Stiness was born in Providence on August 9, 1840, to a family with strong New England civic and military roots. His great-grandfather Samuel served in Colonel John Glover's famous maritime regiment from Marblehead, Massachusetts, during the American Revolution, and his grandfather was sailing master aboard the schooner *Growler* on Lake Ontario during the War of 1812.

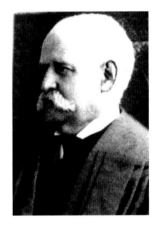

Stiness entered Brown University in 1857. Near the end of his senior year, the Civil War began. In response to the crisis, he accepted a commission as a second lieutenant in the Second New York Artillery, eventually seeing Civil War action at the Second Battle of Bull Run. He was discharged honorably on a physical disability in 1862, returned to Providence, studied law in the offices of Benjamin Thurston and was admitted to the bar in 1865. He married Maria E. Williams, a descendant of Rhode Island's founder, in 1868.

This rise of John Stiness in the profession of law was rapid. After one term in the state House of Representatives, he was appointed associate justice of the Rhode Island Supreme Court in 1875, only ten years from the date of his admission to the bar. After a quarter century of distinguished service, he gained the position of chief justice, remaining in that office from 1900 to 1904. As the chief, he championed the modernization, restructuring and independence of the judiciary.

During his exemplary career, Stiness became involved in myriad causes and endeavors. He chaired the Providence Charter Revision Committee and the special committee on locating and building the Providence County Courthouse. He served as president of the Rhode Island Historical Society,

chaired an international arbitration conference, was president of the Brown Alumni Association and of the Providence Humane Education Society, was active in the Episcopal Church and promoted the cause of international peace through arbitration between nations at the Lake Mohonk Conference in New York.

After his retirement from the bench, Justice Stiness chaired the seven-member blue-ribbon commission that recommended the Court and Practice Act of 1905—a measure crafted principally by Stiness, Amasa Eaton and Charles E. Gorman that forms the basis of Rhode Island's present judicial system. Stiness is best known today for his authorship of "The Struggle for Judicial Supremacy," a lengthy history of the Rhode Island court system published in Edward Field's cooperative history of Rhode Island in 1902. He also wrote a history of Rhode Island's lotteries.

Justice Stiness died on September 6, 1913, at the age of seventy-three in his home at 210 Governor Street in Providence from a variety of ailments. He is buried at Swan Point Cemetery. Stiness was survived by his wife, Maria; his daughter, Flora Tilden; and his son, Henry.

BENJAMIN F. THURSTON

One of America's premier patent lawyers, Benjamin Francis Thurston was born in the town of Hopkinton on November 7, 1829. He was the son of Harriet E. Deshon, who died when he was three, and Benjamin Babcock Thurston, who served as lieutenant governor of Rhode Island and as a U.S. congressman from 1847 to 1849 and again from 1851 to 1857.

Benjamin Francis graduated from Brown University with the class of 1849, studied law at Harvard and in 1851 began the practice of law in Providence. He quickly became known for his trial and oratorical talents. His brilliance and leadership skills led him to the state legislature, where he gained the office of Speaker of the House in 1854, 1856–57 and 1864–65. He also served as a Republican in the state Senate in 1868–69.

Thurston's talents were not confined to Rhode Island after he developed a specialty in patent law. Because industrial Rhode Island registered more federal patents per capita than any other state, this area of practice became Thurston's main source of clients. Among those clients were Thomas Edison (for some electrical inventions), George Pullman of the Pullman Palace Car Company of Illinois and numerous railroad corporations. He also

The Benjamin Thurston memorial in Swan Point Cemetery.

represented many Rhode Island inventors, including George Corliss. As one contemporary observed, he was widely sought after in patent infringement cases "not only for his consummate ability as a lawyer, but because of his comprehensive knowledge of engineering and mechanics, and his capacity to grasp the most intricate and involved points of an invention."

Thurston served as president of the Republican and Independent Club of Providence, as a member of the Brown Corporation, as a vestryman of Grace Episcopal Church and as a trustee of the Providence Public Library. His alma mater, Brown University, conferred an honorary doctorate on him (LLD) in 1888, the year he delivered an oration to the Brown Alumni Association titled, "The Relation of the College to the Republic."

Thurston frequented New York City to visit business clients and mingle with the financial leaders of the day. He died at the University Club in that city on March 13, 1890, at the age of sixty and was buried at Swan Point Cemetery. He was survived by his wife, Cornelia Rathbone, whom he married on May 9, 1853, and one of their two children.

Amasa M. Eaton

Amasa Mason Eaton was a prominent Providence attorney who might be described as the quintessential Progressive reformer. His distinguished lineage included Providence's Brown family and the Herreshoffs of Bristol. He was born on May 31, 1841, in Providence, the son of Levi Eaton and Sarah (Brown) Eaton.

Eaton graduated from Brown University in 1861, fought with the First Rhode Island Volunteers in the Civil War and served as a state representative from Providence in 1865 and 1866 and again from 1872 to 1874. Then he studied law at Harvard, receiving his degree in 1878. He was elected president of the Rhode Island Society of the Sons of the American Revolution in 1893.

Amasa was an outspoken advocate of home rule for Providence to free it from legislative control. He was a member of the Metropolitan Park Commission, the Blackstone Neighborhood Improvement Association and various good-government organizations. He supported the local equal rights movement of the 1880s and advocated the implementation of the merit system and civil service reform. In one reformist essay, he stated that "the routine business of government should be conducted on business principles" and "officeholders should be appointed on account of their fitness for the work to be done."

State constitutional change was Eaton's major concern. In 1899, he wrote a learned 128-page tract titled *Constitution-Making in Rhode Island*. It traced the history of his subject and made numerous recommendations for

reform, including women's suffrage, removal of all property qualifications for voting, a strengthening of the governor's powers and municipal home rule. From 1903 to 1905, he played a leading role in advocating the establishment of Rhode Island's modern court system through his strenuous advocacy of the Court and Practice Act of 1905 in conjunction with fellow reformer Charles E. Gorman and Justice John Henry Stiness.

On the national stage, Amasa was a member of the Commission on Uniform State Legislation, serving as its president from 1901 to 1910. He also held the post of first vice-president of the National Divorce Congress during 1906–7.

Attorney Eaton was such a persistent advocate of political, legal, constitutional and social improvements that in the breadth of his reformist zeal, he resembled Thomas Wilson Dorr. Undoubtedly it was this self-perceived similarity that led Eaton in 1908 to write an extensive (fifty-three-page), accurate and highly favorable biographical sketch of Dorr for William Draper Lewis's multivolume *Great American Lawyers* series. In 1913, he published his final book, *Free Trade and Protection*.

Eaton married Maude Dunnell of Pawtucket in 1878. The couple had no children. He died on October 3, 1914, at Rhode Island Hospital of post-operative complications from hernia surgery and was buried at Swan Point Cemetery. His wife survived him. The couple lived at 701 Smith Street in the Elmhurst section of Providence. Eaton Street, near his home, is named in his honor.

V

THE CLERGY

BISHOP THOMAS F. HENDRICKEN

Bishop Thomas Francis Hendricken was born in Ireland just outside the town of Kilkenny, County Leinster, on May 5, 1827. His father, John, descended from a German officer named Hendricken who fought at the Battle of the Boyne in 1690 for the Catholic cause of deposed King James II, was a cottier who scratched an existence from the unyielding soil for his wife and six children. His death left eldest son, James, head of the household. He worked together with his mother and the younger children to maintain the farm. Their efforts were aided by the generosity of a Kilkenny merchant, James Fogarty, who had married Mrs. Hendricken's sister. Impressed by Thomas's studious nature, Fogarty and his wife took a special interest in him and promoted his formal education. Enrolling at St. Kiernan's College (Kilkenny) in 1844, Thomas excelled in his studies, particularly English literature, which became his lifelong interest. Three years later, he entered Maynooth, the Irish national seminary, to begin his journey to the priesthood.

The future bishop was an idealist who dreamed of joining the Jesuits and laboring for God in the missions of China and Japan. His goal was changed by a fateful encounter at Maynooth in 1852 with Bernard O'Reilly, bishop of Hartford—head of a diocese that then included Connecticut, Rhode Island and southeastern Massachusetts but had its seat in Providence. Hendricken's resultant decision to head west instead of east was the turning point of his life.

Father Hendricken may well have second-guessed the wisdom of his choice after his initial experiences on board the steamer *Columbia*, bound for the United States early in 1854. One of the female passengers, dying of a contagious disease, desired the last rites of the church. Wishing to bring her the consolation of religion, the young priest was confronted by the ship's officers and crew, who refused to allow him access to the woman. In spite of their warnings that contact with the unknown disease might endanger both passengers and crew, Hendricken insisted on comforting the unfortunate woman. Fearing contagion and professing hatred for his religion and nationality, the crew became enraged at this tenacity and decided to teach him a lesson. After beating him senseless, they were about to cast him overboard when a fellow passenger to Rhode Island, Reverend Samuel Davies, a young Protestant clergyman from Germany, "interposed and rallied a lot of the German emigrants on board to the priest's rescue…and nursed him back to life."

This experience, coming at the height of Know-Nothing intolerance, was a cruel initiation into American life for the immigrant priest. It did, however, result in establishing a lifelong friendship between Hendricken and his benefactor. Reverend Davies eventually became superintendent of the Workingman's Home in Providence, and during the Hendricken episcopacy, the bishop would substantially aid his friend's charitable endeavor.

The first few months of his ministry in Rhode Island were hectic. Bishop O'Reilly, a man who shifted his clergy frequently, appointed Hendricken first to the cathedral, then to St. Joseph's in Providence, to St. Mary's in Newport and finally to St. Joseph's Church in Winsted, Connecticut, a rural parish covering a fifty-mile area. Once settled in this parish, Father Hendricken employed the exceptional administrative and organizational ability that was to mark his entire priestly life. In the sixteen months before being reassigned, he was able to pay off the substantial debt on the church and secure eight additional church sites through the purchase of lots in the scattered villages of his parish.

In July 1855, Hendricken received an appointment that was to last seventeen years. Named as pastor of St. Patrick's in Waterbury, Connecticut, he built a religious complex that became the model

parish of its diocese. The youthful pastor, with characteristic zeal and administrative expertise, employed the foremost church architect of the day, Patrick Keely, to erect a new edifice for his growing congregation. Completed in three years, the Gothic structure was the most impressive church in the area. Dedicated by Bishop Patrick McFarland and renamed the Immaculate Conception in honor of the Blessed Virgin, it was the first church in the United States to bear that title following the papal pronouncement of 1854 regarding that miracle.

In rapid succession, Hendricken followed up this initial success with a series of notable accomplishments. Turning first to education, he began teaching the children of the parish in an effort to develop a school. It was an impossible task in light of his many duties as the only priest in the community. Therefore, he invited the Montreal-based Sisters of the Congregation of Notre Dame to Immaculate Conception. Their acceptance resulted in the establishment of a day and boarding school for girls.

For his accomplishments, Hendricken received several honors. In 1868, Pius IX named him a doctor of divinity. Earlier, he had refused a promotion tendered by Bishop McFarland. In his journal, he stated his feelings simply: "I am now satisfied that I will best do the will of God by remaining quietly working and doing whatever good I can, where His will has placed me."

When the bishops of the Province of New York deliberated on whom to nominate as first bishop of the new diocese of Providence, an 1872 offshoot of the Hartford diocese, they agreed that Hendricken "was the most fitting candidate in every respect, health alone excepted." Archbishop John McCloskey disregarded Hendricken's physical infirmity—a severe asthmatic condition—with the startling rationale that "the labors of the new diocese would not be very onerous."

Hendricken did not record his sentiments when he learned of his elevation to the episcopacy, but to judge from the reaction of citizens of Waterbury, he must have been saddened to leave. The *Waterbury American* spoke for the community at large by praising his "urbanity and ability."

On April 28, 1872, amid all the religious splendor of the church, Father Hendricken was ordained the first bishop of Providence by his sponsor, Archbishop John McCloskey of New York. The immigrant priest who had barely survived his voyage to the United States was now a bishop of his church. Reverend Thomas M. Burke, OP, a moving force in the Devotional Revolution that had reinvigorated the church in Ireland, preached at the ceremony. His presence in Providence that day symbolized in many ways the direction the new diocese would follow.

Under Bishop Hendricken—whose fourteen-year episcopacy would be marked by strong leadership, immigrant assimilation and social involvement—the Diocese of Providence expanded physically and witnessed the growth of educational institutions and religious orders. In an indefinable way, the eloquent Burke and the zealous Hendricken represented all that made late nineteenth-century Irish Catholicism so vibrant. Their joint appearance on that crisp April day in 1872 crowned nearly a half century of steady progress against adversity and foreshadowed a much longer period of growth and vitality.

Hendricken was a "brick and mortar" bishop, one concerned with establishing the physical presence of the church. His principal project was the construction of the magnificent Cathedral of Saints Peter and Paul, to which he devoted many years of his administration. Ironically, he died on the eve of the cathedral's completion, and his funeral and burial was the first event held in that elegant structure. Hendricken's "Cathedral dream" was a manifestation of the spirit of devotion and self-sacrifice that characterized the faithful of his diocese during the late nineteenth century. Today, his memory is best preserved by the prominent and highly rated Warwick high school that bears his name.

BISHOP WILLIAM STANG

William Stang was born on April 21, 1854, in Langenbrücken, in the Grand Duchy of Baden, Germany. He studied for the Catholic priesthood at Louvain in Belgium and was ordained on June 15, 1878. Little else is known of his early life.

Irish-born bishop Thomas F. Hendricken (whose surname indicates his German ancestry) sought a German-speaking priest for the small but growing German community in the Diocese of Providence. His eventual choice was young William Stang, who began his designated diocesan ministry in late 1878. By the following March, Stang had begun holding prayer services and instruction for German Catholics in the old Providence cathedral. Stang moved upward rapidly because of his great ability and also because of his cordial relations with the Irish American hierarchy (one of his many publications was a pamphlet entitled "Germany's Debt to Ireland").

Notwithstanding his efforts, Stang was unable to establish a German national parish in Rhode Island because German Catholics "were not yet

wealthy or numerous enough to build a church," according to an 1886 religious survey. In addition, they tended to disperse rather than congregate in a particular neighborhood or village.

Despite this disappointment, Stang's great talent and intellect led him down other paths. When Matthew Harkins became bishop in 1886, Stang, already a pastor, became one of his principal advisors. He was appointed the rector of the new Cathedral of Saints Peter and Paul. He then became

a major force in the establishment of St. Joseph's Hospital in Providence, serving as that institution's treasurer and principal fundraiser.

On March 19, 1895, the Feast of St. Joseph, Harkins blessed the new building. Three days later, Stang left for Louvain, where he had been summoned to teach pastoral and moral theology. At the urging of Bishop Harkins, Stang was returned in June 1899 to Providence, where he resumed supervision of the hospital while working with the diocesan mission band and performing pastoral duties. He continued these various tasks until his ordination as the first bishop of the new diocese of Fall River in May 1904, when this see was created from the Massachusetts sector of the Diocese of Providence.

Bishop Stang's reception in Fall River was enthusiastic, with an estimated twenty-five thousand people staging a "monster demonstration" of welcome. During his brief tenure, Stang would establish a total of thirteen parishes, seven of them national. First among the latter was the Portuguese church of Espirito Santo in Fall River. Most gratifying was the German church of St. Boniface in New Bedford. Although he supported the use of national parishes for cultural purposes, Stang opposed divisive nationalism.

During his episcopacy and with his support, St. Anne's Hospital was founded and staffed by the Dominican Sisters of the Presentation. The bishop also wrote three Lenten pastoral letters and other essays.

Stang's most significant literary and philosophical effort was a scholarly book titled *Socialism and Christianity* (1905), in which he condemned socialism while defending the rights of workers. He recognized the legitimacy of the laborers' claim to a fair share of the wealth that they created, supported the trade union movement as a means to achieve social justice and acknowledged labor's right to strike as a last resort "to restrain the despotism of capital."

In January 1907, Stang traveled to the Mayo Clinic in Rochester, Minnesota, for a risky surgical procedure to remove an intestinal tumor. Despite the apparent success of the operation, which was performed by Dr. William Mayo himself, the bishop developed a serious infection and died at St. Mary's Hospital in Rochester on February 2, 1907, at the age of fifty-two.

Bishop Stang's name is honored today by a high school in North Dartmouth not far from the German parish that he established in New Bedford during his all-too-brief episcopacy. His body was returned from Minnesota to Fall River, where he was laid to rest in the crypt of the Bishop's Chapel in the Cathedral of Saint Mary of the Assumption.

Monsignor Charles C. Dauray

Monsignor Charles Casimir Dauray, who was regarded by his contemporaries as the dean of Catholic clergy in the Diocese of Providence, was born in Marieville, Quebec, on March 15, 1838. At the age of thirty-two, he was ordained a priest and assigned to teach at a local college.

Dogged by ill health and overwork, Dauray was granted a leave of absence and traveled southward to his brother's home in Pawtucket, Rhode Island, to recuperate. Soon, he began to immerse himself in the spiritual needs of the rapidly growing French Canadian population in that city. Recognizing his talent and leadership ability, Providence bishop Thomas Hendricken convinced the young priest to "stay a little longer" to help establish a French church in nearby Central Falls. Dedicated on October 2, 1875, Notre Dame du Sacre Coeur became Rhode Island's first Catholic church completed and occupied exclusively by French Canadians.

In December 1875, the bishop prevailed on Dauray to complete the building of another French national parish church in Woonsocket. Two months after his arrival, however, a severe windstorm destroyed the partially constructed edifice. Undaunted and with fierce determination, Dauray persisted and celebrated the opening of the impressive Church of the Precious Blood in 1881. It was here that the tall, dignified, widely respected priest would remain for the next half century.

By the time of his death in February 22, 1931, three weeks before his ninety-third birthday, Dauray had been directly involved in the construction of many French churches (six in Woonsocket alone), a French high school (Mount St. Charles), convents, elementary schools, academies, an orphanage and a home for the aged. He also played a leadership role in the establishment of several French Canadian cultural organizations. In 1918, Pope Benedict IV conferred on Father Dauray the title of "Monsignor." A short time later, the French government awarded him the Cross of the Legion of Honor for his efforts in the Great War.

Monsignor Dauray's remains are buried at the base of Precieux-Sang (Precious Blood), his beloved Woonsocket church. As a testimony to his importance, Dauray's funeral was celebrated by four bishops and witnessed

by more than three hundred priests and an overflow crowd that spilled into the local streets. Bishop Hendricken's fateful decision to "adopt" Father Dauray as a priest of the diocese continues to pay a handsome spiritual dividend for the Franco-American community in Rhode Island.

Monsignor Dauray's pioneering role in the development of Franco-American Catholicism in the Diocese of Providence from its inception in 1872 has made Dauray that community's preeminent priest. His life and achievements prompted Congressman Ambrose Kennedy, also a Hall of Fame inductee, to write his biography in 1948. This detailed work is appropriately titled *Quebec to New England: The Life of Monsignor Charles Dauray.*

REVEREND MAHLON VAN HORNE

Reverend Mahlon Van Horne had a career that ranged from minister of the gospel at the black Union Congregational Church at Newport to minister of diplomacy as United States consul to St. Thomas in the West Indies when that island was owned by Denmark.

Born in Princeton, New Jersey, on March 5, 1840, the son of Mathias and Diana Van Horne, he graduated from Lincoln University. This school was America's first institution of higher education for African Americans in Pennsylvania. After graduation, Mahlon taught school at Huntington, Long Island, and Charleston, South Carolina, where he was principal of the Zion School. He was ordained a minister of the African Methodist Episcopal Church in 1866. Arriving at the Union Congregational Church in Newport in 1869 as its first permanent pastor, he served the congregation for the next twenty-eight years.

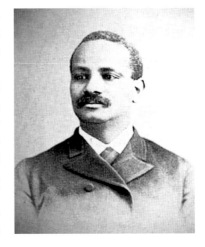

Under his pastorate, which was noted for its fine sermons, the congregation moved from its old quarters to a new building at 49 Division Street. It had been erected over a previous structure rented from the First Congregational Church, a group once under the direction of Reverend Samuel Hopkins, an eighteenth-century abolitionist and a Hall of Fame

inductee. Van Horne led the new building campaign as the congregation swelled to 223 members.

With the help of Newport restaurateur and philanthropist George Downing, Van Horne became the first person of color to sit on the Newport School Committee, a post he held for nearly twenty years. For twelve of those years, he chaired the committee on textbooks. He was also Rhode Island's first black member of the General Assembly, serving three successive one-year terms from 1885 to 1887 as a Republican.

Although Downing led the statewide effort to integrate all the public schools, Van Horne joined him in a letter-writing campaign to the Newport and Providence newspapers to explain the new civic role of blacks under the Fourteenth and Fifteenth Amendments to the U.S. Constitution. He also took part in the Colored Union Labor League—a group that helped freed slaves gain employment skills—and taught school in Newport.

In the state legislature, Van Horne frequently reminded legislators that black men had defended American liberties from the time of the American Revolution to their recent sacrifices in the Civil War.

President William McKinley recognized Van Horne's public service in 1897 by appointing him the U.S. consul to the island of St. Thomas in the Danish West Indies (now part of the American Virgin Islands). During the Spanish-American War in 1898, Van Horne was instrumental in preventing the Spanish fleet from purchasing much-needed coal in St. Thomas for its operations in Cuba. Van Horne, who remained as a consul until 1903, advocated for the American purchase of the Danish West Indies—a wish that was fulfilled in 1917. He later became a missionary in Antigua; he died in the West Indies on May 25, 1910. His son, Alonzo, graduated from Howard University's medical school and became Rhode Island's first black dentist.

REVEREND ANNA (GARLIN) SPENCER

Anna (Garlin) Spencer was born in Attleboro, Massachusetts, on April 17, 1851, but spent her formative years in Providence. She was the daughter of Francis W. Garlin, a town clerk, and Nancy Mason Carpenter, an abolitionist. Her embrace of progressive causes and her quest for social justice can be traced to her zealous mother and an aunt who worked with the homeless.

Anna began to write for the *Providence Journal* at age nineteen and worked at the newspaper for eight years. She was also a Providence public school teacher from 1869 to 1871. She would employ her writing and teaching skills throughout her reformist career.

In 1878, Garlin married Reverend William H. Spencer, a Unitarian minister, and left Rhode Island with her husband to preach and teach. Returning in 1888, she became actively involved with the nondenominational Religious Society of the Bell Street Chapel and soon published the writings of its founder, the philanthropist James Eddy. On March 16, 1891, she made history when she was ordained as a minister, the first woman in Rhode Island to attain that distinction. She led the Bell Street Chapel for more than a decade, until 1902, and upon leaving that ministry wrote *The History of the Bell Street Chapel Movement* (1903).

By that time in her life, she was already a veteran feminist, participating in a wide range of causes centered on the rights of women. She had also become a confidante of many prestigious national leaders.

During her Rhode Island years, Spencer served as the president of the Rhode Island Equal Suffrage Association, helped to establish the Society for Organizing Charity in Providence and worked for the regulation of child labor and factory safety. As a board member of the Rhode Island State Home for Dependent Children, she chaired the International Congress of Charities, Correction, and Philanthropy, held as an adjunct to the 1893 World's Columbian Exposition in Chicago, and she later edited its proceedings.

While operating on the national scene, she helped found the Women's Peace Party in 1915 and led the National Council of Women in 1920. She was also a founding sponsor of the National Association for the Advancement of Colored People (NAACP) in 1909 and an officer in the Free Religious Association.

Anna, who was an accomplished public speaker, taught at a number of institutions after 1902, including the University of Wisconsin, Meadville Theological School in Chicago and Columbia University. She authored several books about women and family relations and wrote a seminal article

in 1913 on the role of older women, "The Social Use of the Post-Graduate Mother." While in New York she became part of the influential Society for Ethical Culture and the School of Philanthropy. Her association with the former, however, was short-lived because its genteel leaders found her public demeanor "unwomanly" and also objected to her suffrage activities.

Anna participated in efforts to encourage temperance and abolish child labor, and she engaged in several social work programs. At the time of her death on February 12, 1931, at the age of seventy-nine, she was a special lecturer in the social sciences at Columbia University.

Swarthmore College has microfilmed most of her papers, including material relating to her Rhode Island years. They are located in the school's Peace Collection. Few Americans, male or female, so embodied the progressive spirit characteristic of late nineteenth- and early twentieth-century liberalism as Anna Garlin Spencer. Her impact on Gilded Age Rhode Island was profound.

VI

PHYSICIANS

Dr. Edwin M. Snow

Dr. Edwin Miller Snow was born in Pomfret, Vermont, on May 8, 1820, the son of Nathan Snow, a merchant, and Rhoda (Miller) Snow. He received his early education in the Pomfret common schools and prepared for college at Kimball Union Academy in Meriden, New Hampshire, and at the New Hampton Academic Institution. Like many out-of-state men with talent and ambition, Snow was attracted to Rhode Island by Brown University, where he enrolled in September 1840. An eye infection slowed his academic progress, but he graduated in 1845.

In 1847, Snow engaged in medical studies with Dr. W.D. Buck in Manchester, New Hampshire, and then studied at the College of Physicians and Surgeons in New York City, graduating in March 1849. After a brief stay in Holyoke, Massachusetts, Dr. Snow returned to Providence in November 1850 to begin a thirty-eight-year career that included work in such areas as public health, vital statistics, demography and prison reform.

In May 1850, he married Ann Pike of Providence, by whom he had two children that survived to adulthood. Two years later, Dr. Snow became clerk of the First Baptist Church, a position he held for the remainder of his life.

Snow's first major health problem was the deadly Providence cholera epidemic of 1854, which led him to study the connection between the disease and conditions of filth. His analysis led to the creation of a municipal health department in 1856. Snow was appointed its superintendent, a post

he held until 1884. During that span, and until 1888, he also served as Providence's registrar of births, marriages and deaths.

In 1863, as the Civil War raged, Snow was appointed an inspector of hospitals by the U.S. Sanitary Commission. He spent several weeks examining the military hospitals in the Philadelphia area and those established after the deadly Battle of Fredericksburg in Virginia.

Registrar Snow distinguished himself as a statistician, serving as superintendent of the state censuses of 1865 and 1875, tallies instituted to monitor the immigrant influx. He was also the supervisor of the Rhode Island federal census of 1880. Snow's ability

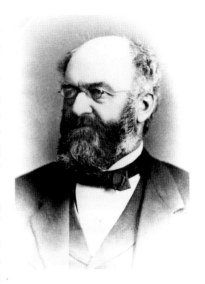

earned him a federal appointment as delegate to the International Statistical Congress, held at St. Petersburg, Russia, in August 1872.

Dr. Snow was also a leading advocate of prison reform. From May 1866 to May 1869, he was the state prison inspector. Then he served as a member of the National Prison Conference in 1870 and as the Rhode Island delegate to the International Prison Congress held in London in July 1872. From 1874 to 1876, he chaired the commission that built the new state prison in Cranston.

Dr. Snow was also active in purely medical affairs. He was a consulting physician at Rhode Island Hospital from its inception in 1869, president of the Rhode Island Medical Society in 1876–77 and secretary of the Providence Medical Society for several years.

Snow's national stature was evident when he became one of the original founders of the American Public Health Association in 1872. He was elected vice-president of that organization from 1872 to 1874 and then assumed its presidency in 1875–76.

In the field of public health, Dr. Snow wrote numerous reports dealing with such diseases as smallpox and cholera, as well as various aspects of municipal sanitation. Under Snow's direction Providence became one of the first cities in America to mandate vaccination for smallpox as a requirement for school enrollment.

Snow's immediate successor in 1884 as Providence's superintendent of health was the equally able and prominent Dr. Charles V. Chapin,

whose work through the first quarter of the twentieth century won him national respect and acclaim. Chapin and Snow both earned Hall of Fame induction for their outstanding service in the fields of public health and communicable diseases.

Dr. Snow died in Providence on December 22, 1888, of heart disease at the age of sixty-eight. He was buried at Providence's North Burying Ground.

DR. ANITA E. TYNG

Anita E. Tyng, the daughter of Charles A. and Anna A. (McAlpine) Tyng, was a medical doctor and surgeon. She was born in Massachusetts on February 4, 1838. Her father's ancestors dated back to the early years of the Massachusetts Bay Colony.

Little is known of Anita's childhood or adolescent years. What is known is that she studied at the New England Hospital for Women and Children in Boston and then earned her MD from the Women's Medical College of Pennsylvania in 1864. The title of her doctoral thesis was "Ulceration and Ulcers."

Returning to Boston, she worked in private practice as a surgical assistant to Horatio Storer before joining the staff of the New England Hospital for Women and Children as its first woman staff member, but she was not admitted to medical practice. With the experience gained in these jobs, she moved to Providence, where there was no sufficiently educated woman practitioner. There in 1870, she applied to the venerable Rhode Island Medical Society for admission, but her initial application failed to receive a two-thirds affirmative vote and was therefore rejected. Undaunted, she tried again in 1872, and on December 18, she became the first woman to be admitted as a fellow of the society. Even the propriety of that election was questioned, but it was resolved in her favor by a committee headed by Dr. Edwin Snow.

At the society's annual meeting in 1882, ten years after her path-breaking acceptance, Dr. Charles W. Parsons glowingly described Tyng as the medical society's first "soror-socius" (sister-member) and then remarked in a tribute to Tyng, "If we are to have women doctors at all, do let us have well-educated ones, and if this society does anything to keep up the standard let them and their patients have the go of it." He also noted "the contrast between the action of this society and our brothers in Massachusetts, who have not yet opened their doors to women."

The opening of Rhode Island Hospital in 1868 was soon followed by the arrival of Anita Tyng to Providence.

Dr. Tyng's thirteen-year tenure in Rhode Island was productive. She ran a successful practice that included gynecological surgery. She was not only a skilled surgeon but also the author of illuminating medical essays and a contributor to the development of the library of the Rhode Island Medical Society.

In the late 1870s and early 1880s, she mentored a number of young women physicians. She was an early advocate of women in medicine and urged the study of women's health. In a paper she delivered to the alumnae of the Women's Medical College of Pennsylvania in 1880, she called for a concerted effort by women physicians to investigate female health.

According to Dr. George H. Hersey, who wrote her eulogy, Dr. Tyng's most famous case was "one of removal of the ovaries by abdominal section to check the growth of a uterine fibroid." This operation was performed in January 1880 in Providence with only women aides in the operating room,

"all of whom had carefully bathed with carbolized water and wore fresh, clean calico dresses."

While in Providence, Dr. Tyng also addressed several medical societies on scientific topics and reported on some of her "interesting cases." For the 1881 annual report of the Rhode Island State Board of Health, she contributed a judicious essay on heredity and one on "The Causes of Ill Health in Women." In 1874, she wrote a learned analysis of eclampsia, a condition in which one or more convulsions or seizures occur in a pregnant woman suffering from high blood pressure or in a mother who has just delivered, often followed by a coma. This condition, though rare, still poses a grave threat to the health of both mother and baby.

In 1883, Dr. Tyng returned to Philadelphia to teach and practice surgery at her alma mater. The adventuresome physician then journeyed to Florida, to Cuba as a missionary and, finally, to California, where she died in Berkeley on October 16, 1913, at the age of seventy-five. She was cremated—a practice unusual for that time.

Anita was never married, except to her profession. While in Providence, she was a devout communicant of Grace Episcopal Church and was involved in a number of Episcopalian societies during her time in California.

VII

THE LITERATI

Secretary of State John Russell Bartlett

The Rhode Island Heritage Hall of Fame has developed a tradition of listing its inductees by the title of their highest public office or by the title "Dr." if they have earned that distinction in their chosen field of endeavor. John Russell Bartlett's title, though prestigious, only begins to embrace his many notable achievements. Clearly Bartlett was Rhode Island's greatest secretary of state and the one who most expanded and fulfilled the historical duties of that office, but there is more to his career than the holding of a mainly ministerial political position.

Bartlett was born in Providence on October 23, 1805, the second of the six children of Smith and Nancy (Russell) Bartlett. Shortly after his birth, his parents took the family to the Canadian town of Kingston, at the eastern end of Lake Ontario, where Smith Bartlett established a thriving mercantile business and where this American family weathered the War of 1812. One of the five American diplomats who negotiated the Treaty of Ghent, ending the conflict, was Providence-born congressman Jonathan Russell, Nancy's cousin, who is also a Hall of Fame inductee.

Bartlett was raised in Kingston, where he received his early education prior to studying for two years at Lowville Academy in upstate New York and then receiving a year of private tutoring in Montreal. In 1824, when he was eighteen, he returned to Providence and worked for several years as a clerk in his uncle's dry goods store on Westminster Street opposite

from where the Arcade was being built by developer Cyrus Butler. When Bartlett's uncle moved his shop to the Arcade, Butler became acquainted with young John and offered him the position of clerk in Butler's Bank of North America, also located in the Arcade. By 1831, Bartlett had persuaded Butler to open a library and reading room on the building's second floor. This facility soon evolved into the prestigious Providence Athenaeum, which Bartlett not only helped to found but also supported throughout his life.

During his twelve-year association with Rhode Island from 1824 to 1836, Bartlett left the employ of Butler to become a cashier at the Globe Bank, which was owned by the William Sprague family. In 1831, the year he assumed his new post, he married Eliza A. Rhodes of Pawtuxet, the sister of Colonel Elisha Rhodes, by whom he had seven children prior to her death on November 11, 1853. Until 1836, the couple lived in an apartment above the bank.

Bartlett embarked on a much more exciting career than that of store clerk or bank cashier when he began to paint and draw during his early years in Providence. Around 1835, he produced his most famous local image, *The Great Gale of September 1815*, an oil painting depicting the raging waters of the Providence River inundating Market Square. In addition, his association with the Athenaeum, the Franklin Society and the Rhode Island Historical Society put him in contact with the young bibliophile John Carter Brown and launched Bartlett into the world of books.

In 1836, Bartlett took a more lucrative bank position in New York City, but the bank dissolved in the Panic of 1837. In the late 1830s, he was active in the revival of the nearly defunct New York Historical Society, and in 1843, he entered the book business with Charles Welford. This duo marketed large consignments from prominent London bookseller William C. Hall and books from their own searches. Bartlett later claimed that his firm was "the first to keep a large stock of choice old books in every department of literature, hence our establishment was the resort of literary men not only from New York, but from all parts of the country." Prominent among his regular clientele were Albert Gallatin and James Fenimore Cooper. Not content merely with selling

books, however, Bartlett began to write. With Gallatin, former secretary of the treasury under Jefferson and Madison, Bartlett was prominent in the formation of the American Ethnological Society, an organization created to further the study of primitive cultures. He contributed to this scholarly endeavor as the society's corresponding secretary by publishing a book titled *Progress of Ethnology* in 1847. He followed this work a year later with his most commercially successful volume, the still valuable *Dictionary of Americanisms: A Glossary of Words and Phrases Usually Regarded as Peculiar to the United States* (1848, revised edition 1857), which was later translated into Dutch and German.

In 1850, Bartlett sought other work for health and financial reasons. His political and scholarly connections brought him an appointment as the American commissioner of the Mexican Boundary Survey, a task necessitated by the American acquisition of a huge area from Mexico in its Treaty of Guadalupe Hidalgo, which had ended the Mexican-American War. This post afforded Bartlett an opportunity to combine ethnological and scientific exploration with his artistic skill. During his two-and-a-half-year tenure in the U.S.-Mexico borderlands, Bartlett sketched the terrain, collected specimens of plants and animals and studied the languages, artifacts and cultures of the southwestern Native Americans. He published his observations at his own expense in his *Personal Narrative*, a two-volume work that appeared in 1854 and remains a study of great scholarly merit. It is described by Robert V. Hine, a leading historian of the American West, as "a vivid, literate account of enduring value to scholars and naturalists." In 1968, Hine published a study of Bartlett's work titled *Bartlett's West: Drawing the Mexican Boundary.*

In October 1853, Bartlett came back to Rhode Island with his wife, Eliza, and their children. The timing of this return may have been related to Eliza's failing health; she died a few weeks after her arrival at her father's Pawtuxet home. During the next several months, Bartlett made provisions for the care of his youngest children, settled his accounts with the U.S. government and wrote essays for the *Providence Journal*.

In April 1855, he was placed on the Whig/American/Republican Party fusion ticket as a candidate for Rhode Island secretary of state. His nomination was undoubtedly the work of former governor and future U.S. senator Henry Bowen Anthony, a founder of the Republican Party and the *Providence Journal*'s publisher. In addition to Bartlett's outstanding qualifications, he was aided by the facts that Anthony had married Sarah Rhodes, Eliza's younger sister, and that one of Bartlett's sons had been

named Henry Anthony Bartlett. Here was a classic case of political nepotism that proved to have good results.

Bartlett won the April 1855 election and commenced a seventeen-year tenure in a post he would dramatically transform. He began immediately to organize, edit and publish the ten-volume *Records of the Colony of Rhode Island and Providence Plantations...1636–1792* (1855–65), still the basic primary reference for Rhode Island's early history. Then, in succession, he published *A History of Lotteries in Rhode Island* (1856), *A Census of the Inhabitants of the Colony of Rhode Island* (1859), *A History of the Destruction of His Britanic Majesty's Schooner Gaspee...* (1862), two indices to Rhode Island's early acts and resolves and the invaluable *Bibliography of Rhode Island* (1864), an annotated listing of all printed books, articles and pamphlets written about Rhode Island from its founding, prepared with assistance from Elisha Potter Jr.

The Civil War gave rise to his *The Literature of the Rebellion* (a catalogue of works relating to that conflict) and *Memoirs of Rhode Island Officers Who Were Engaged in the Service of Their Country During the Great Rebellion of the South* (1867).

While serving as secretary of state, Bartlett also assisted John Carter Brown in compiling a catalogue of Brown's large collection of early Americana, which they titled *Bibliotheca Americana: A Catalog of Books Relating to North and South America in the Library of John Carter Brown, of Providence, R.I.*, a work still much used by the John Carter Brown Library's staff. After Bartlett relinquished the office of secretary of state in 1872 because his Republican Party failed to re-nominate him, he continued to work with Brown in the expansion of that remarkable library.

During the final fourteen years of his life, Bartlett traveled, compiled genealogies of the Wanton and Russell families of Rhode Island, continued his work (commenced in 1856) of developing a gallery of Rhode Island portraits at Brown University and enlarged a very sizable private library of his own, with concentrations in geography, ethnology, antiquities, philology, history and the classics. He also compiled large and elaborate scrapbooks relating to major current events, and he made numerous watercolor sketches of various Rhode Island scenes.

In 1874, as an active member of the Soldiers' National Cemetery Commission at Gettysburg, Bartlett produced a 109-page memorial volume for the laying of the cornerstone of the monument erected by that organization. In his *Autobiography*, skillfully and thoroughly edited by geomorphologist Jerry E. Mueller, Bartlett stated that he was on the platform "within ten feet of Mr. Lincoln" when the president delivered his immortal

address. In November 1863, shortly after that memorable event, Bartlett married Ellen E. Eddy, daughter of Nelson S. Eddy of Providence, the ancestor and namesake of the famed singer.

Bartlett's brilliant career ended with his death on May 28, 1886. He was survived by his second wife and was buried in the Bartlett family plot at Swan Point Cemetery. His memory and legacy survive, however, through the efforts of local historians and bibliophiles who honored him by creating the John Russell Bartlett Society in 1983.

SAMUEL GREENE ARNOLD JR.

Samuel Greene Arnold Jr. is one of the two foremost historians of colonial Rhode Island. He was born on April 12, 1821, into a prominent merchant family, the son of Samuel Greene Arnold Sr. and Frances Rogers. On his paternal side, he was descended from Thomas Arnold, one of Providence's earliest settlers.

Samuel was educated by private tutors, attended private schools including St. Paul's College on Long Island, graduated from Brown University in 1841, earned a law degree from Harvard in 1845 and was admitted to the Rhode Island Bar.

During the 1840s, Samuel visited England, France, Russia, the Near East and South America. While in Europe, he spent considerable time copying records and state papers relating to American colonial history. This research would reinforce the accuracy and depth of his projected history of colonial Rhode Island.

After the kind of extensive travels that were available to a man of wealth and leisure, Arnold wrote a biography of Revolutionary War leader Patrick Henry in 1854. He then embarked on the writing of a detailed and scholarly *History of the State of Rhode Island and Providence Plantations*, covering the seventeenth and eighteenth centuries. This two-volume magnum opus was published in 1859–60, and it earned Arnold election to the American Academy of Arts and Sciences.

Arnold's public service included three terms as lieutenant governor (1852–53 and 1861–62), the last of which was interrupted by brief, three-month service in the United States Senate from December 1, 1862, to March 3, 1863, to complete the unexpired term of James F. Simmons, who resigned when confronted with charges of war profiteering.

Arnold was a Rhode Island delegate to the Peace Conference of 1861 as a supporter of the Constitutional Union Party. When compromise failed, he helped to organize a company of light artillery and served, with the rank of colonel, as aide-de-camp to Governor William Sprague.

After the Civil War, Arnold became involved in numerous academic and civic projects. He served as a trustee of Brown University, from which he received an honorary doctorate in 1878. He was president of the Charitable Baptist Society of Providence's First Baptist Church, president of the Rhode Island Historical Society from 1868 until his death, a trustee of Butler Hospital and a member of the Providence School Committee. In 1876, Arnold served as a Republican elector in the famed Hayes-Tilden presidential contest. He was a stockholder in several mining companies and president of one, the Haiti-based Nevassa Phosphate Company.

Arnold also continued his writing on a lesser scale, penning memorial addresses, recollections of a few prominent Rhode Islanders and brief histories of Providence and of Middletown, where he resided with his wife and their three children on an estate that he named Lazy Lawn. His marriage was notable because his wife, Louisa (Gindral) Arnold, was also his first cousin.

Samuel Arnold died on February 14, 1880, at the age of fifty-eight. He was buried at Swan Point Cemetery like most prominent Rhode Islanders of his era. Arnold's grandnephew, Hall of Fame inductee Theodore Francis Green, was governor of Rhode Island from 1933 to 1937 and then served four terms in the United States Senate (1937–61), a tenure much longer than that of Uncle Samuel.

GEORGE WASHINGTON GREENE

George Washington Greene, a prominent educator and author, was born in East Greenwich to Nathanael Ray Greene and Anna Maria (Clarke) Greene. He was the grandson of Nathanael Greene, the great Revolutionary War general, whom he came to revere.

In 1824, George entered Bowdoin College in Brunswick, Maine, but withdrew because of poor health in his junior year and traveled to Europe in hopes of recovering. For much of the next several years, he remained in Europe, traveling and mastering the French and Italian languages. More important, he married an Italian woman named Maria Carlotta and befriended poet Henry Wadsworth Longfellow, with whom he established a close relationship until Longfellow's death in 1882.

George and Maria came to the United States in 1831 or 1832. He was unsuccessful in his effort to secure a position as professor of modern languages at Bowdoin, but he taught in 1833–34 at Kent Academy in his hometown of East Greenwich.

In August 1835, the couple returned to Italy, where George used his family connections to secure an appointment as the United States consul in Rome. He held that post from 1837 to 1845. In the mid-1840s, Greene encountered marital troubles, so with his career and his marriage ended, he returned alone to America in 1847 to embark on new careers in teaching, writing and politics. After his Italian divorce became final in 1850, he met and married Catherine Van Buren Porter of Catskill, New York, who eventually gave him four children.

George wrote many articles on his European travels and prepared manuals for learning French and Italian while he served as instructor of these languages at Brown University from 1848 to 1852. His great historical project was a filiopietistic three-volume biography of his grandfather, published from 1867 to 1871. This work led to his appointment as professor of history at Cornell University from 1873 to 1875.

In addition to his Greene biography, George wrote several other historical volumes relating to Rhode Island and the American Revolution. Most notable are *Historical View of the American Revolution* (1865), *The German Element in the War for American Independence* (1876) and a *Short History of Rhode Island* (1877). He was also a prolific writer of historical articles for such journals as the *North American Review*.

Many of Greene's literary and historical efforts were sponsored by his friend Longfellow, who remained Greene's lifelong patron. Not only did the famed poet subsidize Greene's publications, he even purchased a house and

furnishings for George and his second wife in East Greenwich. This home, called Windmill Cottage, still stands at 144 Division Street.

Greene participated in local politics and served as a Republican state representative from 1866 until 1872, when he went to teach history at Cornell. His varied career as language expert, orator, historian, politician and travel writer ended at age seventy-one on February 2, 1883, when he drowned while canoeing. He was survived by Catherine, their four children and his one-hundred-year-old mother. George was buried at Island Cemetery, Newport, next to his father.

SIDNEY S. RIDER

Sidney Smith Rider was born in Brainard's Bridge, Nassau County, New York, on November 5, 1833, the son of George Clinton Rider and Ann (Turner) Rider. He attended schools in New York and Pomfret, Connecticut, before coming to Providence at the age of twelve. There he began an apprenticeship with bookseller Charles Burnett at his mentor's store in Market Square.

In 1859, Rider went into a partnership with Henry Stewart selling new, old and rare books as well as stationery at a shop at 17 Westminster Street, but Rider quickly became its sole proprietor. In 1890, the shop was moved to Snow Street, where it remained until it closed at the turn of the century.

After the Civil War, Rider began publishing pamphlets on Rhode Island history. In 1883, he started a twice-monthly magazine called *Book Notes*, an 870-issue publication that he continued for thirty-three years. It was jammed full of lively reviews, literary and political criticism and opinionated essays by Rider and a few guest authors that challenged then current interpretations of Rhode Island history.

In the recent bibliography of the New England states edited by Roger Parks, there are more than one hundred citations for Sidney Rider. Some of them, like *The Lands of Rhode Island as They Were Known to Caunounicus and Miantunomou*, were books of nearly three hundred pages in length. But

many of Rider's little essays in the *Book Notes* cited by Parks dealt with the origins of Rhode Island place names, while others were fractious jabs about historical forgeries, misdeeds and abuses of power—both historical and contemporaneous with his own day. Several local banks advertised in the periodical to help with the cost of its production.

In addition to *Book Notes*, between 1878 and 1895 Rider edited and published a series of nineteen pamphlets followed by a general index volume. He called this set the *Rhode Island Historical Tracts*. Five of the pamphlets plus the index were done by Rider. Other authors included Elisha R. Potter Jr., John Russell Bartlett, Thomas Durfee (all Hall of Fame inductees) and Henry C. Dorr, brother of the "People's Governor," whose topic was "The Planting and Growth of Providence." Other topics included alleged Norse visitations, Roger Williams, William Coddington, Samuel Gorton, colonial paper money issues, the Albany Plan of Union, the Black Regiment, the Battle of Rhode Island, Stephen Hopkins, the first Brown University medical school and brief biographical profiles of attorney James K. Angell, Frances H. (Whipple) McDougal and Catherine R. Williams. These tracts are very valuable, but overlooked, contributions to our understanding of Rhode Island history.

The acerbic Rider died on January 31, 1917, at the age of eighty-four. Annie and Burnett Rider buried their father next to his wife and partner, Loriana Burke, at Providence's North Burying Ground. She had passed away years earlier. At the time of Rider's death, and for nearly a century thereafter, no one had written so extensively about the history of Rhode Island, even if such writing was episodic.

Unfortunately, Rider's major work has gone unpublished. His factually accurate, minutely detailed and valuable analysis of "The Development of Constitutional Government in Rhode Island" reposes, almost unnoticed, in twenty-seven scrapbook volumes in the library of the Rhode Island Historical Society.

In the long-standing controversy between Roger Williams and William Harris of Pawtuxet over the true boundaries of Providence, Rider sided with Harris. In the power play by William Coddington to become the governor-for-life of Aquidneck Island, Rider took the side of Coddington's adversaries, Roger Williams and Dr. John Clarke.

Of the pressing issues of his own time, Rider was a neo-Dorrite Progressive reformer; he frequently criticized the Union Railroad Company, other monopolies and the politically corrupt Republican boss Charles R. Brayton, whom Rider blamed for the suicide of his brother,

Frederic, when both were officials of the Providence Post Office. Ironically, it was one of Brayton's contemporary financial supporters, utility baron Marsden J. Perry, who bought Rider's own collection of historical books and manuscripts—particularly the important materials pertaining to Thomas Wilson Dorr's constitutional uprising—and presented them to Brown University's John Hay Library, where they have become part of the Sidney S. Rider Collection, one of the truly great treasure-troves of Rhode Island history. Its more than fifteen thousand items include books, pamphlets, manuscripts, broadsides and newspaper clippings dealing with Rhode Island's development from its founding to Rider's own time.

Reverend Edward Everett Hale

Edward Everett Hale—noted author, social and economic reformer and Unitarian minister—was born in Boston on April 3, 1822. His father was a nephew of Revolutionary War hero Nathan Hale, and his maternal uncle and namesake, Edward Everett, was a noted orator, U.S. secretary of state, U.S. senator and congressman, governor of Massachusetts and president of Harvard.

Hale graduated from Boston Latin School at age thirteen and then from Harvard College as the second-ranking student in the class of 1839. He then gained valuable journalistic and political experience working as a reporter on Boston's first daily paper, the *Daily Advertiser*, which his father owned and edited from 1814 to 1854. Meanwhile, Hale prepared for the Protestant ministry. After his ordination in 1846, he became minister to the Congregationalist Church of the Unity in Worcester, Massachusetts. In 1856, he left Worcester to become pastor of Boston's South Congregational Church, where he served until 1899.

During the 1840s, Hale also embarked on a long career as a writer of stories and, later, of novels and essays. These productions brought him national prominence. During a fifty-five-year span, he published nearly one hundred short stories of varying quality plus many socio-religious essays. His most notable effort was *The Man Without a Country*, the tale of traitor Philip Nolan, which he wrote in 1863 during the Civil War to rally support for the Union against the efforts of the Peace Democrats. At Hale's death, this work was described as "the most popular short story written in America" and "the best sermon on patriotism ever written."

In the years after the Civil War, Hale's prominence and liberal theological views allowed him to play an important role in the establishment of the Unitarian Church of America. He also became a leading spokesman for the practice of promoting good works through social action and was an influential molder of American public opinion on a range of issues, such as race relations, religious tolerance, regulation of monopolies and the reform of public education.

Throughout his life, Hale contributed many articles on a variety of subjects to the magazines and periodicals of his day. He was the author or editor of more than sixty books and pamphlets on fiction, travel, sermons, biography and history. By the end of the nineteenth century, he was recognized as one of America's most important and influential men of letters.

Hale became an acknowledged role model for Theodore Roosevelt, who described him as "one of the most revered men in or out of the ministry in all of the United States." Late in life, Hale was honored by his appointment as chaplain of the United States Senate and by his election to charter membership in the newly established Academy of Arts and Letters.

Despite his strong Boston roots, Hale maintained a long and steady connection with Rhode Island. Nearly each summer from 1873 onward, he made the trek from Massachusetts to the seaside resort of Matunuck in South Kingstown, where he maintained a still-extant summer home, just across the Post Road from the residence of his close friend, Rhode Island economic historian William B. Weeden. Adjacent to this summer retreat, which the Hale family owned until 1954, is the Robert Beverly Hale Library, which was built in 1896 as a memorial to Hale's son, who died at age twenty-six. The large Victorian summer home has been recently acquired as a museum and historic site by the Kingston-based Pettaquamscutt Historical Society, now the Museum of South County History.

In 1852, Hale married Emily Perkins, who was related to the famous Beecher family. The couple had nine children. Hale died on June 10, 1909, in Roxbury, Massachusetts, at the age of eighty-seven. He was buried at

Forest Hills Cemetery in Jamaica Plain. A life-size bronze statue of Hale stands in the Boston Public Garden.

Hale's many summer sojourns at Matunuck—a tranquil setting where he wrote extensively—entitle him to an honored position in the Rhode Island Heritage Hall of Fame.

James N. Arnold

James Newell Arnold, whose contributions to the study of Rhode Island history are as useful today as they were when first transcribed, dealt in the data of family life: official town documents and records; newspaper accounts; birth, marriage and death records in church archives; and history on stone in local graveyards. While historical interpretations pass in and out of favor, the cold facts remain.

Assembling these annals of the rich and poor required Arnold to travel from place to place and spend hours doing laborious hand transcription. He had the additional challenge of a lifelong physical handicap: lameness. Emerging from all this effort was a twenty-one-volume publication known as *The Vital Record of Rhode Island, 1636–1850.*

An unanticipated benefit of his graveyard research was the recognition by later generations of the value of graveyard information. This insight led to the preservation and further documentation of family burial grounds and historical cemeteries, several thousand of which are scattered across Rhode Island.

Arnold was born on August 3, 1844, to a farm family near the Cranston village of Knightsville. His parents were James Lincoln Arnold and Amey Underwood. Part of his interest in family history was prompted by his own descent from the earliest settlers of Rhode Island. Thomas Arnold of Dorset, England, had two sons, William and Thomas, who immigrated to New England in 1635. Settling originally in Massachusetts, they both joined Roger Williams in Providence in 1636. Thomas Street, next to the First Baptist Church and Arnold Street in nearby Fox Point, marks their presence. Benedict Arnold, son of Thomas and ancestor of the Revolutionary War traitor, became Rhode Island's first governor under the Royal Charter of 1663.

Eventually, the Arnold family spread out to Woonsocket Falls, along Great Road in Lincoln, and to such communities as Portsmouth, Newport and

Charlestown, so when James N. Arnold decided to pursue research into his family history, he had the entire state as his laboratory. He claimed that his reading of Samuel Greene Arnold's colonial history served as his inspiration.

After James's father relocated the family in 1869 to a farm in North Kingstown near the Gilbert Stuart birthplace, Arnold began his lifelong practice of visiting local burial grounds to transcribe the information spread across the stones. His researches expanded to include the family lore of the Narragansett Country's early settlers, as well as accounts of local Native Americans.

Arnold moved to Providence in 1884 and became an editorial assistant to Edward B. Hitchcock. His work brought him to the attention of historian Henry E. Turner of Newport, who introduced Arnold to the process of critically examining documentary evidence rather than merely repeating previous writers.

In 1882, Arnold became the editor of the *Narragansett Historical Register*, a quarterly magazine of antiquities and genealogy for the southern Rhode Island region. By 1881, he had edited eight volumes before embarking on his *Vital Record* compilation.

The first six volumes of this major research project were birth, marriage and death records from the various city and town archives. Another eleven volumes comprised newspaper and church records. In this publication process, he assembled his own prodigious files and library: a collection of notes and transcripts, 1,500 genealogical works, 2,500 books of history and some 10,000 pamphlets.

Arnold, though handicapped and introverted, wrote and delivered many historical addresses and contributed numerous articles to local newspapers. He was also a contributing member of several historical and genealogical societies. He often lamented the lack of sufficient state funding for his mammoth publication project.

James Newell Arnold died on September 18, 1927, at Dexter Asylum in Providence at the age of ninety-one. He is buried in the family's Peleg Brown Lot in South Kingstown. He never married.

The man some called Rhode Island's "unofficial statistician of the dead" and "Old Mortality," after the character in Sir Walter Scott's novel of the same name, donated his vast collection to the Knight Memorial Library on Elmwood Avenue in Providence. After years of neglect, it was transferred to the Providence Public Library in 2015 as part of that institution's Rhode Island Collection. In this setting, it will be a great resource for future Rhode Island historians and genealogists.

ALFRED MASON WILLIAMS

Alfred Mason Williams was born in Taunton, Massachusetts, on October 23, 1840, the son of Lloyd and Prudence (Padelford) Williams. He acquired his early education in local public schools and at Bristol Academy. In 1856, he entered Brown University. Trouble with eyesight made him drop out after a few semesters, but his eyesight did not keep him from joining the Fourth Regiment, Massachusetts Volunteer Infantry, at the outbreak of the Civil War. From the front, he sent battle reports to his hometown paper and to Horace Greeley's *New York Tribune*. His principal service was in the Louisiana Campaign under General Nathaniel Banks. Williams never returned to Brown, although

the university awarded him an honorary master's degree in 1883.

Impressed by young Williams, Greeley sent him to Ireland at war's end in 1865 to cover the story of the upstart Fenian Movement, a military campaign by Irish rebels to reestablish Irish control over their own land. Williams sent twenty reports to Greeley about the conflict. While on assignment, Williams not only developed a lifelong sympathy for Irish Home Rule but also became enchanted by the ballads and poems of Ireland and became an avid collector of Irish folklore.

Returning from Ireland in 1871, Williams assumed the editorship of the *Taunton Gazette* and married Cora Leonard. The couple moved in 1872 to southwest Missouri, where he edited the *Neosho Journal*. On the border of the Indian Territory that would become Oklahoma, Williams developed a deep concern for the civil rights of Native Americans. He was also affected by recurring war-caused fevers contracted in Louisiana, so for health reasons, he and his wife gave up frontier Missouri in 1875. Back in New England, he landed a job as a reporter for the *Providence Journal*.

Within a year, Williams was writing editorials for the *Journal*, but Rhode Island was not the only focus of his attention. In 1881, he published a well-received book on the *Poets and Poetry of Ireland*. In that year, he also made a trip back to Neosho and visited his Indian friends.

The deaths of *Journal* executives George Danielson and Henry Bowen Anthony in 1884 not only advanced Alfred Williams into the top spot of the newspaper but also provided an opportunity for the *Journal* to declare its independence from the Republican Party. Williams immediately attempted to separate the *Journal* from the state GOP organization and make the paper a catalyst for governmental reform.

A "Mugwump" in the political terminology of the 1880s, Williams supported Democrat Grover Cleveland over Republican James G. Blaine in the 1884 presidential election and backed Democrat "Honest" John Davis against Brayton's gubernatorial candidate, George Peabody Wetmore, in 1887. His choices prevailed.

When GOP party boss Charles Brayton made a mockery of newly enacted state temperance legislation by having himself installed as the chief of state

police and appointing a number of legislators as judges in a new district court system that was set up for hearing cases about prohibition, Williams and the *Journal* railed against this chicanery, blasting it as the "May Deal." Two years later, Brayton arranged to have the *Journal* formally drummed out of the Republican Party at a state convention meeting.

The death of his wife, Cora, in 1886 was a turning point in Williams's life. To console himself, he embarked on a long trip to Ireland, where he met some of the emerging Irish literati. Upon his return, he published in the pages of the *Journal* the works of these fledgling writers, including William Butler Yates, Katharine Tynan, Mary Banim and Douglas Hyde, the future president of Ireland. This venture has been described by Professor Horace Reynolds in his book titled *A Providence Episode in the Irish Literary Renaissance*.

In 1891, Williams retired as *Journal* editor, citing health reasons and a desire to pursue his other literary and cultural activities. Thereafter, in quick succession and despite failing eyesight, he coedited *Men of Progress*, a volume containing biographical portraits of Rhode Island business leaders; wrote a book about Sam Houston and the Texan war for independence; edited a volume of folk songs and poetry; and authored a work titled *Under the Trade Winds*.

On March 9, 1896, Williams died suddenly at St. Kitts while on a trip in the Caribbean. He was only fifty-five years old. Prior to his demise, he had made a decision to donate his remarkable collection of Irish literature to the Providence Public Library, where it is still housed and used. This Williams Collection has since been supplemented by the Irish collection of George Potter, another *Journal* writer and the author of the acclaimed book *To the Golden Door: The Story of the Irish in Ireland and America* (1960).

VIII

THE EDUCATORS

Dr. William Augustus Mowry

William Augustus Mowry ranks among Rhode Island's foremost educators. Besides writing a score of books (especially texts on history and civics), Mowry founded a highly regarded private high school in Providence, pioneered in the establishment of teachers' institutes and served as superintendent of schools in Cranston and in Salem, Massachusetts.

Born in Uxbridge, Massachusetts, on August 13, 1829, the son of Jonathan and Hannah (Brayton) Mowry, he was raised by his grandparents after his father died when he was only three years old. Like the sons of many old-line New England families, he attended Phillips Academy in Andover. Then he received his advanced education at Brown University, graduating in 1857, and at Bates College in Maine, from which he earned his doctorate in 1882. By that time, Mowry had been teaching on the elementary and secondary level for thirty-five years, since 1847.

Mowry served in the Civil War, rising to the rank of lieutenant colonel in the Rhode Island state militia. After the war, however, he became a prominent member of the American Peace Society. He relentlessly espoused the cause of temperance, urged temperance education in the public schools and served as a director of the Boston-based Scientific Temperance Federation.

Mowry taught at the Providence High School, became a member of the Providence School Committee, served as president of the Rhode Island Institute of Instruction (1864–66) and edited a professional journal called

the *Rhode Island Schoolmaster* from 1857 to 1860. In 1864, he established the English and Classical School for Boys and ran this private secondary school under the name of Mowry and Goff's. At its peak enrollment, this facility had 250 pupils and 15 teachers. In 1884, health problems caused Mowry to relinquish the demands of his Providence academy. Consequently, he accepted a position in Boston as managing editor of the prestigious *Journal of Education* from 1884 to 1891.

After his move to Massachusetts, Dr. Mowry lived in Dorchester, Salem, where he served as superintendent of schools and, finally, in Hyde Park. He died on January 24, 1917, at the age of eighty-seven.

Mowry summered in Martha's Vineyard, where he ran a summer institute for teachers. During all his years in the Bay State, he continued his activism in the Congregational Church, the educational field, the peace movement and the temperance crusade. He was the author of twenty books or booklets on topics such as American history, genealogy, biography and education.

Mowry was highly regarded and universally praised by those prominent citizens with whom he came in contact during his long career. One eulogist described him as "teacher, soldier, proprietor of a large school, lecturer, author, Congregational preacher, editor, superintendent of city schools, and for nineteen years president of the Martha's Vineyard Summer [Teachers] Institute." Mowry's *Recollections of a New England Educator, 1838–1908* (1908), his twentieth book, offers an excellent analysis of nineteenth-century secondary education.

EBEN TOURJÉE

Eben Tourjée is regarded as an American pioneer in the establishment of music schools and conservatories—an effort crowned by his founding of the world-famous New England Conservatory of Music in Boston in 1867.

Tourjée was born in Warwick on June 1, 1834, of French Huguenot lineage that could be traced to East Greenwich's Frenchtown settlement

of the late 1680s. His parents were Ebenezer and Angelina (Ball) Tourjée. At the age of eight, Eben began his working career in an East Greenwich calico mill, and by age thirteen, he was employed at the Harrisville cotton mills, a facility owned by Governor Elisha Harris, who recognized Eben's musical talent and became his patron. At age sixteen, after study in the East Greenwich Academy, Eben moved to Providence and began working at a music store and playing piano in the store orchestra.

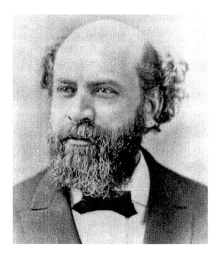

Although he took lessons in voice, piano and organ, Tourjée was more interested in teaching others the art of music than in his own concert career. Influenced by the conservatory system employed in Europe at that time, he believed that music lessons should be taught in classes rather than by private lessons. Accordingly, in 1853, he began a series of business teaching ventures—first in Fall River, then in East Greenwich, Newport and Providence, where he started his own independent musical institute in 1865 after an informative trip to Europe to observe the system of music instruction there. That facility, in Franklin House at Market Square, was one of the first of its kind in America. It offered courses in social, instrumental and theoretical music and awarded diplomas to those who completed the program.

With the support of many leading citizens as well as musicians, Tourjée planned another conservatory to be located in Boston that he would operate simultaneously with the Providence institute. On February 18, 1867, Tourjée's New England Conservatory of Music opened in seven rooms of the Music Hall in Boston to a large number of students. In its first year, 1,414 pupils were enrolled, a number that grew to 1,824 in the conservatory's second season. Tourjée not only directed the school, but he also taught organ, piano, vocal culture and the theory of music.

After the death of his first wife, Abbie, in October 1867, he closed his Providence school and centered his activities in Boston, where he married Sara Lee, his children's governess, in 1871. Sara bore him two children.

Tourjée did things on a grand scale. He staged huge concerts in the Boston area, called the first national music conference, arranged musical tours of

Europe, served as the founding president of the Music Teachers National Association (MTNA) and established an academic affiliation with the new Boston University. He was also a devout Methodist and held leadership positions in a number of religious enterprises.

Tourjée died on April 12, 1891, and is buried with his family at Newton (Massachusetts) Cemetery. He was survived by four children from his first marriage and a son from his second. As his biographer, Edward J. Fitzpatrick, observed, "Tourjée had lived a full life completely devoted to making the art of music available to countless thousands and endless generations of fellow humans through his conservatories."

JAMES BURRILL ANGELL

Brown University graduate, professor of languages, *Providence Journal* editor, university president and diplomat James Burrill Angell is best known as the longest-serving president of the University of Michigan, where he aspired to provide an "uncommon education for the common man."

Born on January 7, 1829, in Scituate, Rhode Island, Angell was the eldest of the eight children of Amy and Andrew Angell. The Angell family in Rhode Island traced its lineage to Thomas Angell, who came to Providence with Roger Williams. He was named for James Burrill, Rhode Island's U.S. senator from 1817 to 1820.

Although reared on an outlying farm, Angell had an excellent early education, studying in Seekonk, Massachusetts, and at the Smithfield Academy before entering Brown. A little too young for college admission, he spent a year at the University Grammar School under the instruction of Henry Frieze, who would later spend many years as professor and interim president of the University of Michigan.

James B. Angell became a Brown graduate in the class of 1849. Following graduation, he traveled with Rowland Hazard through the American South in 1850 and again with Hazard to France, Italy and Austria. During this sojourn, he was offered the chairmanship of Brown's Modern Language Department by President Francis Wayland, who was busy attempting to restructure the university away from the traditional college curriculum. Two of Angell's Brown students were future U.S. secretaries of state: Richard Olney and John Hay. Angell himself would become an expert on American diplomacy.

In 1855, Angell married Sarah Swope Caswell, whose father became president of Brown in 1868. The couple had three children. The same year as Angell's marriage, President Wayland left Brown, discouraged by the lack of funding for his reforms. Angell's interest in Brown similarly waned, and he began writing articles for the *Providence Journal.* When the *Journal's* editor, Henry Bowen Anthony, left the paper to take up the duties of United States senator in 1858, he urged Angell to take the editor's job. He did so in 1860, after resigning from his position at Brown.

Initially supporting William Seward for president of the United States, Angell switched his allegiance to Abraham Lincoln and continued as a Lincoln promoter throughout the Civil War. Angell strongly favored abolishing slavery, an institution he had observed firsthand during his long trip through the South. In 1866, he was offered the presidency of the University of Vermont and moved his family to Burlington. He took the job in part because his efforts to buy the *Journal* from Anthony had failed.

In 1869, Angell's prep school mentor, Henry Frieze, recruited Angell to become the third president of the University of Michigan. Although initially turning the job down and spending another school term in Burlington, Angell went to Ann Arbor in 1871 and spent the next thirty-eight years there as the university's leader. While at Michigan, he carried out many of the modernizing ideas Wayland had tried to impose on Brown while utilizing the political skills he had honed in Vermont, namely convincing a recalcitrant or laggardly legislature that there was a public responsibility to fund higher education.

At Michigan, Angell found an existing undergraduate college and departments for medicine, law and instruction in engineering and pharmacy. A recent innovation had been the admission of women students. Angell immediately assumed the task of shoring up existing programs and staking out a path to bring on more. Much funding was needed to build laboratories and libraries to support prospective graduate study.

Calling on the state for greater financial assistance, Angell argued that higher education was not just for the rich and the well born but that it was "just and wise for the State to place the means of obtaining generous

culture within the reach of the humblest and poorest child upon its soil." Furthermore, the horizon of this work should not be limited to the boundaries of the state, but the work "must be part of the great world of scholars...[flinging] its gates wide open to all seekers after knowledge, wherever their home." He set the agenda for the University of Michigan to become a national institution with international fields of endeavor and impact.

Serving as the registrar for incoming students, Angell also taught courses in the history of diplomacy. During his tenure, graduate schools of dentistry, pharmacy, music, nursing, architecture and urban planning joined the existing array of medicine, engineering and law. Favoring the German approach to graduate studies, he introduced the seminar method of teaching at Michigan. Angell wrote a lengthy diplomatic history essay in Justin Winsor's *Narrative and Critical History of America* based on his lectures. He was a founding member of the American Historical Association in 1884 and its president in 1893–94. He also became a regent of the Smithsonian Institution in Washington.

Angell's background in diplomatic studies led to presidential appointments by Democratic and Republican presidents. He negotiated a treaty with China concerning immigration in 1880 when he was U.S. minister to that country and another with Canada in 1888 dealing with fisheries. In 1897, he became United States minister to Turkey. During these absences from his university, his Brown mentor, Henry Frieze, was interim president.

Following the death of his wife, Sarah, in 1903, Angell began to look toward retirement, but he was persuaded to stay on as president for a few more years, so he did not officially step down until 1909. Angell died on April 1, 1916, in the president's house on the University of Michigan campus and was buried locally at Forest Hills Cemetery.

Theodore Barrows Stowell

Theodore Barrows Stowell, a prominent Rhode Island educator, served as president of Bryant & Stratton Commercial College (now Bryant University) for nearly four decades. Descended from one of New England's earliest settlers, he was born in Mansfield Center, Connecticut, on July 8, 1847, the son of Stephen Stowell, a prosperous farmer, and Cornelia (Stebens) Stowell.

Theodore Stowell was drawn to the profession of teaching, and upon graduation from the Connecticut State Normal School, he accepted a position with the Toilsome Hill District in Bridgeport. By 1870, he had relocated to Rhode Island, joining the teaching staff at Bristol Ferry School in Portsmouth. Soon his talents were recognized, and less than two years later, Stowell received an offer from a fledgling business college in Downtown Providence to become a member of its teaching staff. That institution, Bryant and Stratton National Business College, was founded as part of a national chain of private, coeducational commercial schools.

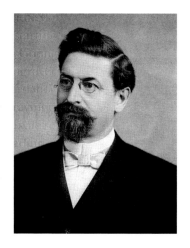

Schools such as Bryant and Stratton were an important product of industrialization, a development that greatly enlarged the white-collar class. As factories expanded their markets, as businesses became larger and more complex and as banks and insurance companies proliferated, demand grew for bookkeepers, clerks, stenographers, secretaries and other office personnel. To meet this local demand, Bryant and Stratton opened a Providence branch in 1863 in the Howard building on Dorrance Street. Once employed at this facility, Stowell became not only a good teacher but an entrepreneur as well.

In 1878, six years after joining the faculty, Stowell bought out the interests of the founders, moved to more spacious quarters in the Hoppin Homestead Building on Westminster Street and installed himself as president of the now independent college. Under his thirty-eight-year stewardship, Bryant and Stratton grew and prospered. In June 1915, Brown University awarded Stowell an honorary degree. One year later, even though in ill health, Stowell successfully negotiated the consolidation of the Rhode Island Commercial School with Bryant and Stratton under the new ownership of Harry Loeb Jacobs. Stowell was chosen as president emeritus in April 1916, one month before succumbing to a long-term illness on May 29 at the age of sixty-eight.

Professor Stowell married Florence A. Taylor of Plymouth, Connecticut, on January 1, 1871. They resided on Pallas Street in Providence. She survived him, but the couple had no children. Stowell's funeral was conducted at Beneficent Congregational Church, where he was an active member.

After relocating to a modern eight-story building on the corner of Fountain and Union Streets (still standing) in 1925, and later to Providence's East Side, the school moved in 1971 to a suburban campus in Smithfield, on 220 acres of land donated to it by Earl Tupper of the Tupperware Corporation. Today, Bryant University enjoys a reputation as one of the region's preeminent business colleges and is steadily diversifying.

Maximilian D. Berlitz

During the final three decades of the nineteenth century, Providence emerged as one of the leading industrial cities in America. Woolen and cotton textiles, base metals and machinery, jewelry and silverware and a newly emergent rubber goods industry led the way. Large-scale manufacturing brought jobs to many and great wealth to those who captained the city's major firms—and the latter increasingly made time for leisure and travel.

The simultaneous development of more luxurious steel-hulled steamships prompted those with substantial means to undertake the Grand Tour of Europe. For the well-to-do, this lavish excursion became the thing to do.

Affluency, however, needed to be augmented by language fluency for a traveler to derive the greatest benefit from the Grand Tour. The leading citizens of Providence were fortunate to have in their midst a young German-born master of linguistics to prepare them for their European adventure. His name (which now has a familiar ring) was Maximilian D. Berlitz. To my knowledge, no general history of Providence or Rhode Island (including my own) has ever recognized the fact that the worldwide network of Berlitz language schools began and flourished in Providence late in the decade of the 1870s! Only the ethnic heritage pamphlet *The Germans of Rhode Island* (1985) gives passing notice to his presence.

Although much is known of Berlitz's post-Providence career, little is known for certain regarding his early years. The traditional Berlitz company history claims that he was born in 1847 in southern Germany

to a family of teachers and mathematicians. Recent researchers on both sides of the Atlantic dispute these claims. They persuasively argue that Berlitz was born on April 14, 1852, in the village of Mühringen at the edge of the Black Forest in southwest Germany. His birth name was David Berlitzheimer, and he was the son of a village cantor and Jewish religious teacher. He came to America, according to ship records, in July 1870 after serving a three-year apprenticeship with a German clockmaker. The outbreak of the Franco-Prussian War and the militaristic regime of Otto von Bismarck probably influenced his decision to emigrate.

Upon arrival in America, David Berlitzheimer transformed himself into Maximilian Delphinius Berlitz. Surely such deception concerning one's origins and early exploits is not uncommon. Perhaps Berlitz realized that Rhode Island in the 1870s was nearly devoid of Jews (the famed Newport Touro congregation had disbanded), while the local German American community was growing in size and influence. A desire to avoid prejudice might have been another motivation, or he may have simply renounced his faith. Whatever the reason, he changed his name, married the Christian daughter of German immigrants (love conquers all) and raised his children as Christians.

This prelude is merely incidental to the local business origins of Berlitz and his subsequent global influence as a language-teaching innovator. In 1872, two years after his arrival from Germany, Berlitz found his way to Westerly, Rhode Island, where he worked briefly as a private language tutor. He then moved to Providence to accept a permanent position as a teacher of French and German at the lavishly named Warner Polytechnic College, a small institute on 283 Westminster Street affiliated with the Bryant and Stratton chain of business colleges. In 1878, following a tenure of about five years, Berlitz purchased this business from William W. Warner. At that time, he lived at 14 Vernon Street in the Federal Hill section of the city.

Initially, the twenty-six-year-old served not only as the director of the Berlitz School of Languages but also as its only instructor. Soon he hired Nicholas Joly, a young man who had immigrated to New York City from Lyons, France. Together, the pair revolutionized the teaching of language as they prepared the leisure class for a European sojourn.

This linguistic revolution was unplanned. Upon his arrival in Providence, Joly found his new employer ill with exhaustion, and Berlitz discovered that his stand-in could not speak English. Before taking a leave of absence to recuperate, Berlitz instructed the Frenchman to teach not by focusing on grammar, translation and bilingual interaction but by pointing to objects and acting out verbs solely in the language to be learned.

When Berlitz recuperated and returned to the classroom, he noticed that his students had advanced remarkably. Their communication had flourished when they spoke only in the new tongue, without the delay and pressure of memorizing written rules or grammar. Thus the Berlitz method was born, and Providence was its incubator.

In the 1880s, Berlitz seized on the technique that he and Joly had developed by opening other schools in Boston, New York and Washington. An astute and energetic promoter, eventually Berlitz brought his concept to audiences at the Paris World's Fair (1900) and the St. Louis World's Fair (1904). He even returned to his homeland to tutor Kaiser Wilhelm II in English.

When Berlitz died in New York City on April 6, 1921, at the age of sixty-eight, his obituary noted that his system was being taught in "more than 300 schools…covering nearly every large city in the world." Today, the Berlitz empire spans fifty countries, maintains well over four hundred language centers and annually publishes millions of dictionaries, travel books and audiocassettes. Lessons are still taught in the target language by native speakers like Berlitz and Joly, and the founder's cardinal principle still prevails: "The pupil should never during his lesson resort to the words of his own language, but rather force himself to speak in the tongue he is trying to master."

Ironically, neither Providence nor Rhode Island now has a Berlitz language school; the nearest establishments for aspiring multilinguists can be found in Boston and Wellesley Hills, Massachusetts. The firm's international headquarters is in Princeton, New Jersey.

Helen (Rowe) Metcalf

Helen Adelia (Rowe) Metcalf was born in Providence on July 17, 1830. Little is known of her early years, but her marriage to entrepreneur Jesse Metcalf Sr. changed that.

Metcalf was a cotton broker for several years prior to the Civil War, but when the supply of cotton was interrupted by the conflict, he switched his textile business to woolens in 1862 and founded the Wanskuck Company on Branch Avenue in what was then the town of North Providence. Jesse and his partner, Henry Steere, flourished, and with their wartime profits from woolen sales to the government, they greatly expanded their operations and made a significant contribution to the ranking of Providence in 1900 as the nation's leader in the production of woolen goods.

Helen, who complemented Jesse nicely in drive and ability, developed her own project. Twenty years before the U.S. Centennial Exposition of 1876, some Rhode Islanders recognized a need for well-trained industrial designers, especially for textile and jewelry manufacturers. They petitioned the General Assembly and were granted a charter to establish a "permanent Art Museum and Gallery of the Arts of Design." It was not until 1876,

however, that action was taken to implement this admirable goal. Helen Adelia Rowe Metcalf initiated the action.

As members of the Rhode Island Centennial Committee, Helen, Sarah Doyle and several other women traveled to the Centennial Exposition in Philadelphia with Rhode Island's exhibit. While there, Helen toured the Women's Pavilion and saw firsthand the superiority of European design. She and the other committee members elected to take the $1,675 left over from commission funds, once exhibit expenses were paid, and start a School of Design in Providence. Within weeks of their return, they selected twelve trustees, and by the end of March 1877, they had drafted a constitution and an organizational model. The mission of the new school was trilateral: To train artisans, to teach students the principles of art so that they could teach others and to inform and elevate appreciation of the arts in the community through exhibits, lectures and studies. These ladies named their creation the Rhode Island School of Design.

Helen Adelia Rowe Metcalf deserves much of the credit for this bold experiment. In addition to her leadership role in founding the school, she devoted much of her time to running it, right up until her death in 1895. According to an early school history, Helen spent many of her days in the school assisting teachers, observing their methods and encouraging students. Little escaped her eye. She concerned herself with the ordering of supplies, the utilization of space and even the arrangement of furniture. On occasion, she was known to "take a hand at cleaning" when and where necessary.

Helen's time away from the school was often passed in visiting manufacturers in order to induce them to contribute patterns and models for the classes, to loan equipment, to donate materials, to provide funds for prizes or to give money for a student tuition. Helen Metcalf made it clear that the school was there for all, no matter their socioeconomic situation or gender. Indeed, the fees were kept so low that the school ran in the red for almost three generations, with the Metcalf family providing the needed funds for operation and expansion.

Helen died in Providence on March 1, 1895, and was buried with her husband, Jesse, at Swan Point Cemetery. Her example and her legacy have survived in part because of her dedicated and talented descendants. Immediately upon Helen's death, her daughter, Eliza G. Radeke, also a Hall of Fame inductee, took the position of chair of the Committee of Management of RISD and served as the school's president from 1913 to 1931. Then Helen's granddaughter Helen Danforth assumed the presidency until 1947, after which she chaired the board of directors until 1965. She

guided RISD from being merely a diploma-granting vocational school to a degree-granting accredited college. Both ladies greatly expanded the campus, enhanced the collection of RISD's famous Museum of Art and shifted the school's focus from the industrial arts to fine art.

Not to be outdone, Helen's son, Jesse Houghton Metcalf, and his wife, Louisa, also lent their generous hands to RISD. They used the Wanskuck wealth to fund not only RISD but also numerous Rhode Island charitable and educational enterprises, the most notable of which is the Rhode Island Foundation. Both Jesse and Louisa are also Hall of Fame inductees.

Mary C. Wheeler

The founder of Providence's Wheeler School was born on the family farm in Concord, Massachusetts, on May 15, 1846, the daughter of Abel and Harriet (Lincoln) Wheeler. The Wheeler family members, direct descendants of one of the first families of Massachusetts, were friends and neighbors of the Transcendentalists and literary leaders of their times—the Alcotts, Thoreaus, Hawthornes, Peabodys and Emersons. Miss Wheeler is buried along with these Concord notables on Author's Ridge at Concord's Sleepy Hollow Cemetery.

An appreciation for the value of the arts and education came naturally to Mary Wheeler. After studying in the public schools of Concord and at Abbot Academy in Andover, she began her teaching career in the Concord public schools as an instructor of mathematics and Latin. In 1868, she moved to Providence to teach at Miss Shaw's, a finishing school for young ladies.

During the 1870s, Miss Wheeler traveled to Europe to study art, returning in 1882 to Providence, where she began teaching painting to young women in the Waterman Building on North Main Street. Two years later, she moved to a house and studio that she built at 24 Cabot Street. Here she painted under the influence of the French Impressionists, whose works she had observed firsthand.

Starting in 1887, she traveled with groups of young women to Giverny, France, to paint and study art history and French. Her summer trips led her to lease the property next door to Claude Monet. Soon Miss Wheeler and her students were friends and dinner companions with the Monet family and many of the Impressionist artists who visited Giverny.

With her background in art and academics, Mary Wheeler believed that girls deserved more than a "finishing school" approach to education. In 1889, she founded the Wheeler School in Providence; in 1900, she added an academic college preparatory program to her art instruction. At that time, she accepted ten girls as boarders.

Miss Wheeler also continued her travels. In 1900, she was a U.S. delegate to the World Congress of Secondary Schools held in Paris, and in 1904, she was an American delegate to the World Congress of Teachers held in Berne, Switzerland.

Mary died on March 10, 1920, at the age of seventy-three as a result of complications arising from a fall on an icy street. By the terms of her will, the Mary C. Wheeler School was left to a board of trustees who were to maintain her experiment as the same kind of school that she had created and developed.

For her time, Mary Wheeler was considered an educational innovator, a visionary, an artist and an activist for women's rights. Her spirit continues today at the Wheeler School, which celebrates her legacy of individual creativity and opportunity in education.

REVEREND DR. ELISHA BENJAMIN ANDREWS

Although E. Benjamin Andrews had only one eye—the result of a Civil War wound from a friction primer ejecting from his artillery piece during the siege of Petersburg in August 1864—some might say he was one of the most visionary presidents of Brown University. During his nine-year tenure as the eighth chief executive of Brown (1889–98), he moved the school from a college to a university, drove it in the direction of a research institution and opened opportunities for women by establishing Pembroke with the aid of Sarah Doyle. Any one of these accomplishments would have earned him recognition as a distinguished educator, but all of these were mastered while he performed his own scholarship. In addition, Andrews was an inspiring figure in the classroom and in the pulpit on Sunday as a Baptist minister.

"Benny," as he was called, developed a remarkable camaraderie with the students as a classroom teacher, and that continued into his presidency. He became acquainted to an extraordinary degree with his student body. Their respect and loyalty rallied to his advantage when his outspoken political support of bimetallism (i.e., free silver) in the U.S. presidential campaign of 1896 threatened to doom his career at Brown—a school with fiscally conservative Republican benefactors.

Andrews's abiding concern for his students of all backgrounds was a model for any college president. For example, he took an interest in a young, but impoverished, degree candidate named James H. Higgins, who had missed the cut for financial aid to be admitted as a freshman only to discover that a student loan had miraculously appeared allowing his enrollment. Later, after beginning a successful career as a Rhode Island attorney, he returned to Brown to discharge the loan. It was then he discovered that the amount had not come from the university but had been personally underwritten by Andrews. Higgins went on to become the first Catholic governor of Rhode Island in 1907 and to remove that figurative sign on the Executive Chamber of the statehouse warning that "no Irish-Catholic need apply."

The "Andrews effect" extended also to those of greater means, such as oil magnate John D. Rockefeller Jr., who later endowed Brown's main library, and Mary E. Woolley, whose Brown education helped her to become president of Mount Holyoke College. Another student personally assisted by Andrews was the black scholar John Hope (1868–1936), who became the president of Morehouse College and Clark Atlanta University.

All of these warm recollections and associations flooded back in the form of letters and petitions to the Brown corporation during the "Andrews Controversy." Fearing the loss of alumni financial support, some conservative Republican members of the corporation took Andrews to task for his support of the monetary system reform proposed by Democrat and Populist William Jennings Bryan that would have elevated silver to an equal status with gold and allow it to back the currency of the United States. Andrews took this rebuke as an abrogation of his right of free speech and delivered a letter of resignation. Given the outpouring of support on his behalf, the corporation retracted its rebuke, and Andrews withdrew his resignation, but not before the issue had achieved national notoriety in 1897 and had become a major victory for free speech.

Andrews was born into a family of Baptist ministers in Hinsdale, New Hampshire, on January 10, 1844. His father was Reverend Erastus Andrews,

and his mother the former Almira Bartlett, a schoolteacher. He attended a series of preparatory academies prior to serving in the Civil War with the First Connecticut Heavy Artillery unit. Andrews arrived at Brown in 1866 and graduated in 1870. Deciding at first to pursue the ministry, he earned a degree from Newton Theological Seminary in 1874. In the next year, he assumed the presidency of Denison University in Ohio but returned to Newton in 1879 as a professor of pastoral theology.

Drifting into the fields of history and political economy, Andrews came back to Brown in 1883, where he wrote several texts on U.S. political history and the U.S. Constitution and also taught economics. His classes were extremely popular. In 1888, he left Brown to teach at Cornell, but within a year, he was invited back to Brown to serve as its president.

During his productive presidency, he became a charter member and the organizing president of the Rhode Island Society of the Sons of the Revolution in 1890. In 1892, he was an American commissioner to the Brussels monetary conference, where he advocated for international bimetallism.

After his tenure as president, Andrews became superintendent of the Chicago public schools for a two-year period. He completed his educational career as the chancellor of the University of Nebraska, where he was instrumental in establishing schools of education, medicine and law and trebling state appropriations for the university.

Declining health forced his retirement from Nebraska in December 1908. It was his final academic position. After a two-year world trip, he and his wife, Ella, retired to Interlachen, Florida, in 1912. Andrews died there five years later, on October 30, 1917, at the age of seventy-three. He was survived by his wife and two children.

IX

ARCHITECTS AND ARTISTS

GEORGE CHAMPLIN MASON II

George Champlin Mason II was born in Newport on July 17, 1820, the son and namesake of George Champlin Mason and Abby (Mumford) Mason. He was descended from families with deep roots in colonial Newport's maritime trade and from Christopher Champlin, one of the sea captains who assisted Oliver Hazard Perry in winning the critical Battle of Lake Erie during the War of 1812.

Although Hall of Fame inductee Peter Harrison (1716–1775) is generally regarded as Newport's first architect and hailed as the designer of Touro Synagogue, the Brick Market and the Redwood Library, it was George Mason II who was Newport's first resident professional in the field of architecture.

In the years following the American Revolution and the War of 1812, Newport was a "stabilized ruin" of its former self. Many of the merchant families who had made the town a leading seaport had fled during wartime, never to return. The age of the slave trade was over, and the town lacked the power of waterfall force that was turning Rhode Island's hinterland towns and villages into centers of manufacturing. Newport's colonial architecture and famed waterfront, later to be reclaimed and celebrated, was at the time in a decrepit condition. Mason became part of a new generation of planners, architects and community boosters who began the process of turning Newport into a visitor destination and a summer seaside retreat for the wealthy of Boston, Charleston, Philadelphia and especially New York City.

Mason did not set out to be an architect. His first job was in a mercantile house in New York City that became the forerunner of the Arnold & Constable department store. In 1844, taking the advantage of an inheritance from his father, he set off for Europe to study landscape painting and architecture in Rome, Florence and Paris. Upon his return two years later, he opened an art studio in Newport. Unsuccessful in that endeavor, he became a writer for the *Newport Mercury* in 1851 and eventually its editor and publisher by the time he left the paper in 1858. He was successful, turning the *Mercury* into a highly respectable and prosperous enterprise.

Teaming up with real estate speculator Alfred Smith, who was beginning to develop Bellevue Avenue to promote a grand seaside promenade called Ocean Drive, Mason opened his architectural firm in 1860, thereby becoming the city's first resident architect.

Between 1860 and his death in 1894, Mason and his firm erected more than 150 residential houses in Newport, many of them large and costly. The last work with which he was professionally concerned was the design of the U.S. Naval War College, which was erected in 1891–92.

Although some of Mason's homes of the 1860s and 1870s were eventually superseded by works of out-of-town architects who designed on a grander scale, his literary descriptions of Newport life endure. One of the principal founders of the Newport Historical Society in 1853, a promoter of Touro Park and an advocate for the preservation of the Old Stone Mill, Mason published *Newport and Its Environs* (1848), *Newport Illustrated* (1854), *Reunion of Sons and Daughters of Newport* (1859), *Newport and Its Cottages* (1875), *The Life and Works of Gilbert Stuart* (1879), *Reminiscences of Newport* (1884) and the *Annals of Trinity Church* (1890, 1894). These and other writings became documentary building blocks for later preservationists, just as his buildings became landmark features in the architecture of one of America's most beautiful cities.

Unfortunately, many of Mason's homes have been demolished to make way for residential subdivisions. The best-known of those surviving are Eisenhower House (1873) on the grounds of Fort Adams, the summer retreat

of President Dwight Eisenhower; Woodbine Cottage, now the Architect's Inn; and Chepstow at 120 Narragansett Avenue.

In addition to his architectural and historical work, Mason engaged in many civic activities. He was a vestryman and senior warden at Trinity Episcopal Church for many years, he was one of the founders and a trustee of Newport Hospital and he served as a director of the Redwood Library.

On August 10, 1848, Mason married Frances Elizabeth Dean. Their only child, George C. Mason III, born in 1849, became an architect and his father's partner from 1871 onward. The elder Mason died in Philadelphia on January 30, 1894, at the age of seventy-three and is buried at Newport's Island Cemetery.

RICHARD MORRIS HUNT

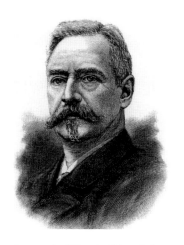

Born in Brattleboro, Vermont, on October 31, 1877, Richard Morris Hunt had impressive lineage. His mother, Jane Leavitt, came from a prominent Connecticut family, and his father, Jonathan, was a U.S. congressman whose own father had been lieutenant governor of Vermont. His family antecedents also included Gouvernor Morris of New York, a principal draftsman of the U.S. Constitution.

Hunt was the first American to study at the famed École des Beaux-Arts in Paris. He was an accomplished architect in New York, Boston and Chicago (where he designed the 1893 World's Fair Administration Building), but it was in Rhode Island that he accomplished most of his enduring masterworks. A favorite of New York City's rich and famous, Hunt was the architect of their Newport "cottages"— Marble House, the Breakers, Ochre Court, Chateau-sur-Mer, Belcourt Castle and others.

He was married to Catherine Clinton Howland, a union that provided social entrée to both New York and Newport circles. The Hunts lived in a house they called Hypotenuse on what is now the site of the Viking Hotel. One of his first commissions in Newport was the Griswold House (1863–64), now the Newport Art Museum. Hunt was often credited for putting the

gilding on the "Gilded Age." He is also cited for creating the profession of architecture in America.

Hunt formed the famous "Tenth Street Studio" upon his return from France in 1855. It became the training ground for some of the most famous architects in nineteenth-century America. Hunt cofounded the American Institute of Architects and became its third president, from 1888 to 1891. His advocacy for professional stature led his student William Robert Ware to establish university programs in architecture at MIT in 1866 and at Columbia in 1881.

Besides the spectacular "cottages" at Newport, reminders of Hunt's work are the base of the Statue of Liberty, the New York Tribune Building, the façade of the Metropolitan Museum of Art in New York (which was finished by his architect son) and many Fifth Avenue mansions. He was a frequent collaborator with America's premier landscape architect, Frederick Law Olmsted. Their most famous partnership produced the magnificent and huge Biltmore Estate in Asheville, North Carolina, which was constructed for George W. Vanderbilt.

Hunt died in Newport on July 31, 1895, at the age of sixty-seven and was buried at the Island Cemetery in his adopted city-by-the-sea. He is the subject of an excellent biography by Paul R. Baker.

CHARLES F. MCKIM

Charles Follen McKim was born in Chester County, Pennsylvania, on August 24, 1847. He was the son of an abolitionist father, who was also a Presbyterian minister, and a Quaker mother. The radical politics of his parents had little impact on McKim. He became a cosmopolitan architect who traveled in the company of wealthy and prominent businessmen and politicians.

After study at Harvard, McKim enrolled at the École des Beaux-Arts in Paris and traveled throughout Europe. Upon his return to America, he worked in New York City with the famed architect Henry Hobson Richardson. In 1879, he formed a partnership with William Rutherford Mead and Stanford White. This trio became nationally renowned for designing grand public buildings and splendid private mansions.

McKim and his associates were identified with the promotion of classicism as the basis for American public architecture. His firm's nearly

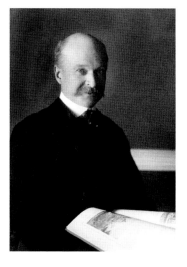

eleven thousand individual commissions during McKim's tenure were mainly from New York City and the Northeast, but the partners designed significant structures in many other states.

After 1887, as both the firm and the projects grew in size and complexity, a single partner would take charge, and the individual hand of each became easier to distinguish. McKim's dominant motif was the establishment of an architectural imagery appropriate for the United States. The result became known as American Renaissance— an attempt to both emulate and rival old-world culture and artistic standards.

McKim's strong contacts with Rhode Island began in 1874 when he married Anne Bigelow of New York, the sister of his one-time partner. He spent portions of the next several summers with Anne's family in Newport before divorcing her in 1879. By that year, he had gained a reputation for designing wooden summer houses in Newport and other East Coast resorts. These commissions dominated his firm's early work. The partnership's early shingle-covered structures included such Newport landmarks as its Casino, the Samuel Tilton House, the Isaac Bell Jr. House and Ochre Point. In Bristol, he designed the beautiful (and now demolished) William G. Low House on Bristol Point.

In the late 1880s, McKim moved to the more formal and classical American-Georgian style of the late eighteenth century and then to Greek and Roman classicism, which tended toward austere grandeur. Rhode Island examples of this transition include Newport's Beacon Rock (1891) and the magnificent Rosecliff, which was built for Hermann and Theresa Fair Oelrichs between 1897 and 1902 on a site formerly occupied by historian, rose horticulturist and Hall of Fame inductee George Bancroft.

McKim, with the aid of Richard Morris Hunt, was instrumental in the formation of the American School of Architecture in Rome in 1894, now the American Academy. His partnership designed its main buildings.

The firm's crowning Rhode Island achievement was the state capitol building, constructed between 1895 and 1900 on Smith's Hill overlooking Downtown Providence. According to one local architectural historian: "What set the Rhode Island State House apart from the other state capitols was…

the strength and clarity of the architects' interpretation....The success of this abstract design owes a great deal to McKim, Mead & White's organization of Renaissance-and Georgian-inspired sources into a tight, focused composition.... More important, the building projected the emerging American Renaissance, a new vision of urban America as the cultural inheritor of Ancient Greece, Republican Rome, and Renaissance Italy."

Shortly after completion of the statehouse, McKim was selected by President Theodore Roosevelt to remodel the White House. In 1902–3, he served as president of the American Institute of Architects (AIA), an organization that he helped to transform from a small, New York–based gentlemen's club into a national organization with political influence that promulgated standards for all American architects. He also received numerous awards and honorary doctorates. McKim died on September 14, 1909, in St. James, New York, at the age of sixty-two.

As this book went to be published, the Princeton Architectural Press released a lavishly illustrated 428-page volume titled *McKim, Mead & White: Selected Works, 1879–1915*, featuring the Rhode Island Statehouse, the Newport Casino, the Narragansett Pier Casino, Rosecliff and several other Newport mansions.

STANFORD WHITE

Although he was born in New York City on November 9, 1853, Stanford White found in Rhode Island the perfect social and natural setting for his artistic talents, and Rhode Island found in Stanford White the architectural genius that perfectly captured the spirit of its "Gilded Age." Whereas one without the other would have been noteworthy, the combination produced one of the greatest epochs in Rhode Island architectural history.

At the age of nineteen, Stanford White began an apprenticeship in the Boston office of Henry Hobson Richardson, the most famous architect of his time. He then studied architecture in Europe, accompanied by his lifelong friend, sculptor Augustus Saint-Gaudens. Upon his return in 1879, White entered into partnership with Charles F. McKim and William R. Mead, forming the firm of McKim, Mead & White. This trio received major commissions that included New York's Pennsylvania Station and Madison Square Garden, the Washington Memorial Arch and the Boston Public Library. The firm also secured several Rhode Island institutional

commissions that included the Newport Casino, Narragansett Pier Casino and the Rhode Island Statehouse (described in the profile of White's partner Charles McKim).

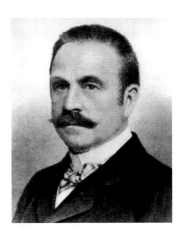

As the most flamboyant, gregarious and socially mobile member of the partnership, White developed a bevy of high-profile, private residential commissions. Many of his finest examples, done in the distinctive "Shingle" and "Beaux-Arts" styles, are still to be admired in Newport. From 1881 to 1891, White, individually or in conjunction with his firm, produced such famous Newport mansions as Kingscote, Ochre Point, Fairlawn, the Isaac Bell House, Sunnyside and Beacon Rock. From 1896 to 1902, he presided over the construction of the magnificent Rosecliff, which was later chosen as the backdrop for such Hollywood movies as *The Great Gatsby*, *The Betsy* and *True Lies*.

Even in death, White was sensational. He was murdered on June 25, 1906, at age fifty-two in the Roof Top Supper Club of Madison Square Garden, a facility that he had designed. His killer was millionaire Henry K. Thaw, husband of actress Evelyn Nesbit, with whom the womanizing White once had an affair. The press called the ensuing courtroom drama the "Trial of the Century." The erratic Thaw was the first defendant to gain acquittal by reliance on the controversial theory of "temporary insanity."

White has gained lasting fame through his magnificent Rhode Island architectural legacy. He is the subject of a fascinating biography by Paul R. Baker titled *The Gilded Life of Stanford White*.

JOHN LA FARGE

John Frederick La Farge was born in New York City in March 31, 1835, the son of John Frederick La Farge and Louisa Josephine Binesse de Saint-Victor, both of whom were prosperous emigrants from France. His interest in art began during his training at Mount St. Mary's College in Maryland and St. John's College (now Fordham University) in New York City. He had only the practice of law in mind as a career until he returned from his first visit

to Paris, France, where he studied art with Thomas Couture and became acquainted with famous literary people of the city. La Farge subsequently worked with painter William Morris Hunt in Newport.

Even La Farge's earliest drawings and landscapes, done in Newport after his marriage in 1861 to Margaret Mason Perry, granddaughter of Commodore Oliver Hazard Perry, show marked originality, especially in the handling of color values. They also display the influence of Japanese art, the study of which he pioneered. It should be noted that his wife's grand-uncle, Commodore Matthew Calbraith Perry, had opened Japan to western influences in 1854. Their marriage was nearly as productive as La Farge's artistic career. The couple had ten children, seven of whom survived to adulthood.

The period from 1859 into the early 1870s is described by art historians as La Farge's "Newport period." During this phase of his career, he painted religious subjects, landscapes and seascapes, and he also did book illustrations. While in Newport, La Farge gained an avid following in Boston and New York, and that prompted his move to these cities to work while his wife maintained their Newport residence. Such an arrangement strained the marriage.

Between 1859 and 1870, La Farge illustrated Alfred Lord Tennyson's *Enoch Arden* and Robert Browning's *Men and Women*. Breadth of observation and structural conception, as well as a vivid imagination and sense of color, are shown by his mural decorations. His first work in mural painting was done in Trinity Church, Boston, in 1875–76. Then followed his decorations in the Church of the Ascension (the large altarpiece) and in St. Paul's Chapel at Columbia University in New York. At age seventy-one, he executed four great lunettes for the Minnesota State Capitol in St. Paul representing the history of law, as well as a similar series with justice as the theme for the Maryland Court of Appeals building in Annapolis. In addition, he generated vast numbers of other paintings and watercolors, notably those recording his extensive travels in the Orient and the South Pacific.

La Farge is best known for his pioneering use of opalescent glass and stained-glass window design. His important work in this field graces churches,

public buildings and homes throughout America. A brief profile such as this cannot do justice to the volume and scope of his work. La Farge was the most versatile artist of his time.

His labors in almost every type of art earned him the Cross of the Legion of Honor from the French government, membership in the principal artistic societies of America and the presidency of the National Society of Mural Painters from 1899 through 1904. In that latter year, he was one of the first seven artists chosen for membership in the American Academy of Arts and Letters.

La Farge possessed an extraordinary knowledge of literature, art and languages ancient and modern. He venerated the traditions of religious art and preserved always his Roman Catholic faith. After his passing on November 14, 1910, in Providence at the age of seventy-five, he was interred at Brooklyn's Green-Wood Cemetery.

La Farge's descendants were also extraordinary. His sons Christopher and Oliver Hazard Perry La Farge became prominent architects, and another son, John, became a Jesuit priest, a prolific author and a pioneer in the national civil rights movement. His grandson Oliver H.P. La Farge was a distinguished anthropologist, Native American rights advocate and Pulitzer Prize–winning novelist. Another grandson, Christopher La Farge, was also a noted novelist. Both grandsons have been inducted into the Rhode Island Heritage Hall of Fame.

EDWARD MITCHELL BANNISTER AND CHRISTIANA (BABCOCK) BANNISTER

Edward Mitchell Bannister, one of Rhode Island's foremost artists, was born in St. Andrews, New Brunswick, Canada, in 1828. His father, William, came from Barbados in the West Indies; his mother, Hanna Alexander, was of Scottish ancestry. Edward's interest in art was encouraged by his mother, who raised Edward and his brother following her husband's death in 1832.

Edward worked briefly on coastal commercial ships before moving to Boston in 1848. There he worked as a barber and hairdresser in the African American community. His desire to become an artist was thwarted by his inability to find an artist for a mentor or an art school who would accept him, so he became largely self-taught.

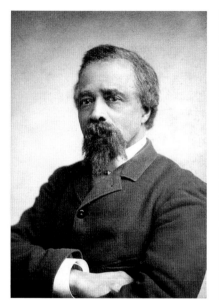

By the early 1850s, while he was working at a salon owned by Christiana Carteaux, he had acquired a local reputation for his portraits in crayon. In 1854, Bannister received his first commission for an oil painting: *The Ship Outward Bound*. In addition, his work relationship blossomed into a marital union when he married his boss in 1857. With her financial support, Edward was able to work full time as an artist by 1858 and opened a studio on Tremont Street. In the mid-1860s, he spent time in New York City studying photography. He also attended evening drawing classes in Boston taught by physician and sculptor Dr. William Rimmer.

In 1869 or 1870, the Bannisters moved to Providence, where Edward opened a studio and gained both recognition and acceptance because of the quality of his work.

In 1876, at the Philadelphia Centennial Exposition, where industrial Rhode Island was much in evidence, Bannister became the first African American artist to win a national award when he received a bronze medal for his large oil painting *Under the Oaks*. Bannister later recounted the story of how he was initially refused entrance to receive his prize because of his race. It is ironic that an accomplished Tonalist painter could be denied an award because of his own color!

Once back in Rhode Island, Bannister worked with the founders of the new Rhode Island School of Design, became a founder of the Providence Art Club, maintained a studio and executed a variety of artworks. His style

and predominantly pastoral subject matter were inspired by his admiration for Millet and the French Barbizon School.

Edward died of a heart attack on January 9, 1901, while attending services at the Elmwood Free Will Baptist Church in Providence, not far from his home at 60 Wilson Street, where he had recently moved. He was laid to rest at the North Burying Ground.

Five months after his death, the Providence Art Club held a memorial exhibit containing 101 of his paintings. At that event, John Arnold wrote the following epitaph in the exhibit catalogue:

> *His gentle disposition, his urbanity of manner and his generous appreciation of the work of others made him a welcome guest in all artistic circles…he was par excellence a landscape painter, the best our state has ever produced. He painted with profound feeling, not for pecuniary results, but to leave upon the canvas his impression of natural scenery, and to express his delight in the wondrous beauty of land, sea, and sky.*

The art gallery at Rhode Island College is dedicated in his honor, and Bannister House on Dodge Street in Providence, a senior living rehabilitation and healthcare center, honors both Edward and his social activist wife, Christiana. Today, much of Edward's work can be viewed at the Smithsonian American Art Museum and in Rhode Island at Brown University and Rhode Island School of Design.

Christiana Carteaux Bannister was born Christiana Babcock in North Kingstown sometime between 1820 and 1822. Her parents were John and Mary Babcock. Details concerning the exact date of her birth and background are obscure, but she appears to have been of mixed Native American and African American parentage and was undoubtedly descended from slaves who worked the plantations of South County during the eighteenth century.

As a young woman, she moved to Boston and took up the trade of hairdressing. During her twenty-five-year residence in Massachusetts, she owned salons in both Boston and Worcester and prospered as an independent businesswoman and self-styled "hair doctress."

Christiana first married Desiline Carteaux, a Boston clothes dealer, probably of Caribbean origin. After this union failed, she wed Canadian-born Edward Mitchell Bannister, who with her financial support became one of America's most successful black artists. The Bannisters lived and worked with Lewis Hayden, a noted black activist, in the operation of Boston's Underground Railroad, assisting runaway slaves to maintain their

freedom. During the Civil War, Christiana helped to raise money to sustain the famous Fifty-Fourth Massachusetts Regiment of black soldiers, the unit immortalized in the 1999 motion picture *Glory*.

After the Civil War, the Bannisters moved to Providence, where Christiana opened another salon and became a patron of the arts. She was deeply involved in improving the lives of African American women and founded the Home for Aged and Colored Women at 45 East Transit Street, a facility that evolved into today's Bannister Nursing Care Center on Dodge Street in Providence.

Christiana Bannister's significance is that she rose above the constraints that her era placed on women and minorities and moved with facility and effectiveness among all levels of society, from runaway slaves to Providence's artistic community. She was a remarkable civic leader and humanitarian.

Christiana died on December 29, 1902, and was buried in her husband's plot at the North Burying Ground. Ironically, her name does not appear on the large gravestone erected in his honor, but a bronze bust of Christiana, based on a portrait painted by her husband, was dedicated at the Rhode Island Statehouse in December 2002.

James Sullivan Lincoln

James Sullivan Lincoln was Rhode Island's premier portrait painter of the nineteenth century and was acclaimed by his peers as the "Father of Rhode Island Art." Unlike Rhode Island's famed Gilbert Stuart, who was nationally recognized as the portraitist of the American founders, Lincoln painted mainly Rhode Island places and personalities, including many of those profiled herein.

Lincoln was born on a farm in Taunton, Massachusetts, on May 13, 1811, the oldest of the six children of Sullivan and Keziah Lincoln. James was orphaned while still in his teens, but he soon traveled eighteen miles westward to cosmopolitan Providence, where he first became an apprentice to the engraving firm of Horton & Hidden and then to Providence portraitist C.T. Hinckley. While working with Hinckley, Lincoln discovered his talent for painting, especially portraiture, and in 1832 he began a sixty-year career during which he produced more than four thousand painted and photographic images. His oils, crayons and photographs were the media he used to create and preserve the faces of nineteenth-century Rhode Islanders.

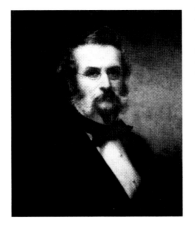

He recorded his progress from 1837 to 1887 in a handwritten logbook of his commissions that is now preserved at the Rhode Island Historical Society Library.

Lincoln received numerous commissions to depict local men, women and families during the course of six decades, and he did so by rendering faithful likenesses guided by his creative instincts. It has been said that his calm and objective temperament allowed him to paint both those he admired and those he did not. Not only did this attitude comport with his temperament, but it also enabled him to paint politically incompatible clients. Lincoln's contemporary subjects included such Rhode Island Hall of Fame inductees as Samuel Slater, Zachariah Allen, John Howland, William Read Staples, Henry Barnard, Wilkins Updike, Elisha Dyer II, Ambrose Burnside, William Sprague II, Amos Chafee Barstow and John Russell Bartlett. His portraits of fourteen Rhode Island governors adorn the walls of the statehouse. In addition, Lincoln painted copies of such earlier Rhode Island notables as Reverend James Manning (1738–1791), the first president of Brown University, and General William Barton (1748–1831), a Revolutionary War hero.

Amazingly, the man who revealed and preserved on his canvases the faces of so many Rhode Island leaders of his era is not well remembered himself. None of the standard biographical volumes containing entries detailing the lives of nineteenth-century Rhode Islanders includes a profile of Lincoln. Had he not signed his canvases, he would have remained almost anonymous, despite the lofty title conferred on him posthumously.

Lincoln was not known to be active outside the field of art, but at the end of his long career, he joined with four younger artists—Edward Bannister, Charles Walter Stetson, George W. Whitaker and Sydney Richmond Burleigh (all Hall of Famers)—to form the Providence Art Club in 1881, with Lincoln as its first president.

This quiet family man, praised by contemporaries for his "gentle and loving nature," possessed a humility that belied his stature as the premier portraitist of Rhode Islanders. He lived in various modest Providence dwellings with his wife, Rosina (whom he married in 1844), and their daughter, Ellen, the subject of one of his most admired portraits.

Lincoln died in Providence on January 19, 1888, and was buried at Swan Point Cemetery. A year after his death, the Providence Art Club commissioned a bust of Lincoln by visiting Italian sculptor Apolloni that still graces the organization he helped to create. Among those profiled herein, Lincoln is unique in that his brief biography is illustrated by his self-portrait, the original of which is on display at the Providence Art Club.

George William Whitaker

George William Whitaker was born in Fall River, Massachusetts, on September 25, 1840. He became one of the five founders of the Providence Art Club in 1880, along with James Sullivan Lincoln, Edward M. Bannister, Charles Walter Stetson and Sydney Burleigh. His father, James, was born in England. Both of his parents died at a young age, leaving him an orphan at the age of two.

Whitaker was raised by his maternal grandparents in Providence, where he attended public schools. At age fourteen, he went to live at the North American Phalanx, a transcendental community in Red Bank, New Jersey. There, he studied with a painting instructor, and the following year, he apprenticed with his uncle, Nathaniel Monday, a New York City engraver. He worked at that trade until he was thirty-one years old.

During his time as an engraver, Whitaker became more interested in landscape painting and was influenced by the painters of the Hudson River School. He was mentored by landscape artists George Inness and Alexander Wyant. Then he went to Europe for further training. Because he studied in Paris with László Paál, his work was influenced by the Barbizon School of landscape painters, where natural scenes became the subjects of paintings rather than being mere backdrops. He is best known for his Tonalist landscapes, which he developed in his years at Barbizon and Fontainebleau.

Often called the "Dean of Providence Painters," Whitaker promoted collegiality among artists and was comfortable working with other painters. He had a studio for several years at 65 Westminster Street. Then, in 1895, he joined fellow artist Sydney Burleigh in Burleigh's Fleur de Lys Building on

Thomas Street, a few doors down the hill from the Providence Art Club. He was the first instructor in oil painting at the Rhode Island School of Design and a founder of the Providence Watercolor Society. He exhibited at the National Academy in 1867 and 1869 and at the Boston Art Club throughout the 1880s. Whitaker's achievements in art were equal to his efforts to create, via the Providence Art Club, an organization that nurtured and supported talented Rhode Island artists.

Whitaker married Sarah L. Hull in 1863 and took up residence in the Fruit Hill section of North Providence. The couple had one daughter. He died in Providence on March 6, 1916, at the age of seventy-five and is buried at Swan Point Cemetery.

Sydney Richmond Burleigh

Sydney Richmond Burleigh was born in Little Compton, Rhode Island, on July 7, 1853. He was a descendent of Pilgrim governor William Bradford. In 1875, he married Sarah Wilkinson, and with her encouragement and financial support, he studied art in Paris from 1878 to 1880 with Jean-Paul Laurens.

Upon his return to Rhode Island in 1886, he was one of the first exhibitors in and a cofounder of the Providence Art Club. He taught at the Rhode Island School of Design from 1897 to 1906, served RISD as a trustee from 1919 to 1931 and was one of the founders and the first president of the Providence Watercolor Society.

Burleigh became a champion of the emerging Arts and Crafts movement. In 1885, this advocacy took physical form in the design of his Thomas Street studio in Providence, called the Fleur de Lys Building, on the slope of College Hill. This building, placed in the National Register in 1992, is now owned by the Providence Art Club.

Another of Burleigh's studios was an eccentric, small building he called Peggotty, which he built over the hull of a small sailboat that had been used as a ferry between Middletown and Little Compton. It is now on display at the Little Compton Historical Society.

In addition to his Little Compton paintings, Burleigh was interested in arts and crafts and worked with Providence's Handicraft Club. He helped form the Art Workers Guild and took part in the national Arts and Crafts Exhibit of 1901. This expansion from two-dimensional depictions into the third dimension of arts and crafts added new variety to the Providence art

scene. He was a painter of the realist style who also worked as an illustrator of several children's books written by William Henry Frost.

Burleigh rose to national prominence when he was awarded a bronze medal at the famous St. Louis Exposition (the World's Fair) of 1904. He received an honorary degree from Brown University in 1913.

Burleigh's prominent role on the local art agenda endured for the next thirty years, until his death on February 25, 1931.

CHARLES DE WOLF BROWNELL

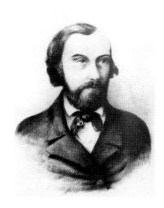

Charles De Wolf Brownell was born on February 6, 1822, in Providence. When he was two years old, his family moved to East Hartford, Connecticut, where his father, Dr. Pardon Brownell, practiced medicine. On his paternal side, his genealogy may be traced to Captain Benjamin Church, a leader in King Philip's War. His mother, Lucia Emilia De Wolf of Bristol, was an amateur artist who was descended from that town's major mercantile family. Charles had three eminent brothers: Henry Howard (the Civil War poet), Clarence Melville (famed explorer who was one of the first Americans to navigate the Nile) and Edward (a leading physician in the South).

In 1843, Brownell became an attorney and lived in a house in Hartford directly opposite Connecticut's famed Charter Oak, which fell in a windstorm in 1856. He later rendered a well-known painting of that historically famous tree where Connecticut hid its Royal Charter of 1662 to keep the colony from being absorbed by the Dominion of New England in 1686.

After a decade of practice, Brownell abandoned his career as a lawyer, having become enamored of landscape painting as a result of his sketching trips through the Connecticut River Valley with artist Henry Bryant.

In 1865, Charles married Henrietta Knowlton Angell Pierce of Bristol, and that union prompted him to take up permanent residence on Walley Street in his mother's hometown. From his Bristol base, Charles and his family (a wife and four sons) traveled extensively in Europe during the 1870s, and he painted some of his finest works. Later, Brownell's solo expeditions took him to the Hudson River Valley, the Caribbean, Mexico, Cuba, South America and the American Southwest. He captured the beauty of all these areas in his paintings. On June 6, 1909, twelve years after the death of his wife, the wandering Brownell (who had taken a 'round-the-world cruise in 1897–98) finally came to rest and was buried at Bristol's Juniper Hill Cemetery.

Many of Brownell's best-known paintings—*Pinkham Notch*, *White Mountains*, *The Charter Oak* and *The Burning of the Gaspee*—reflect the spirit and talent of a Rhode Island Renaissance man who compiled an

impressive collection of artistic works during his fifty-year career. In 1991, Kennedy Galleries in New York City gave Brownell's works their first major exhibition and published a detailed catalogue titled *Charles De Wolf Brownell: Explorer of the American Landscape*.

JANE STUART

Jane Stuart was born in Roxbury, Massachusetts, in 1812. She became Newport's first woman portraitist, following in the illustrious footsteps of her famous father, Gilbert Stuart. Jane was the youngest of his twelve children and his tenth daughter. She appears to have been the great artist's favorite offspring, and she worked with him in his declining years until his death in 1828, often completing the portraits he had begun.

Jane painted for brief periods in New York and Boston but spent most of her career in Newport. In 1863, she acquired a home and studio at 86 Mill Street. There, for the final twenty-five years of her life, she worked, entertained a wide spectrum of local literati and community leaders and displayed her paintings, as well as several relics from her father's career. She died in Newport on April 27, 1888, and was interred at Newport's Common Burying Ground.

Jane was not only a skilled copyist of paintings, especially those of her father, but also a fine portraitist in her own right whose recognition was to a degree hampered by her gender. She was adept at a variety of subjects and had a distinctive style of her own. Jane was also an influential art teacher. One art historian has noted that there are 120 citations to her paintings in collections across the country, describing Jane as "a lively and prolific contributor to American art." Berit M. Hattendorf wrote a detailed and informative essay on Jane's career that was featured in *Newport History* magazine in 1996.

JEAN PAUL SELINGER

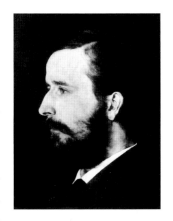

Jean Paul Selinger was born on June 24, 1850, in Boston. He studied art at the Lowell Institute, next trained abroad at the Art Academy in Stuttgart and then studied under Wilhelm Leibl at the Academy of Fine Arts in Munich. Selinger was a colleague of William Merritt Chase and became a skilled portraitist, genre painter and landscape artist.

In the 1880s, Selinger opened an art studio in Providence and married Rhode Island–educated floral artist Emily Harris McGary (a distinguished silver medalist in Providence and Boston Art club competitions). Together, the Selingers became prominent fixtures in both Rhode Island and New England art circles, and their papers are preserved in the Archives of American Art.

Between 1886 and 1909, Jean Paul maintained summer studios at grand resorts in New Hampshire: at the Glen House in Pinkham Notch and in Crawford Notch, where he achieved further regional and national recognition as a leading artist of the "White Mountain School." His paintings were exhibited at or became acquisitions of such prestigious institutions as the Pennsylvania Academy of Fine Arts, the Boston Art Club, the National Academy of Design, the Boston Museum of Fine Arts, the Rhode Island School of Design Museum, the Massachusetts Historical Society and the Bostonian Society.

Selinger was also a successful commercial artist whose 1904 painting *Bringing the Wanderer Home* won the national Osbourn Prize. His sentimental lithographs were distributed nationally by such Providence outlets as the Tilden-Thurber Company and became popular fixtures in households across America at the turn of the twentieth century. He died of cancer in Boston City Hospital on September 11, 1909, at the age of fifty-nine.

William Trost Richards

William Trost Richards, a noted marine artist in watercolor and oils, was born in Philadelphia on November 14, 1833, the son of Quaker parents. His formal academic education ended in 1847 following his father's death when he began work as designer and illustrator of ornamental metalwork to help support his family. His first local public exhibit was held in New Bedford in 1858 as part of a larger showing organized by artist Albert Bierstadt.

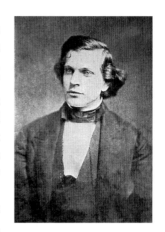

Richards married writer Anna Matlack in 1856 and settled in Germantown, Pennsylvania, where he lived until 1881. He studied drawing with the German-born artist Paul Weber and traveled and sketched with William Stanley Haseltine.

Richards traveled widely and was often accompanied on painting trips by his artist daughter, Anna Richards Brewster. He did not fully embrace the romanticized and stylized approach of the so-called Hudson River School of painters, instead insisting on meticulous factual renderings, as evidenced by his membership in the Association for the Advancement of Truth in Art. By the 1870s, he had turned increasingly to the marine paintings for which he is best known.

Richards first summered in Newport in 1874 and then purchased a home on Gibbs Avenue in 1875. In 1882, he built a large cliff-top home, Gray Cliff, on Conanicut Island (i.e., Jamestown) overlooking Narragansett Bay. He continued to paint in Newport and Jamestown for the rest of his life, dividing his time among his Chester County farm in Pennsylvania, Newport, England and the European continent.

Richards's works are featured today in many important American museums, including the National Gallery, the Smithsonian American Art Museum, the Metropolitan Museum of Art, the Philadelphia Museum of Art, the Yale University Art Gallery and Boston's Museum of Fine Arts. By the late nineteenth century, he was one of the best-known watercolorists in America. He enjoyed financial success and acclaim during his lifetime, and his Luminist views of the coast of Rhode Island are among his best-known images.

Richards died in Newport on November 8, 1905, just prior to his seventy-second birthday.

JOHN FREDERICK KENSETT

John Frederick Kensett was born in Cheshire, Connecticut, on March 22, 1816, the son of Thomas Kensett, an English engraver who had immigrated to America, and Elizabeth Daggett. By age twelve, after schooling at Cheshire Academy, he was working in his family's engraving and printing business in New Haven. When he was thirteen, Kensett was sent to New York as an apprentice to Peter Maverick, then America's leading engraver. In Maverick's shop, he met John W. Casilear, who would also become a painter and would remain Kensett's lifelong friend. In 1840, they traveled throughout Europe, sketching and painting together while moving to London, Paris and Italy.

Kensett first came to Newport in 1854, and he continued to visit the Narragansett Bay region until his death in New York City on December 14, 1872, at the age of fifty-six. He succumbed to pneumonia and heart failure contracted while trying to retrieve the body of a friend's wife from the chill waters of Long Island Sound. He was interred at Brooklyn's Green-Wood Cemetery.

By the 1860s, Kensett had reached the height of his career as a Luminist painter of quiet, atmospheric landscapes and New England coastal views. Many of Kensett's finest and most sought-after paintings were executed along the Newport shore.

Kensett's entrée into artistic circles in New York and his acceptance into high society occurred almost instantaneously. In 1857, he was a founder of the Artists' Fund Society and later served as its president. He was also a founder and trustee of New York's Metropolitan Museum of Art when that prestigious institution was created in 1870.

When the contents of his studio were auctioned in 1873 following his tragic death, they brought more than $136,000, a huge sum for that time. He is regarded as one of the most influential members of the second generation of the Hudson River School of landscape artists.

MARTIN JOHNSON HEADE

Martin Johnson Heade was an accomplished landscape, portrait and still-life painter, in addition to being a poet and a naturalist. Heade is one of the most important American Romantic painters of the nineteenth century and one of the major figures in the development of Luminism. Born in Lumberville, Bucks County, Pennsylvania, on August 11, 1819, the son of a storekeeper, he received his first art training around 1838 from local folk artists Edward and Thomas Hicks.

In 1858, Heade took a studio in the Tenth Street Studio building in New York City. He also kept a studio at times in Providence and in Boston. Heade made painting trips to Brazil, Nicaragua, Colombia, Puerto Rico, Panama, Jamaica, British Columbia, California and Florida. During his many travels, the artist closely observed the local flora and fauna and painted both small, detailed nature studies and large landscapes.

Although Heade traveled throughout the world, the time he spent living and working in Rhode Island from the late 1850s to the early 1870s had the greatest impact on his work. His early landscapes were roughly imitative of the Hudson River School. Inspired, however, by the rich natural beauty and the unusual qualities of light and atmosphere in the Narragansett Bay region, Heade began to develop his mature Luminist style. His 1861 painting *Approaching Storm, Beach Near Newport* has been interpreted by some art historians as his expression of the imminent Civil War.

During the early 1880s, Heade resided in New York and Washington, D.C. In 1883, he settled in historic St. Augustine, Florida, where his chief patron was the oil and railroad baron Henry Flagler. There Heade painted Cherokee roses, orchids and magnolias, often depicting the same flower again and again in various stages of bloom. Heade's work can be found in the collections of many major American museums. He died on September 4, 1904, at the age of eighty-five in St. Augustine and is buried there.

CHARLES WALTER STETSON

Charles Walter Stetson was born at Tiverton Four Corners on March 25, 1858, to Joshua Stetson, a Baptist preacher who dabbled in herbs, and Rebecca Steere. He was raised from age eleven in an impoverished Providence household. During his career, he gained national recognition as a distinguished painter and an incomparable colorist. Self-taught, Stetson was painting by the age of fourteen and was quickly admired for his colors and his landscapes, which he patterned after the British art critic, essayist and watercolorist John Ruskin. At age twenty, Stetson opened his own studio in Providence and befriended the talented African American artist Edward Bannister and painter George Whitaker, the "dean" of the Providence Art community. Their professional meetings, beginning in 1879, resulted in the founding of the Providence Art Club on February 19, 1880. Stetson served briefly as an art critic for the club, and his comments were published by the *Providence Journal*.

In the fall of 1881, Stetson was not only painting his landscapes, portraits and etchings but also beginning a love relationship with Charlotte Perkins, a young lady connected through her father to the famed and powerful Beecher family, of which the grande dame was the best-selling novelist Harriet Beecher Stowe.

Charles and Charlotte were married in 1884 and the following year had a daughter, Katherine Beecher Stetson, who also became a noted artist. In 1888, Charles and Charlotte separated, and she departed for California. Two years later, Charles went west to reconcile the marriage, but to no avail. The couple was amicably divorced in 1894, and Charlotte went on to marry George Gilman and become a leading feminist and social reformer. Charles soon

married Charlotte's cousin and closest friend, Grace Ellery Channing, a poet and descendant of William Ellery, Rhode Island statesman and signer of the Declaration of Independence. The triangular relationship among the three stayed friendly through the years.

Stetson remained in Pasadena after his marriage to Grace, living there long enough for the California arts community to claim him as its own. In 1901, he and Grace went to live in Rome, where Charles had many artist friends and did considerable painting, but he was

never active there in artistic organizations. Always a man of fragile health, he died in Rome on July 21, 1911, at the age of fifty-three. A memorial exhibition of Stetson's work in 1912 generated praise from critics, one of whom exclaimed that "few paintings convey such majesty and sublimity of feeling."

Stetson was highly praised in Europe by artists and critics alike. He was considered one of the greatest Symbolists of his time, a painter who could heighten the experience of nature and could paint softly contoured landscapes and figure studies to evoke moods of reverie and nostalgia. Stetson's most prominent feature was color. According to one critic, his work stood out for its allegorical and imaginative qualities.

EDMUND DARCH LEWIS

Edmund Darch Lewis was born in Philadelphia on October 17, 1835, the son of David and Camilla (Phillips) Lewis, well-to-do parents who could subsidize his artistic study. He became one of the most popular of the Philadelphia landscape painters and one of the best-known artists of Narragansett Bay, particularly in capturing the Victorian heyday of the Towers and grand Casino of Narragansett Pier.

A student of Paul Weber from 1850 to 1855, Lewis exhibited at the Pennsylvania Academy of Fine Arts, the Boston Athenaeum, the National Academy of Design and the Boston Art Club.

In the second half of the nineteenth century, Lewis was one of America's premier watercolorists. Employed briefly in Narragansett by a photographer to touch up photos, he also painted original watercolor works prolifically— sometimes three per day. Lewis's watercolors of resorts and yacht races— many with a Rhode Island setting—are part of the broader *fin-de-siècle* artistic interest in leisurely subjects executed in watercolors, pastels and prints, known

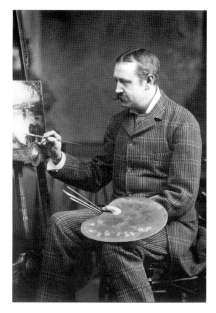

in artistic circles as "the genteel media." Also notable are his Rhode Island seaside scenes such as *Forty Steps, Newport* and *Indian Rock, Narragansett*. He is considered one of the Luminist painters of the Hudson River School.

Lewis died in Philadelphia on August 12, 1910, in his elegant downtown mansion, a building that contained his large collection of decorative art, which included furniture, tapestries and ceramics as well as paintings.

X

SAILORS AND THE SEA

Rear Admiral Stephen R. Luce

Rear Admiral Stephen R. Luce was born in Albany, New York, on March 25, 1827, to Dr. Vinal Luce and Charlotte (Bleecker) Luce. He was a founder and first president of the United States Naval War College in Newport. Luce entered the navy in 1841 as a midshipman and attended the U.S. Naval Academy in Annapolis when it first opened in 1845. After graduation in 1849, he performed a decade of sea duty before returning to Annapolis in 1860 as an instructor in seamanship and gunnery. This assignment launched a career in naval education that spanned the next half century.

Luce served on the Atlantic coast blockade of the Confederacy during the Civil War and commanded the ship *Nantucket* at the siege of Charleston. In 1862, he moved with the U.S. Naval Academy to Newport, summer home of its founder, Hall of Fame inductee George Bancroft, when that facility was transferred for security reasons from Annapolis located in the border slave state of Maryland. There, while serving as head of the Department of Seamanship, he prepared one of the first textbooks in that field of study.

After the Civil War, Luce held a number of commands and specialized in the development and implementation of naval training programs. By 1881, he had attained the rank of commodore, and he commanded the U.S. Navy Training Squadron in Newport.

These efforts were a prelude to Luce's major achievement: the establishment of a school for the advanced education of naval officers in strategy, tactics, diplomacy and international law. President Chester Arthur's secretary of the navy, William Chandler, and Rhode Island's U.S. Senator Nelson Aldrich responded to Luce's initiatives in 1884 by establishing the Naval War College on Coasters Harbor Island in Newport and appointing the commodore as its first president. Luce left this post in 1886 for the command of the North Atlantic Squadron after recruiting a small faculty that included Captain Alfred Thayer Mahan.

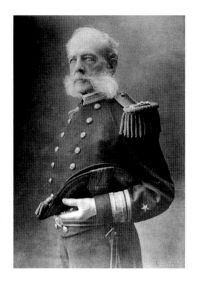

Luce engaged in a diplomatic dispute relating to the Canadian American fisheries controversy and served as president of the U.S. Naval Institute beginning in 1887, before retiring from active duty in March 1889, having reached the mandatory retirement age of sixty-two and the rank of rear admiral. However, he continued to serve as the institute's president until 1898.

In the final two decades of his productive career, Admiral Luce carried out several diplomatic assignments, and in 1901, he began once more to teach at the college that he founded. He retired from the War College faculty in 1910 and died in Newport on July 28, 1917, at the age of ninety. He is buried at the cemetery of St. Mary's Episcopal Church in Portsmouth, where he had served as a vestryman and a warden. An excellent account of Luce's impact on Rhode Island is Anthony S. Nicolosi's article "Rear Admiral Stephen B. Luce, U.S.N. and the Coming of the Navy to Narragansett Bay" in *Rhode Island History* (Summer 2008).

REAR ADMIRAL ALFRED THAYER MAHAN

Alfred Thayer Mahan, the best-known and most influential naval officer of the late nineteenth century, was, ironically, born at West Point on September 27, 1840. He was the son of Mary Okill and Dennis Hart Mahan, a professor of military engineering and dean of faculty at the U.S. Military Academy.

Admiral Mahan was a man of contradictions—an army brat who became a navy officer, a brilliant intellectual who disdained formal study and a captain who was prone to seasickness and hated sea duty. Despite a less than inspiring career as a naval officer in the quarter century following his graduation from the U.S. Naval Academy in 1859, he was selected by publisher Charles Scribner's Sons in 1883 to write a book for the Navy in the Civil War series. Mahan's volume, *The Gulf and Inland Waters*, impressed Admiral Stephen Luce, prompting him to invite Mahan to lecture on naval history at the newly established U.S. Naval War College in Newport.

Mahan came to teach, but he became college president in 1886 after Luce's reassignment. Of much greater importance, he published his class lecture notes in 1890 under the title *The Influence of Sea Power upon History, 1660–1783*, a volume that attributed England's global influence to the power and scope of the Royal Navy. According to Mahan's biographer, "the book electrified foreign offices and war departments all over the world" and furnished a rationale (unintended by Mahan) for the great naval arms race of the next quarter century. Two years later, Mahan followed his blockbuster book with a sequel, *The Influence of Sea Power upon the French Revolution and Empire, 1793–1812* (two volumes, 1892).

Mahan led the Naval War College from June 22, 1886, to January 12, 1889, and again from July 22, 1892, to May 10, 1893. During his first term, he met and befriended a young New York aristocrat named Theodore Roosevelt, on whom he would assert tremendous influence.

Captain Mahan argued for a modern naval buildup that would protect America's coasts—Caribbean, Gulf and Pacific—and he espoused an isthmian canal. He did so, however, for security reasons. His expansionism was strategic and defensive. Notwithstanding the limits of Mahan's proposals, contemporary American imperialists like Theodore Roosevelt, John Hay and Henry Cabot Lodge used Mahan's basic thesis to justify a more aggressive and acquisitive American expansionism in emulation of England and other leading European powers.

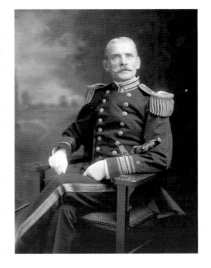

Captain Mahan retired from active duty in 1895 and was given the rank of rear admiral in 1906. He continued to

write voluminously on the naval, military and diplomatic issues of his era. Eventually, he published twenty-one books and attained the presidency of the American Historical Association. His most notable productions after his retirement were *The Life of Nelson: The Embodiment of the Sea Power of Great Britain* (two volumes, 1897) and *Sea Power in Relation to the War of 1812* (two volumes, 1905).

Although his reputation as an imperialist has been overstated, Mahan's insistence that the United States must become and remain a sea power is his greatest contribution to America's modern superpower status. His ideas still permeate U.S. naval doctrine. He has been called the "Apostle of Sea Power."

Mahan died in Washington, D.C., on December 1, 1914, of heart failure at the age of seventy-four. He is buried in Batavia, New York, a small town between Rochester and Buffalo.

IDAWALLEY "IDA" LEWIS

Idawalley "Ida" Lewis was born in Newport on February 25, 1841, the daughter of Idawalley Willey and lightkeeper Hosea Lewis. She is considered the most famous person ever to serve in the U.S. Lighthouse Service, an agency that evolved into the U.S. Coast Guard. In 1833, when she was eleven years old, her father, Hosea, was appointed keeper of the Lime Rock Light in Newport Harbor. In 1856, Ida became her father's assistant in running the lighthouse. Three years later, he suffered a stroke that left him partially paralyzed, and Ida assumed most of his duties in conjunction with her mother. In 1870, she entered into a brief marriage with William Wilson, a Connecticut sailor, that ended in divorce two years later.

After Hosea's death in 1872, Ida continued to maintain Lime Rock, but she was not officially appointed lightkeeper until 1879, becoming the first woman to hold such a post. By that time, she had gained national fame for several daring rescues and earned the support of Rhode Island's U.S. Senator Ambrose Burnside, who secured her official appointment.

Ida became an expert handler of boats, and it was said she could row a boat faster than any man in Newport. She was also an expert swimmer. Ida was visited by President Ulysses Grant, appeared on the cover of *Harper's Weekly* and had a song composed in her honor. In her fifty-five years at Lime Rock, she was credited with saving eighteen lives in the

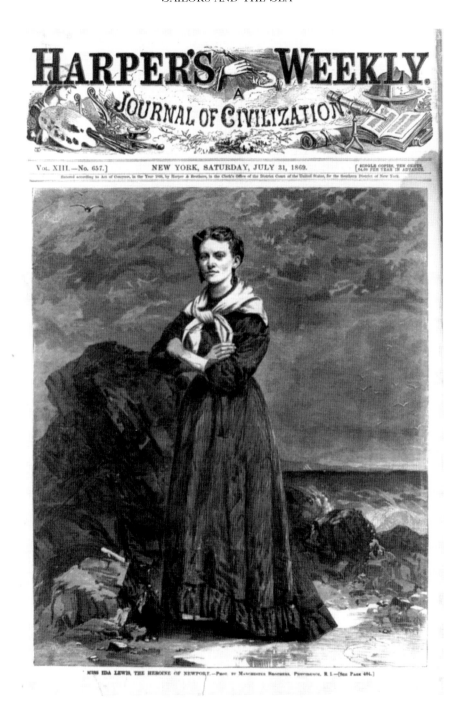

Ida Lewis. From *Harper's Weekly*, July 31, 1869.

choppy waters off Newport by risking her own. During her lifetime, Ida Lewis rose above the bias aimed at strong and assertive women and gained national notoriety for her rescues of shipwrecked sailors, earning the title of the "Bravest Woman in America." For her heroism, she was showered with gifts and honors.

In October 1911, while on duty, Ida suffered a paralytic stroke similar to the one that had felled her father. She died in her beloved lighthouse two weeks later on October 24 at the age of sixty-nine. Ida was laid to rest at Newport's Common Burial Ground on Farewell Street after more than 1,400 people had come to view her body at the Thames Street Methodist Church.

NATHANAEL GREENE HERRESHOFF AND JOHN BROWN HERRESHOFF

Known throughout America and the Atlantic world as the "Boatbuilders of Bristol," "Captain Nat" and "J.B." Herreshoff revolutionized the yachting world during the late nineteenth and early twentieth centuries.

Like so many of our Gilded Age inductees, they descended from prominent ancestors. Their grandparents were Karl Friedrich Herreshoff (1769–1819), a German immigrant from Prussia who was acquainted with ruler Frederick the Great, and Sarah Brown, daughter of the dominant Providence merchant and businessman John Brown. The parents of Nat and J.B. were Charles Frederick Herreshoff Jr., who was adept both at sailing and boat design, and Julia Ann Lewis of Boston.

Charles and Julia had nine children. Their fourth, John Brown Herreshoff, was born in Bristol on April 24, 1841; their seventh, Nathanael Greene Herreshoff, made his debut in Bristol on March 18, 1848.

At the age of fourteen, J.B. became totally blind, an affliction that was suffered by three other siblings. This handicap did not deter him because J.B. was a genius.

Captain Nat Herreshoff.

J.B. Herreshoff.

After a solo start in 1861, J.B. began a yacht-building business in Bristol with Dexter S. Stone in 1864 under the name Herreshoff & Stone.

At first, the Bristol company built sailing vessels, some of which were modeled by J.B. himself. In the early 1870s, under J.B.'s sole ownership, the firm shifted its focus to building steam yachts and then to innovative torpedo boats for the navies of the United States and three other countries.

While J.B. was operating a very successful and highly regarded business, his younger brother Nat was gaining a formal education and honing his innate mechanical skills. After schooling in Bristol, he enrolled at the Massachusetts Institute of Technology, where he built a rotary steam engine as a class project. Upon graduation in 1869, he went to work for the Corliss Steam Engine Company, as did other notable inventors of that era such as William Nicholson of file fame, whose family later summered in Bristol and sailed Herreshoff boats.

While in the employ of Corliss, Nat in his spare time made designs for his brother, the most notable of which was the novel catamaran yacht *Amaryllis*, built in 1876. That two-hulled boat sailed so fast that its type was banned from sailboat racing competitions in Long Island Sound.

In 1876, Nat traveled with George Corliss to Philadelphia for the great Centennial Exposition and was in charge of assembling the giant Corliss steam engine that powered the machinery displayed at this exhibition of American inventive ingenuity.

After his Philadelphia triumph, Nat joined with J.B. in 1878 to form the Herreshoff Manufacturing Company, and thereafter this dynamic duo made yachting history.

Captain Nat proved to be a naval architect and mechanical engineer without peer. With J.B. as the president, exhibiting management skills and business expertise, and Nat rendering innovative designs, the company flourished. By the 1890s, its facility on Bristol Harbor had grown from about twenty employees to more than three hundred, most of whom were Bristolians.

Despite its great success in building steam yachts, torpedo boats, launches, high-speed marine engines and tubular boilers, the company gained its enduring fame designing and/or constructing a series of racing yachts that eight times won competitions with England for the America's Cup, yachting's most prestigious prize.

A profile of this length does not allow a detailed discussion concerning the background of these occasional competitions or a statistical analysis of the Herreshoff-designed and built Cup defenders, five of which Captain Nat designed: *Vigilant* (1893), *Defender* (1895), *Columbia* (1899 and 1901), *Reliance* (1903) and *Resolute* (1920).

The *Reliance*, the largest and most notable of these vessels, was the fastest mono-hull Cup defender ever. It was 143 feet, 8 inches long and carried 16,700 square feet of sail on a single mast that was 199 feet, 6 inches high to the tip of its topmast. Its image now graces a U.S. coin—the Rhode Island quarter.

J.B. married Sarah Kilton of Boston in 1870 and fathered one daughter, Katherine, who married into Bristol's renowned DeWolf family. After J.B. divorced Sarah, he wed Eugenia Tucker of Bristol in 1892. J.B. died on July 20, 1915, at the age of seventy-four and was buried at Bristol's Juniper Hill Cemetery.

Captain Nat had even greater longevity, living to the age of ninety. During his extensive yachting career, he designed well over two thousand craft, and his company produced more than eighteen thousand boats of various kinds. Among his customers were the Vanderbilts, the Belmonts, the Whitneys and J.P. Morgan. In 1883, Nat married Clara Anna DeWolf, by whom he had six children. After her death in 1905, he married Ann Roebuck, who survived him.

Nat lived to see his company decline in the early 1920s when it was purchased by Hall of Fame inductee Rudolf F. Haffenreffer, a wealthy Fall River, Massachusetts brewer who maintained a summer estate on Mount Hope in Bristol. Under Haffenreffer, who also owned Narragansett Brewing Company in Cranston, the Herreshoff tradition continued, with Captain Nat still playing an advisory role and continuing to model new craft.

The firm's final two America's Cup victors—*Enterprise* in 1930 and *Rainbow* in 1934—were designed by W. Starling Burgess, son of Edward Burgess, a Bostonian who had crafted three successful defenders of the Cup in the 1880s before Captain Nat's long reign.

The Herreshoff Manufacturing Company continued to operate through World War II, producing exactly one hundred vessels for the U.S. military.

In 1946, at war's end, the shipyard closed. By that date, Nat had also passed away. He died at his Hope Street home, Love Rocks, on June 2, 1938, at the age of ninety and joined J.B. at Juniper Hill Cemetery. He was survived by his second wife and five of his six children.

Captain Nat has been the subject of more biographical writing and memorabilia than any Rhode Islander of this Golden Age. His son L. Francis Herreshoff, also a talented marine architect, in a biography entitled *Capt. Nat Herreshoff: Wizard of Bristol* (1953), detailed and analyzed more than two dozen of his father's achievements and innovations. Other notable works are Maynard Bray and Carlton Pinheiro's *Herreshoff of Bristol* (1989), Christopher Pastore's *Temple to the Wind: The Story of America's Greatest Naval Architect and His Masterpiece Reliance* (2005) and a series of excellent books and articles by Bristol historian Richard V. Simpson.

As if the deluge of books was not sufficient, Captain Nat and J.B. are memorialized in the Herreshoff Marine Museum founded on the site of the shipyard in 1971 by Nat's son A. Sidney DeWolf Herreshoff and daughter-in-law Rebecca (Chase) Herreshoff. Allied with the museum is the America's Cup Hall of Fame, created in 1992 by Kenneth Dooley and Halsey Chase Herreshoff (naval architect, America's Cup sailor and Bristol civic leader), who has joined his grandfather Nat and his uncle, J.B., in the Rhode Island Heritage Hall of Fame.

John A. Saunders Jr.

John A. Saunders Jr. was the central figure, chronologically and symbolically, of the noted South County family of boat builders, marine entrepreneurs and seamen. His Hall of Fame induction is an acknowledgment of his family's great maritime tradition.

Saunders was born in Newport on June 24, 1808, the grandson of Stephen Saunders, a shipwright, and the son of Captain John Aldrich Saunders (1786–1832), who built one of the first three-mastered schooners and discovered that the buttonwood tree provided the best wood for a ship's keel. In all, Captain Saunders Sr. constructed twenty-two sailing vessels, many of original design.

Among the captain's eleven children by Catherine (Maxson) Saunders was his namesake, John Aldrich Saunders Jr., our Hall of Fame inductee. Young John carried on the family tradition, helping his father complete his

The North Kingstown Bayside village of Saunderstown.

final vessel, the *Lark*, in 1832. He then built fifteen vessels of his own design, plus many small boats at a shipyard and marine railway he established on the West Bay at Willettville in 1855.

Because of the prominence of this enterprise and the migration of his siblings and in-laws to the site, this area of North Kingstown became known as Saunderstown. John's 1855 house on 166 Ferry Road still stands. It later became the home of his equally famous son Stillman Saunders, a designer of steam ferries (such as the ones he operated between Saunderstown,

Jamestown and Newport) and the founder of both the Narragansett Transportation Company and the Saunders House Hotel.

By the late nineteenth century, the Saunderstown community had evolved into a summer colony, initiated by Benoni Lockwood, a young Manhattan businessman and the son of a Providence China merchant by the same name. It attracted such luminaries as writers Edith Wharton, Christopher and Oliver La Farge, Caroline Hazard and Owen Wister. Like Edward Everett Hale and historian George Bancroft, Wister, the La Farges and Hazard earned Rhode Island Hall of Fame induction because they wrote extensively during the many summers they spent in residence on the Rhode Island coast. The village even received a brief visit from President Theodore Roosevelt, himself a major historian.

John Aldrich Saunders Jr. and his wife, Susan C. Gould, had thirteen children, including Stillman. Three of their other sons—Captain Daniel Saunders, Captain William Gould Saunders and Captain Martin Luther Saunders—carried on this renowned family's seafaring tradition, earning a reputation as "compulsive boat designers and builders." John Aldrich died on October 7, 1882, at the age of seventy-four. His legacy has survived, but an image of him has not.

THE ENTERTAINERS

DAVID WALLIS REEVES AND BOWEN R. CHURCH

David Wallis Reeves was born in Owego, New York, on February 14, 1838, the son of Maria (Clark) Reeves and Lorenzo Reeves, a merchant, Presbyterian deacon and a descendant of the famed jurist Tappan Reeve, founder of America's first law school (who omitted the *s* from his surname).

David was educated at local schools and spent one year at Wells Academy in Aurora, New York, where his older sister taught music. Upon his return to Owego, he studied music for several years under local teacher and bandleader Thomas Canham, playing both the violin and a new musical instrument invented in France called the cornet.

During the 1850s, David traveled extensively with Canham and then with circus bands, rising to the position of band leader. In 1860, he became cornet soloist with the celebrated Rumsey and Newcomb Minstrels and traveled with that group to England, Ireland, Russia and Saxony.

Upon Reeves's return to America, he joined the famous Dodsworth Band in New York City, where he remained cornet soloist until February 1866. At that time, he was recruited by the American Brass Band of Providence to replace its retiring leader and bugler Joseph C. Greene, who had directed that musical group since its formation on November 6, 1837.

For the next thirty-four years, Reeves's American Band, as it came to be known, generated local pride and enthusiasm. Reeves immediately put his stamp on the band by improving its programs, adding woodwind

instruments, enlarging its membership and writing its marches—at least one hundred of them—during his eventful tenure as conductor. He gave many of his compositions Rhode Island–related titles. In addition to being a brilliant concert band, the group enjoyed the reputation as the best street, or marching, band in America.

Not only was the American Band employed on every notable occasion by Rhode Island's military organizations, but it was also adopted by militias in Connecticut and Massachusetts. It played at Brown University commencements, at Rocky Point and Roger Williams Park before huge crowds and at a thirteen-acre amusement center in Providence called Park Garden, a facility created by Reeves and developer John R. Shirley in 1878.

Park Garden, a private venue, demonstrates the creativity of David Reeves. Bounded by Broad, Sackett, Niagara and Sumter Streets in the city's Elmwood section, it contained a natural amphitheater in which the owners created a pond with dimensions of about 350 by 150 feet. Other features were flower gardens, a colorful lighting system, a pagoda and a Japanese pavilion where the American Band played.

In 1879, the pond was the scene of a great theatrical extravaganza. Reeves and Shirley built a 110-foot ship with masts, yardarms and sails on the pond

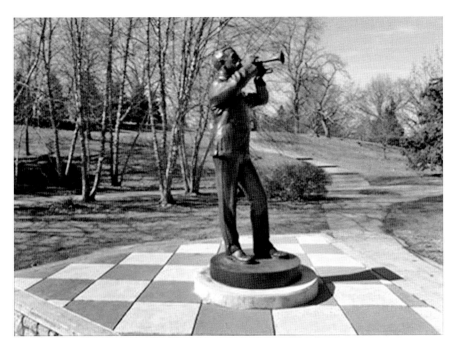

Statue of Bowen R. Church in Roger Williams Park.

as their stage for the performance of Gilbert and Sullivan's new operetta, *H.M.S. Pinafore.* Its thirteen-week run featured a local chorus of one hundred voices and a twenty-eight-piece orchestra that Reeves assembled for the show. Park Garden closed in the summer of 1883 and was platted into house lots, but the Reeves band played on.

It has been said that "all politics is local," but Reeves's American Band, a different form of entertainment, was national. It toured the country from coast to coast now that the railroad had become transcontinental. In 1892, when the band was in Tacoma, Washington, Reeves unexpectedly left town to conduct Patrick Gilmore's equally famous Twenty-Second Regiment Band at a St.

David Reeves.

Louis Fair after Gilmore's sudden death. Bowen R. Church, a protégé of Reeves, replaced him as director.

Fortunately for Rhode Island, Reeves did not mesh with Gilmore's musicians, and Church joined with many influential Rhode Islanders in urging Reeves to return. He did so with great fanfare in October 1893 and stayed until his death on March 8, 1900, of Bright's disease, a form of nephritis. He was sixty-two years of age. After a ceremony at the First Baptist Church, Reeves was buried at Swan Point Cemetery with Masonic honors.

Reeves was a friend of the legendary John Philip Sousa, leader of the U.S. Marine Corps Band, who praised Reeves as the "Father of Band Music in America" and sent two hundred roses to his funeral.

Reeves recruited top-flight musicians for his band, and the greatest of these was cornetist Bowen R. Church. He was born in the Cumberland village of Valley Falls on December 3, 1860, the son of Clark S. Church, a railroad worker, and Elizabeth (Reynolds) Church. The family moved to a farm in East Greenwich along South County Trail when Bowen was very young. He gave evidence of being a musical prodigy, and at age nine, Bowen encountered David Reeves on a train and arranged an impromptu audition using Reeves's cornet. The bandmaster was so impressed that he became Bowen's mentor. At age eleven, Bowen gave his first recital in Providence, at thirteen he was a junior member of the

American Band and by age eighteen he was the band's featured soloist and its assistant director.

In 1893, when Reeves departed briefly to direct Gilmore's band, Church assumed the group's direction and awed the audiences at the Chicago World's Fair with his melodic solos. His cornet was a keyed brass instrument smaller than a trumpet, but with three valves, it was more versatile than a bugle. Both trumpets and cornets were equal components of the brass ensemble, but the former were used in fanfares, whereas cornets played more melodic passages. Those mournful notes were the kind that evoked somber memories of the tragic Civil War for those soldiers of the Grand Army of the Republic who were fortunate enough to survive it. For them, Bowen Church touched their ears but also their minds.

When David Reeves died in late 1900, the mantle of leadership fell to his star performer, but Church was not up to the task. Personal problems with drink and competition among several people for control over the band made his association with it irregular. From 1904 to 1912, Warren R. Fales and local vaudeville impresario Edward Fay, also a Hall of Fame inductee, took charge, while Church served as soloist and occasional conductor. The highpoint of his career as bandmaster was a 1910 fourteen-week tour from Cleveland through Chicago to Denver, during which the American Band played 364 concerts.

In 1912, Church took a position in Jersey City leading the orchestra of the Atlantic and Pacific Tea Company. This was his final gig. On March 13, 1923, he died suddenly while conducting his band. He came home for burial at East Greenwich Cemetery.

In the late 1920s, Rhode Island paid tribute to its two great Gilded Age musicians. In 1926, a marble fountain was built near the Roger Williams Park bandstand as a memorial to Reeves, and in 1928, William James, a friend of Church's, funded a life-size bronze statue of the famed cornetist by Aristide Cianfarani that stands near the Reeves Fountain. The band of this melodic duo has also survived. Currently, it plays under the leadership of Dr. Brian Cardany of the University of Rhode Island.

An excellent essay on Reeves by Robin Murphy titled "David Wallis Reeves: Father of American Band Music" is contained in *Rhode Island's Musical Heritage: An Exploration* (2008).

COLONEL RANDALL A. HARRINGTON JR.

During the Gilded Age, Narragansett Bay became Rhode Island's playground, not merely for traditional pursuits like sailing and fishing but for a new brand of leisure activity catering to the masses: the amusement park. Rocky Point, the most famous and enduring of these innovative recreational sites, was the first to be established.

William Winslow, captain of the steamboat *Argo*, recognized the spot's potential, purchased the point area in 1849 and immediately constructed a wharf to land visitors for picnicking and strolling through the heavily wooded promontory. Eventually, natural attractions gave way to such diversions as a carousel, the state's first Ferris wheel, a clam-dinner hall, a bowling alley and a skating rink. During the 1860s, new owner Byron Sprague added a seventy-five-foot-high observation tower and the Mansion House Hotel. These and other innovations made Rocky Point the premier amusement center on Narragansett Bay during the Gilded Age.

After passing from Sprague to the American Steamship Company in 1869 and then to the Continental Steamboat Company in 1878, the park was acquired in 1888 via a lease from Continental to an extraordinary impresario: Colonel Randall Augustus Harrington Jr.

Randall Harrington was born on July 31, 1854, in the Pawtuxet Valley village of Phenix, now a part of the town of West Warwick. He was the son and namesake of Randall Augustus Harrington and Mary (Madison) Harrington. Both parents had Rhode Island colonial roots. Randall was educated in the public schools of Warwick and at private schools. From the beginning of his business career, he was interested in amusement projects and in the theatrical world. For a decade prior to his lease of Rocky Point, he was active as a theater manager in New York City and was acquainted with many of the stars of the Broadway stage.

A quintessential promoter, Harrington immediately inaugurated new attractions and events that quickly made eighty-eight-acre Rocky Point one of the most famous amusement parks on the Atlantic coast. In the 1890s, he installed a toboggan ride and an $8,000 organ, said to be the

world's largest. He built a scenic railway, added a carousel and built a new shore dinner hall on pilings cantilevered out over the bay. In the early 1900s, he brought in vaudeville shows and the novel amusement of silent movies.

Taking advantage of the Providence ban on playing baseball on Sundays, Harrington built a grandstand to seat ten thousand people, drawing nearly double that number when the Providence Grays played there after their revival as a minor-league team. The April 1908 lease of the stadium to the "Providence Club" was signed by Harrington and the team's manager, future Hall of Fame inductee Hugh Duffy. Harrington's heyday was the time when electric trolleys ran on the now-defunct Warwick Railroad, bringing thousands of toilers from the urban areas of Providence and Pawtucket for a nickel a ride at a time when the steamboats were charging a quarter or more. That railroad had reached Rocky Point in 1874. During the height of the season, trolley cars ran from Providence every five minutes, and boats came to the park's wharf on an hourly basis.

According to a contemporary account, "he introduced amusements of a sort never before seen in this section of the country." The natural beauty of the site, coupled with its attractions, drew large crowds from throughout southern New England, and excursions came by boat and rail. Harrington became so successful that he purchased fifteen abutting acres north of the park in June 1907 and bought the eighty-eight-acre park itself in December 1910 from the Providence, Fall River and Newport Steamboat Company, headed by Albert K. Tillinghast.

The profits generated by his Warwick venture allowed him to control Crescent Park in Riverside, Talaquega Park in Attleboro and the Taunton Theater in Taunton, Massachusetts. After 1900, Harrington wintered in Jacksonville, Florida, where he invested heavily in real estate and promoted the Florida Exposition in 1908.

Economic power and notoriety often beget political power. So it was with Harrington. From 1894 until the end of the decade, he represented Warwick in the General Assembly and also served as an influential member of the Republican State Central Committee. He was a prominent figure in club and fraternal circles in the city of Providence and became a twenty-second-degree Mason.

On December 8, 1908, at the age of fifty-four, he married Amelia Whiteside. The couple had two children, one of whom died in infancy. The colonel's fast-paced life came to a sudden end on October 13, 1918, at the age of sixty-six. He was buried at Warwick's Greenwood Cemetery.

Harrington's descendants continued as owners and lessors through World War II and then sold the park in 1945. Soon thereafter, the Ferla family assumed control and launched Rocky Point into another forty-year period of activity before the final ride stopped.

Matilda Sissieretta (Joyner) Jones

Matilda Sissieretta (Joyner) Jones, an internationally acclaimed black opera singer, was born in Portsmouth, Virginia, on January 5, 1868, the daughter of Jeremeah Joyner, a former slave and a minister, and Henrietta (Beale) Joyner, a homemaker, washerwoman and singer in her church choir. The couple had three children, but only Sissieretta survived childhood.

At the age of seven, "Sissy," as she was called, moved with her family to a house at 20 Congdon Street in Providence. Soon she began singing at her father's new ministry, presumably the Congdon Street Baptist Church. Sissy's parents separated two years after the family moved to Providence, so she was raised by her mother, who took in washing and ironing to support them both. Young Sissy attended Meeting Street Primary School and Thayer Street Grammar School, and before her teens, she was singing at a few of Providence's black churches, most often at the Pond Street Baptist Church.

Sissy's talent was so remarkable and her mother so dedicated that in 1883 she was able to attend the Providence Academy of Music. According to some sources, her formal training continued in the late 1880s at Rhode Island–born Eben Tourjée's New England Conservatory of Music and/or at the Boston Conservatory. After a solo opening act in Providence on October 29, 1885, as a prelude to a performance by a traveling theater troupe, Sissieretta sang at Boston's Music Hall in 1887 and made her New York debut on April 5, 1888, at Steinway Hall.

By the time of these initial public appearances, Sissy Joyner had become Sissieretta Jones as a result of her September 4, 1883 marriage, at age fifteen, to David Richard Jones, a twenty-one-year-old bellman at Providence's Narragansett Hotel.

During a performance later in 1888 at New York's Wallack's Theater, Jones attracted the attention of the manager of Adelina Patti, the renowned Italian opera diva. He recommended that Jones, who soon became known as the "Black Patti," go on a tour of the West Indies with the Fisk Jubilee

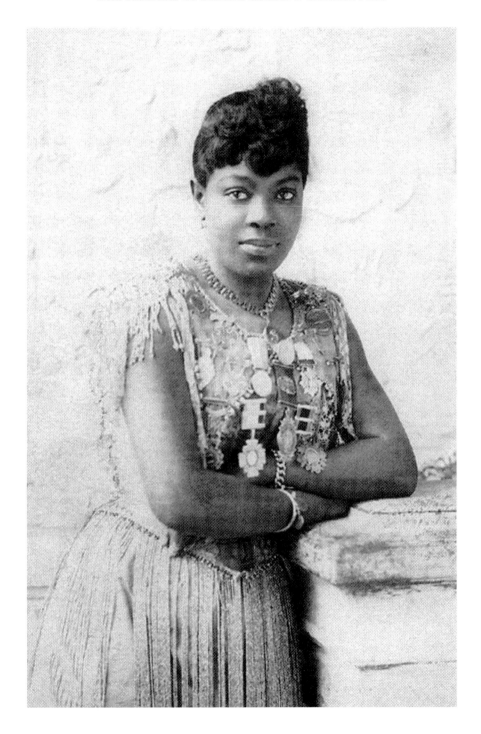

Singers. Two such excursions, in 1888 and 1892, were highly successful and gained Jones national attention.

In February 1892, the pioneering Jones performed at the White House for President Benjamin Harrison. This invitation was followed by requests from the next three chief executives—Grover Cleveland, William McKinley and Theodore Roosevelt. The fourth appearance was a charm because it was the first time she was allowed to enter the White House via the front door rather than the rear entrance. In 1895, she gave a performance for the British royal family attended by the Prince of Wales, the future King George V.

In April 1892, Jones performed in the Grand Negro Jubilee at New York's Madison Square Garden before a crowd of seventy-five thousand. She sang Stephen Collins Foster's "Swanee River," her signature song, and selections from Verdi's opera *La Traviata*. In June 1892, she became the first African American person to sing at Carnegie Hall. This triumphant exposure led to invitations to perform at the Pittsburgh Exposition in 1892 and the huge Chicago World Columbian Exposition in 1893, a venue where Providence's American Band also played.

During the 1890s, Jones met with international success and acclaim. She toured South America, Australia, India, southern Africa and Europe. During her visit to Europe, she sang in London, Paris, Berlin, Cologne, Munich, Milan and St. Petersburg.

From 1896 until her retirement in 1915, Jones toured continually with a troupe called (to her distaste) the Black Patti Troubadours, a group whose performances included blackface minstrel songs, acrobats and comedians. In this variety show, where she was the lead attraction, Jones confined herself to dignified operatic and traditional songs. She presented a most imposing figure, wearing beautifully crafted costumes and gowns, jewelry and an impressive array of the medals that she had garnered from admiring heads of state.

Jones, regardless of race, was one of the greatest American vocalists of her (or any) era. The *Washington Post* described her voice as "clear and bell-like.…Her low notes are rich and sensuous with a tropical quality. The compass and quality of her registers surpass the usual limitations and seem to combine the height and depth of both soprano and contralto." Not surprisingly, Sissieretta was the highest-paid black entertainer of her time, a fact that made poverty during her declining years all the more tragic.

Despite the glamour of her stage career, Sissieretta's personal life was not without its sadness and disappointments. Her marriage failed; her only child, a daughter, died in infancy; and her husband's excessive drinking led

to a divorce in 1899. Her fame and travels were, perhaps, a role reversal too much for him to bear.

Sissieretta performed in Canada and forty-six of the forty-eight contiguous states, but the racial discrimination she encountered in her homeland contrasted with the warmth and respect with which she was greeted abroad. In 1896, when her troubadours were formed, the U.S. Supreme Court legalized racial segregation in the case of *Plessy* v. *Ferguson.*

Because she suffered discrimination herself, Sissieretta had empathy for others who experienced similar injustices, such as nativism. During her career, she often volunteered her talents to local Irish Catholic groups to help them raise funds in support of the movement for Ireland's independence from England.

Her mother's great devotion and support for Sissieretta during her formative years was returned to Henrietta when her daughter interrupted tours to provide for her care. In fact, Sissieretta's retirement and return to Providence in 1915 was prompted, at least in part, by her mother's declining health. From that time onward to her death from cancer on June 24, 1933, at the age of sixty-five, Jones devoted her life to her church and family, which also consisted of two adopted children and some homeless children to whom she gave shelter in her home at 7 Wheaton Street on College Hill.

When her funds became depleted during the Great Depression, Sissieretta was forced to sell most of her property to survive, including her medals and jewels and three of her four houses. In her final years, the president of the local NAACP chapter helped to pay her taxes and water bills and provided her family with coal and wood.

This essay is drawn largely from the research of Maureen D. Lee, the author of a 2012 biography of Jones that relates her career in depth, *Sissieretta Jones: The Greatest Singer of Her Race, 1868–1933*, an abridgement of which was published in the 2014 Summer/Fall issue of *Rhode Island History* magazine.

Local black leaders successfully completed a campaign to raise funds to place a memorial on Sissieretta's unmarked grave in Providence's Grace Church Cemetery. That ceremony took place on June 9, 2018, during the 100th year following her birth. Both the Heritage Harbor Foundation and the Rhode Island Heritage Hall of Fame contributed generously to that campaign to honor this outstanding 1977 Rhode Island Heritage Hall of Fame inductee.

THE ATHLETES

Charles G. "Old Hoss" Radbourn

Tiny Rhode Island, despite its short playing season, had a profound effect on professional major-league baseball during its first quarter century (1876–1901). Two of the unbreakable baseball records were by homegrown athletes. The others were achieved by imports who played for the legendary Providence Grays. Those feats were as follows: (1) most wins in a season by a pitcher (59), by Charles Radbourn in 1884; (2) highest-ever season batting average (.440), by Hugh Duffy of Cranston in 1894; (3) first Triple Crown, though not referred to as such at the time, and first unassisted triple play (both in 1878), by Paul Hines; and (4) highest season batting average of the twentieth century (.426), by Nap Lajoie of Woonsocket in 1901. Most of these marks have been adjusted by baseball statisticians over the last few decades, but the records stand.

"Old Hoss" Radbourn was one of the outlanders. He was born in Rochester, New York, on December 11, 1854, to English immigrant parents and was raised in Illinois. He played twelve seasons in major-league baseball from 1880 through 1891, five of those seasons with the

Providence Grays. He compiled a 309-194 career record. Of his victories, 193 were with the Grays. In 1884, Radbourn earned baseball immortality by winning 59 games (against 12 losses) and pitching the Grays to baseball's first World Series championship. His National League team defeated the New York Metropolitans of the American Association in a best-of-five-game series, with Radbourn starting and winning all three contests.

After the 1885 season, the original Grays folded and Radbourn was transferred to the Boston Beaneaters, where he spent the next four seasons. He then played a year with the Boston Reds (1890) and then the Cincinnati Reds (1891) before retiring. He was inducted into Baseball's Hall of Fame in 1939.

Upon leaving the majors, "Old Hoss" opened a successful billiard parlor and saloon in Bloomington, Illinois, his hometown. Then he was seriously injured and disfigured in a hunting accident. He died on February 5, 1897, at the age of forty-two.

Radbourn's connection to Rhode Island was maintained when *Providence Journal* editor Edward Achorn wrote his authoritative biography, *Fifty-Nine in '84: Old Hoss Radbourn, Barehanded Baseball, and the Greatest Season a Pitcher Ever Had* (Smithsonian Books, 2010).

John Montgomery Ward

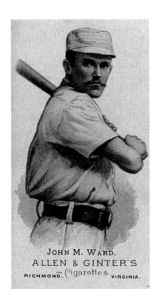

John M. Ward.
ALLEN & GINTER'S
RICHMOND. Cigarettes VIRGINIA.

Baseball has furnished another "bird of passage" for the Rhode Island Heritage Hall of Fame, Pennsylvanian John Montgomery Ward. "Monte," as he was known to fans, was born in Bellefonte, Pennsylvania, and raised in nearby Renovo, 418 miles from Providence. He attended Bellefonte Academy and then entered Pennsylvania State College, from which he was ejected for various disciplinary problems. His "acting out" may have stemmed from the illness and death of both his parents prior to his fourteenth birthday.

After playing baseball for his hometown team in the mid-1870s, he signed with the Providence Grays just after his eighteenth birthday and made his major-league debut on July 15, 1878.

This five-foot-nine, 165-pound youngster was as versatile in baseball as he was in life.

While in Providence, however, his activities were limited to baseball and business. In Monte's first season with the Grays, he confined his talent to pitching compiling a 22-13 record with a 1.51 earned run average. During the following two seasons, he also played in the outfield and third base, but his pitching record was spectacular. He led the Grays to their first National League championship in 1879 with an amazing 47 wins against 19 losses. He struck out 239 batters and registered a 1.74 ERA. In 1880, he had 39 wins and 24 losses. In each season, he pitched nearly six hundred innings.

On June 17, 1880, Monte pitched the National League's second perfect game. The first, a week earlier, had been hurled for the Worcester nine by John Lee Richmond, a Brown University graduate. Such a pitching feat is so rare that it was not repeated in the National League for another eighty-four years, until Jim Bunning threw a perfect game in 1964.

In his five seasons with the Grays, Monte won 146 games while losing 84. He led Providence to one league pennant and three second-place finishes. He even managed the team for a while in 1880. His only unsuccessful Providence venture was the Baseball Emporium, a sporting goods and tobacco shop he opened with a teammate in Downtown Providence.

On August 17, 1882, Monte pitched the longest complete game shutout in major-league history when he blanked the Detroit Wolverines 1-0 in eighteen innings. In an ironic role reversal, the Grays' winning score was a homerun off the bat of "Hoss" Radbourn, this game's right fielder and the greatest pitcher of his era.

The obvious restlessness of Ward and injuries to his arm prompted the Grays to sell him to the New York Gothams (renamed the Giants in 1885). He pitched for New York for only two years (19 wins, 16 losses) and then played other positions.

After brief stints as a player-manager and numerous disputes with team owners over salaries and other issues, Ward finally retired at the end of the 1894 season as the only man in baseball history to win more than one hundred games as a pitcher and collect more than two thousand hits.

While in New York, this brilliant athlete, who was fluent in five languages, entered Columbia Law School, graduating in 1885. He then used his skills to form a quasi-union—the Brotherhood of Professional Baseball Players—that fought (unsuccessfully) against the owners' reserve clause, a provision by which players were forbidden to negotiate with other teams when their contracts expired unless they had owner approval. He

even helped to form a Players' League in 1890 to fight the existing system. It provided profit-sharing for the players and banned the reserve clause, but it dissolved after one year of play.

While Monte was causing controversy, he was also writing a book. In 1888, he published *Base-Ball: How to Become a Player, with the Origin, History, and Explanation of the Game*. It was the first published effort to explore baseball's development from its inception. In 1887, he married the glamorous actress Helen Dauvray, another type of union that brought attention to the couple similar to that created by the marriage of Joe DiMaggio and Marilyn Monroe.

From the mid-1890s onward, Ward practiced law, traveled widely, held a few executive positions in baseball and became a champion amateur golfer. He died in Augusta, Georgia, the American citadel of golf, on March 4, 1925, the day following his sixty-fifth birthday, after a bout with pneumonia. He was buried at Greenfield Cemetery in Uniondale, New York. Monte was elected to the Baseball Hall of Fame by its Veterans' Committee in 1964.

PAUL A. HINES

Paul Aloysius Hines was born in Virginia on March 1, 1855, and died in Maryland, but no player was more associated with the Providence Grays during that team's major-league heyday at Messer Street Park in Olneyville.

Hines's full career consisted of 1,659 games in three leagues from 1872 through 1891. During that span, he made 2,135 hits, batted over .300 eleven times and posted a career average of .302. He ranked twelfth among all nineteenth-century players in total bases (2,884) and tenth in total hits (2,135). He played for Washington and Chicago in the National Association from 1872 through 1875, then for the Chicago Cubs in 1876 (the National League's inaugural season) and next for the Providence Grays of the National League, where he was the team's bellwether and star.

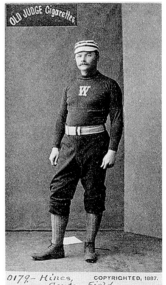

0179.— Hines, COPYRIGHTED, 1887.
Centre Field,
Washington.
GOODWIN & CO., NEW YORK.

From 1878 through 1885—the entire span of the Grays' status as a major-league franchise—Paul Hines was Providence's starting center fielder. In that position, he recorded statistics that should have earned him induction into baseball's Hall of Fame. In 1878 and 1879, he led the National League in batting average (.358 and .357, respectively). In the former year, Hines also won baseball's first Triple Crown by leading the National League in batting average, home runs and runs batted in. Unfortunately, that achievement was not standardized until after his retirement. In 1878, he was also credited with major-league baseball's first unassisted triple play in a game against the Boston Red Caps. During Providence's legendary World Series championship season in 1884, Hines hit .302.

In 1891, Hines ended his twenty-year major-league career back in Washington. After long service as a federal government employee, Hines died at the age of eighty on July 10, 1935, in Hyattsville, Maryland. Tragically, this eagle-eyed center fielder, whose record of sixteen seasons as a team's primary center fielder was not surpassed until 1925 by Ty Cobb and Tris Speaker, died both blind and deaf. His hearing impediment extended as far back as his playing days; for him, there was no "crack of the bat." Hines richly deserves induction into the Baseball Hall of Fame.

HUGH DUFFY

Baseball's all-time record holder for his single season batting average of .440, Hugh Duffy was born to Irish immigrants Michael Duffy and his wife, Margaret, on November 26, 1866. Some sources say that his place of birth was Riverpoint, a mill village in present-day West Warwick, but it is clear that he was raised in Cranston.

As a teenager, Hugh worked in a textile mill and took up baseball as a diversion from his drab factory job. His native talent was such that he soon turned professional and played for two years on Eastern League clubs in Hartford, Springfield, Salem and Lowell before being recruited by the major-league Chicago White Stockings in 1888. Duffy signed with Chicago upon accepting a then "huge" $2,000 offer from the club. When his manager, Hall of Famer Cap Anson, first saw the five-foot-seven, 150-pound Duffy, he said to the Rhode Islander, "We already have a batboy, where is the rest of you?" Much later, Anson would observe of this great hitter that "Hugh Duffy of Boston plays the outfield carrying a

crystal ball. He's always there waiting to make the catch." Duffy batted and threw right-handed.

Following Duffy throughout the topsy-turvy, ever-changing world of early baseball, especially his career after 1900, is far beyond the scope of this essay, but his performances in the 1890s are not only worthy of note but also the key to his Hall of Fame induction (both at Cooperstown and Rhode Island).

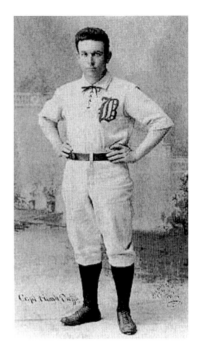

Duffy's major-league debut with Chicago came on June 23, 1888. While playing with that team, he hit .282 (1888) and .312 (1889). Then, in 1890, he jumped to Monte Ward's short-lived Players' League. The following year, Duffy played for the Boston Reds of the American Association, and in 1892, he began his amazing nine-year run with the Boston Beaneaters of the National League. Every year with this team was triumphant, but his performance in 1894 will live forever in baseball history. Not only did Duffy bat .440 (the highest average ever), he also led the National League in hits, runs scored, runs batted in, home runs, doubles and slugging, with a percentage of .679, a Babe Ruthian figure. He won the Triple Crown with diamonds to spare.

When the American League was formed in 1901, Duffy jumped to Milwaukee to become player-manager of the Brewers, that city's minor-league team (not to be confused with the present National League Brewer franchise). When this venture failed, Hugh came to Philadelphia as player-manager of the National League's Phillies from 1904 to 1906. Here he ended his career as a major-league player on April 13, 1906, having posted a lifetime batting average of .325.

Duffy came back to Providence from 1907 to 1909 to manage the minor-league Grays (at that time known as the Clamdiggers). In 1910 and 1911, he directed the Chicago White Sox, and after a stint as a minor-league manager, he coached at Harvard from 1917 to 1919.

In 1921, Duffy was hired as manager of the Boston Red Sox. After guiding the team for two seasons, he became a Red Sox scout in 1924. From that date until the year before his death in Boston on October 19, 1954, at the

age of eighty-seven, Duffy stayed with the Red Sox as coach and scout, even tutoring Ted Williams on hitting. He was inducted into the Baseball Hall of Fame in 1945.

Hugh's wife, Nora, had died in 1953, prompting his retirement after sixty-seven years in baseball. The couple had no children—baseball was Hugh's baby!

EDWARD PAYSON WESTON

One of Rhode Island's most colorful native sons, Edward Payson Weston was born in Providence on March 15, 1839. His father, Silas Weston, was at one time a schoolteacher and at another a publisher and the editor of a semi-monthly paper titled the *Pupil's Mentor*. Edward's mother, Maria Gaines, was a talented writer who published several poems and novels.

Edward was the eldest of four children. When Edward was thirteen years old, his father set out for the California gold fields. When Silas returned to Providence in 1854, he brought back only the memories of his exciting adventures out west, so at age fifteen, young Edward became the publisher of his father's California travelogue and sold it for fifteen cents per copy. When Edward was seventeen, Silas left again, this time for new adventures in the Azores. When he returned two years later, young Edward continued his publishing efforts, selling his father's newest travel accounts. In 1859, Edward printed his mother's third novel, *Kate Felton*, with relative success, selling 2,500 copies by advance subscription.

As the Civil War was brewing, Edward made quite a name for himself. In 1861, after the election of President Lincoln, he wagered that he could walk from Boston to Washington in ten days, in time to attend Lincoln's inauguration. Although Payson was of average stature (five feet, seven and a half inches) and slight build (140 pounds), he made the 453-mile trek to Washington for Lincoln's Inaugural Ball but arrived about ten hours after the inauguration itself. The trip stirred up enough notoriety that Lincoln made a point of meeting with Weston and offering to pay his way for a ride home. Weston declined and, instead, embarked on a lifetime career as a world-famous professional "pedestrian."

Although Edward's publishing business appears to have ended in 1866 with the release of his mother's final two novels, his walking career took off at a record pace, and his exploits became the subject of world renown. Among Weston's more famous accomplishments was a walk from Portland,

Maine, to Chicago (1,326 miles in twenty-five days). Forty years later, at the age of sixty-eight, he made the same walk, beating his old record by twenty-nine hours!

In January 1879, he claimed a record for walking 2,000 miles. He also won the "Astley Belt," beating British champion "Blower" Brown, in a 550-mile, six-day event in London during a lengthy tour of Europe. He went on to claim records for 200, 250 and 300 miles.

During the 1870s and 1880s, Weston's duels with his nemesis, walker Daniel O'Leary, attracted nationwide attention. In all, Weston participated in more than one thousand professional events spanning nearly seven decades, including two transcontinental walks. His exploits earned him the nickname "the Pedestrian."

Perhaps Edward's greatest feat (no pun intended) was his walk from New York to San Francisco, sponsored by the *New York Times* in 1906 when he was seventy years of age. He planned to complete the trip in 100 days. When he appeared in San Francisco on day 104, he proclaimed his late arrival as the greatest disappointment of his life. Undeterred, he walked back—this time covering the route in a blistering 76 days in an era when only a primitive road system existed across vast stretches of America. His last great journey came in 1913, when he walked 1,546 miles from New York to Minneapolis in 51 days.

Bad luck rather than age ended Edward's career. While walking in New York City in 1927, he was struck by a taxicab. Suffered at the age of eighty-eight, this accident confined him to a wheelchair for the remaining two years of his life. He died in Brooklyn on May 12, 1929, at age ninety, beating the average life expectancy for those born in 1839 by fifty years. He was buried at St. John Cemetery, Queens, rather than in his family cemetery in Providence. Even in death, this unique Rhode Islander far outpaced his contemporaries and the odds.

SOCIAL REFORMERS

Elizabeth (Buffum) Chace

Elizabeth (Buffum) Chace's father, Arnold Buffum, was one of Rhode Island's leading abolitionists. He was born on December 13, 1782, and raised in a farmhouse near Smithfield's Union Village, now part of North Smithfield.

Despite his rural roots and meager education, Arnold Buffum became an entrepreneur whose main business was the manufacture and sale of hats in Providence. He also patented some inventions pertaining to his trade and raised sheep on his father's farm as a source of felt for his hats. He and his wife, the former Rebecca Gould, married in 1803 and became the parents of seven children, all of whom were raised in the Quaker faith. The most notable of these children was their daughter Elizabeth.

Arnold Buffum's Quaker beliefs greatly influenced his views on slavery, and soon after William Lloyd Garrison began the publication of the *Liberator* in 1831, the two joined with other like-minded reformers to establish the New England Anti-Slavery Society in 1832. Garrison became the bold new organization's secretary-treasurer, while the eloquent Buffum was selected president and the group's first roving lecturer, a post not conducive to his economic well-being.

Arnold Buffum's reform work had a great influence on his second child, Elizabeth, born in Providence on Benefit Street on December 9, 1806. In 1828, she married fellow Quaker abolitionist Samuel Chace, a Fall River

textile manufacturer. Elizabeth first became publicly active in the cause of abolition in 1835, when she and her two sisters, Lucy and Rebecca, helped to organize the Fall River Female Anti-Slavery Society, a group that allied with the radical wing of the antislavery movement led by Garrison. The Chaces continued their abolitionist efforts after moving in 1840 to Valley Falls, a mill village that spans the Blackstone River between the town of Cumberland and the present-day city of Central Falls. Elizabeth organized antislavery meetings and brought illustrious abolitionists to address them— including Garrison, Sojourner Truth, Lucy Stone, Abbey Kelley and Wendell Phillips—and she made her home a station on the Underground Railroad. She detailed these activities in an 1891 book titled *Antislavery Reminiscences*.

After the ratification of the Thirteenth Amendment abolishing slavery in 1865, Elizabeth Chace shifted her reform focus and joined with Paulina Wright Davis to found the Rhode Island Women's Suffrage Association in 1868. Chace used her position as president of this organization to address the needs of Rhode Island's disadvantaged women and children, and she led the successful drive for the creation of the state Home and School for Dependent Children, which was established in 1885. In the mid-1860s, she became a cofounder of the Free Religious Association and an influential temperance advocate. She also urged reforms to benefit factory workers, especially women and children operatives, as well as prisoners and other deprived groups. She was outspoken, indefatigable and relentless in advancing the reforms that she espoused, earning for herself the soubriquet the "Conscience of Rhode Island."

Chace accomplished her noble deeds despite the great burdens and sorrows of motherhood. She and her husband had ten children in the years between 1830 and 1852, the first five of whom died of childhood diseases before the next five were born. Among those who did survive was their son Arnold Buffum Chace, who became the eleventh chancellor of Brown University and a renowned mathematician and Egyptologist. Even today, their progeny are locally prominent in the fields of business and education.

Elizabeth Chace's long life of reform ended on December 12, 1899, at the age of ninety-three, and she was buried at Swan Point Cemetery. The memory of her achievements in Rhode Island and elsewhere persists, however. In 2002, she was selected as the first woman to be memorialized with a statue in the Rhode Island Statehouse, a recognition for local women long overdue.

A full, though dated, account of Chace's public life, which spanned over sixty years, is *Elizabeth Buffum Chace, 1806–1899: Her Life and Its Environment* (two volumes, 1914), written by her daughter Lillie Buffum Chace Wyman and Elizabeth's grandson Arthur Crawford Wyman. Elizabeth C. Stevens, former editor of *Rhode Island History* magazine, provides a more recent and scholarly account in *Elizabeth Buffum Chace and Lillie Chace Wyman: A Century of Abolitionist, Suffragist, and Workers' Rights Activism* (2003).

During the nineteenth century, the Rhode Island General Assembly created eight new municipalities and changed the boundaries of several others, most notably Providence, North Providence and Smithfield. When the Chaces came to Valley Falls in 1840, the south side of the Blackstone, where they built their home, was located in the town of Smithfield. In 1871, that portion of Smithfield was set off as the town of Lincoln. In 1895, by this process of municipal mitosis, the legislature established the small southeast corner of Lincoln as the city of Central Falls. The Chace mansion, at the corner of Broad and Hunt Streets, survived these boundary changes, but eventually it was demolished to make way for further industrial development. However, the nearby home of Elizabeth's daughter and biographer, Lillie, at 1192 Broad Street, still stands. As the 2020 centennial of the ratification of the Nineteenth Amendment (i.e., women's suffrage) approaches, Central Falls has requested the federal government to name the city's post office in honor of Elizabeth Buffum Chace—a request that will likely be granted.

Congressman Thomas Davis and Paulina (Kellogg) Wright Davis

Thomas Davis was born in Dublin, Ireland, on December 18, 1806. He attended private schools in Ireland and immigrated to America in 1817, settling in Providence. Becoming a pioneer in Rhode Island's jewelry industry, he amassed sufficient wealth to enable him to finance a variety of political, civic and reform endeavors. Little is known of his first marriage, but one can deduce that his wife died very young.

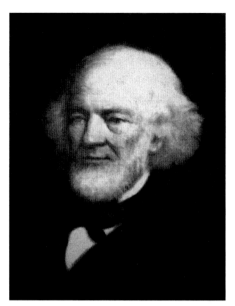

Davis became a state senator from Providence, serving from 1845 to 1853, and he emerged as a leader of the reform wing of the Democratic Party, led by Thomas Wilson Dorr. As a member of the General Assembly, Davis played a leading role in the passage of the 1852 act banning the death penalty in Rhode Island, and he was a strong advocate of constitutional reform. Although he was a Unitarian, he campaigned vigorously for the removal of the real estate requirement for voting and office holding required of naturalized citizens in the state, most of whom were Irish Catholic. As a humanitarian, he was an ardent abolitionist and a leader in Rhode Island's relief effort during Ireland's Great Famine.

In 1853, the Dorr Democrats sent Governor Philip Allen to the United States Senate and nominated Davis as their Congressional candidate from the Eastern District. Davis defeated Whig candidate George G. King by a margin of 5,524 to 4,942, but although he was elected, the presence of a Free Soil candidate in the race narrowed his required majority to 175 votes. In 1855, Davis was soundly defeated in his reelection bid by the American (Know-Nothing) Party candidate, Tiverton farmer Nathaniel B. Durfee, who then easily dispatched Democrat Ambrose E. Burnside of Bristol when Durfee ran for reelection in 1857 as a Republican.

Davis lost his run for reelection in part because he broke with his party by openly opposing Stephen Douglas's Kansas-Nebraska Act, a measure that opened the U.S. territories to the possibility of slavery. However, he

was also a victim of the anti-immigrant hysteria that swept the country in the mid-1850s.

Despite the growing unpopularity of his reform views, he spoke out courageously. In an 1855 Newport address, immigrant Davis denounced the Know-Nothing Party's "persecution of foreign born citizens," describing that party as "a conspiracy against the rights of man" and expressing his extreme displeasure with Durfee's attacks on Roman Catholics. Undaunted by his 1855 defeat, Davis made four more attempts to regain his Congressional seat in 1859, 1870, 1872 and 1878, all of which were unsuccessful.

By the late 1850s, the national Democratic Party's tolerance of slavery had prompted Davis to become a Republican, but his pro-Irish stance incurred the wrath of Republican leader Henry Bowen Anthony, a U.S. senator, arch-nativist, a founder of the Republican Party and the editor of the *Providence Journal*. When Davis sought election to Congress as a Republican in 1859, he was defeated by Christopher Robinson, an American-Republican fusion candidate whom Anthony sponsored. This "treachery," as Davis called it, together with the differences between Davis and Anthony regarding the real estate qualification for naturalized citizens, prompted a bitter feud. The most vitriolic example of this long-running mutual contempt was a thirty-three-page "open letter" from Davis to Anthony in 1866 titled "Rhode Island Politics and Journalism," in which, among other insults, Davis referred to Anthony as a man of "baseness and treachery" and "an apostate politician of unscrupulous character." By the time of his 1872 campaign for Congress, Davis had been prompted by Anthony's leadership role in the Republican Party to return to the much more reform-oriented Democratic fold.

Despite his lack of success on the federal level, Davis again served in the state Senate (1877–78) and then became a state representative (1887–90), as well as a member of the Providence School Committee.

In a supreme irony, the naturalized Davis temporarily lost his right to vote and hold office in 1880 when his jewelry business failed, leaving him as a propertyless naturalized citizen. Needless to say, however, he became a leader in the statewide equal rights movement of the 1880s, a reform campaign that resulted in the abandonment of the real estate voting requirement via the Bourn Amendment of 1888.

Notwithstanding his several political positions, Congressman Davis's principal legacies were as a reformer, a patron of the arts and a philanthropist. In concert with his second wife, Paulina, he hosted cultural gatherings at each of his two Providence residences—a Greek Revival house at 503–7 Chalkstone Avenue dating from 1850, and then a stately Gothic mansion

built in 1869 on a hilltop near the junction of Chalkstone Avenue and Raymond Street in a parklike thirty-four-acre setting. At the salons hosted by Thomas and Paulina, intellectuals, artists and reformers from around the region came to discuss the vital issues of the day.

Thomas Davis's charming and intelligent second wife was born in Bloomfield, New York, on August 7, 1813, the daughter of Captain Ebenezer Kellogg and Polly Saxon. After the death of both parents, Paulina was raised by a strict, orthodox Presbyterian aunt. After a brief immersion with religion, Paulina married Francis Wright, a wealthy Utica merchant, in 1833. The couple became very involved in various contemporary reforms, especially abolitionism and women's rights.

Her husband's death in 1845 left Paulina Wright desolate, but she was wealthy and free to embark on a career as a lecturer and women's health advocate. She studied medicine in New York City and lectured widely on female anatomy and physiognomy. While on tour in Providence, Paulina met widower Thomas Davis, who held reform sentiments similar to hers. The couple married in April 1849 and began a partnership that exerted great influence on Rhode Island's social and cultural life during the late nineteenth century. Paulina hosted numerous gatherings on the Davises' spacious Providence estate in such a manner that she inspired one observer to describe her as "a radiant figure" in her "circle of literary, artistic, and reformatory people."

Paulina Davis worked on the National Women's Rights Convention held in Worcester in 1850, and two years later, she launched the publication of *Una*, which she called the first women's magazine devoted to the "elevation of women." She was determined to promote a dialogue among women on the issues of labor, marriage, suffrage, property rights and education, but *Una* had a short lifespan.

In 1866, Paulina Davis made many of the arrangements for the twentieth-anniversary meeting of the women's suffrage movement held in New York City, and in 1871, she published the proceedings of that gathering as *The History of the National Women's Rights Movement*. During the 1860s and 1870s, she traveled abroad, meeting many prominent European reformers and indulging her love and skill for art by copying the paintings of great masters. She abandoned her artwork only when she became crippled with arthritis.

Paulina Davis died in Providence on August 24, 1876, shortly after observing her sixty-third birthday. Congressman Thomas Davis died on July 26, 1895, at the age of eighty-eight and was laid to rest at Swan Point Cemetery beside his equally illustrious wife.

In 1891, the City of Providence purchased the Davis estate at a bargain price for recreational use, and after enlarging the tract, it created Davis Park. In 1945, the federal government condemned the land, demolished the mansion and built the Veterans' Administration Hospital. However, the flat, low-lying area to the east of the facility was then returned to the city, which uses it presently as a ballfield and a playground.

George T. Downing

In Rhode Island, slavery was placed on the road to extinction on March 1, 1784, when the General Assembly passed a gradual manumission act making any black person born to a slave mother after that date free. Those who were slaves at that time had to be manumitted by their masters. Five such slaves were listed in the federal census of 1840, and it was not until the implementation of the state constitution of 1843 that slavery was banned outright in Rhode Island. Free blacks with real estate could vote until 1822, when they were deprived of suffrage by statute. This restriction was erased by the constitution of 1843, in part to reward black residents for their support of the prevailing Law and Order government.

With black residents politically impotent, socially ostracized, educationally segregated and some still enslaved during the first four decades of the nineteenth century, it is understandable that very few black leaders emerged in Rhode Island during the antebellum era. George Thomas Downing was one notable exception.

Downing was born in New York City on December 30, 1819. His father, Thomas, was a native of coastal Virginia, and his mother, Rebecca West, came from Philadelphia. George, the eldest child, had three brothers and a sister. He was fortunate in that his father established a very upscale and successful New York City restaurant, whose patrons included many of the prominent businessmen and politicians of the metropolis. This success allowed George to attend private school as well as the Mulberry Street

School, where he met several young boys who would soon become vocal abolitionists, like George himself. When he was only fourteen, George and his black schoolmates—James McCune Smith, Henry Garnet, Alexander Crummel and Charles and Patrick Benson—formed a literary society and also discussed racial issues in America. At one of their meetings, they agreed not to celebrate the Fourth of July because it was "a perfect mockery" for African Americans.

George displayed such intellectual and leadership potential that his father sent him to school near Clinton, New York, where he met and married Serena Leanora de Grasse, the daughter of a German mother and a father from India. Contrary to earlier accounts of his upstate New York visit, Hamilton College, where he allegedly enrolled, has no record of Downing as a student. However, he did attend Oneida Institute in nearby Whitestown, New York, eight miles from Clinton.

Upon his return to New York City from Clinton, he joined with his father not only in the food business but also in the business of promoting racial justice. Both became active in the Underground Railroad, personally helping several fugitive slaves escape to freedom, and they lobbied the New York legislature to grant equal suffrage to blacks. Then George struck out on his own.

In 1846, he came to Newport, a town that had a sizable black community, to replicate his father's oyster house restaurant. This enterprise proved successful in a town that had begun to emerge as a fashionable summer resort and which was attracting some of his father's New York patrons. George wasted little time expanding his operations. In 1850, he moved temporarily to Providence, where he established a catering business for that city's polite society. Then he turned his attention again to Newport, and in 1854–55, with some financing from his father, he built his impressive Sea Girt House on South Touro Street (now part of Bellevue Avenue), nearly opposite the Newport Tower. The multistory Sea Girt House included his residence, a restaurant, his catering business and "accommodations for gentlemen boarders." A suspicious fire destroyed the elegant building in 1860, but Downing was able to recover $40,000 of insurance proceeds to rebuild a larger structure on the site, which came to be called the Downing Block. During the Civil War, he rented its upper floor to the temporarily relocated U.S. Naval Academy as an infirmary.

Downing's business success, remarkable as it was, would not confer Hall of Fame status on him, but his successful campaigns against slavery and school desegregation in Rhode Island did earn him that distinction. He vigorously

opposed the African colonization plan supported by Thomas Hazard, but he assisted the efforts of local abolitionists, such as the Buffums, and national leaders of this movement, like Massachusetts senator Charles Sumner and ex-slave Frederick Douglass. Although somewhat of a black elitist, Downing regarded himself as evidence of a black person's ability to succeed and prosper if afforded education and the equal opportunity to do so.

In his quest for human rights, Downing was most uniquely associated with the desegregation of Rhode Island's public schools, a campaign he commenced in 1855 with the support of Senator Sumner. By 1857, he had begun to take bold public action, launching a lobbying campaign, which he personally financed, against segregated education. Among other arguments, Downing appealed to the white leadership of the state by reminding them not only of the heroics of Rhode Island's Black Regiment during the Revolutionary War but also of the assistance that blacks had rendered to the victorious Law and Order Party during the Dorr Rebellion. Such rhetoric did not sit well with Rhode Island's naturalized Irish Catholics, but constitutional restrictions on their suffrage kept those residents of the state politically impotent.

Downing's desegregation campaign had some near misses, but it took the ratification of the Thirteenth Amendment in 1865 to overcome the resistance of such communities as Providence, Bristol and Downing's own Newport. Downing's oft-repeated argument was that all race distinctions stemmed from slavery, and thus they must die with slavery. In 1866, eleven years after Downing first strategized with Sumner, the General Assembly, with little debate, overwhelmingly voted to outlaw separate schools and ended the era of legal educational segregation in Rhode Island.

Downing continued his racial-equality crusade in the decades following the Civil War. In 1869, he helped to form the Colored National Labor Union because of the refusal of the all-white National Labor Union to admit blacks. By the late 1870s, he had become disenchanted with the Republican Party for abandoning Reconstruction and criticized what he called "the blind adhesion of the colored people to one party." He failed, however, in three attempts to secure election as a Newport Democrat to the Rhode Island General Assembly, leaving the honor of becoming the state's first African American legislator to Reverend Mahlon Van Horne, a Newport Republican, who was elected to the House for three consecutive one-year terms beginning in 1885.

Downing's most visible job mixed his two passions, food and politics. For twelve years, from 1865 to 1877, the outspoken Downing was in charge

of the café/dining room of the U.S. House of Representatives, and that position gave him the opportunity to influence and lobby policymakers. One salutary project on which he worked was the passage in 1873 of an equal-opportunity public accommodations law for the District of Columbia. Two years after leaving his post in Washington, he retired from his Newport business.

George Downing died at his Newport home on July 21, 1903, surrounded by his several children, one of whom, Serena, wrote his brief biography in 1910. At his passing, the *Boston Globe* called him "the foremost colored man in the country" and praised his efforts on behalf of liberty and equality for all Americans. He was buried at Newport's Island Cemetery.

SARAH ELIZABETH DOYLE

Sarah Elizabeth Doyle was born in Providence on March 23, 1830, the daughter of Martha (Dorrance) Jones and bookbinder Thomas Doyle. One of seven children and the younger sister of future Providence mayor Thomas Arthur Doyle, she was a lifelong resident of Rhode Island who participated in the social reform ferment that engulfed the state during the Gilded Age. Despite the conservative political nature of local thinking, she successfully pioneered educational opportunities for women at the highest level.

She entered Providence High School during its initial enrollment in 1843 and would later teach there from 1856 to 1892. During that time, she helped nurture other women in the field of education while searching for institutional ways to consolidate academic gains. She participated on a host of committees and commissions that dealt with such issues as female suffrage, child labor, temperance, prison reform, kindergarten classes and higher education for women.

"Miss Doyle," as she was known, regularly used the female club movement as a vehicle of reform in that era. She founded the Rhode Island Women's Club in 1876 as a social sorority to offer a variety of educational opportunities for women and encourage political activism.

In her leadership capacity, Doyle was a prominent member of the committee that founded the Rhode Island School of Design in 1877, and she served as secretary of the RISD board of directors from 1877 to 1889. She was also a member of the board of the Providence Athenaeum and was vice-president of the Rhode Island Institute of Instruction.

In 1884, Sarah became the first woman to preside over a meeting of the National Education Association. She achieved her greatest accomplishment by prying open the doors of Brown University to female students in the 1890s, though as off-campus adjuncts. To further the quest for greater equality in higher education, she served as president of the newly formed Rhode Island Society for the Collegiate Education of Women from 1896 until 1919. The group raised $75,000 and constructed Pembroke Hall on the Brown University

campus, the forerunner to Pembroke College. At the building's dedication on November 22, 1897, Sarah spoke what some have called her most famous words: "The women's sphere is one of infinite and indeterminate radius."

Doyle earned unusual distinction in her own lifetime when a group of her students formed the Sarah E. Doyle Club in 1894 to provide literary sustenance to female teachers through extracurricular activities. In that year, she became the first woman to receive an honorary degree from Brown. In 1975, Brown University established the Sarah Doyle Women's Center to provide services to female students of a different era, but with the same mission of improving education for women.

Although Sarah looked the part of a severe schoolmarm, she was not grim or acerbic; rather, she was a much-beloved teacher and a charismatic and inspiring leader. When she died on December 21, 1922, in Providence at the age of ninety-two, there was an outpouring of praise and admiration for her life's work. She was laid to rest at Swan Point Cemetery near her brother, Thomas.

JULIA (WARD) HOWE

Julia Ward Howe, though born in New York City on May 27, 1819, had deep Rhode Island roots. Two of her ancestors, Richard Ward and Samuel Ward, were prominent colonial governors of Rhode Island, and her grandfather Samuel Ward commanded the Black Regiment in the Battle of Rhode Island on August 29, 1778.

Her father, Samuel Jr., was a prominent New York banker who furnished her with a first-class private education and standing in New York's social circles. In 1843, Julia married Samuel Gridley Howe of Boston, a man almost twenty years her senior. The Howes established a home in Boston, where he founded the Perkins School for the Blind, and Julia bore five children in the first twelve years of her marriage.

Since Boston was the hub of mid-nineteenth-century America's literary and reform activity, Julia avidly partook of both intellectual currents. In 1854, she published her first volume of lyrics, and others followed in rapid succession. Julia and Samuel embraced abolitionism and coedited an antislavery newspaper. Their Boston home, Green Peace, became a center of abolitionist activity where Theodore Parker, Charles Sumner and other antislavery leaders gathered. As a Unitarian, she consistently advocated the tenets of this liberal religion.

After the outbreak of Civil War, Julia visited a military camp near Washington, D.C., in a party led by Governor John Andrew of Massachusetts. The emotional experience prompted her to write a poem that she titled the "Battle Hymn of the Republic." The *Atlantic Monthly* paid her four dollars to publish it, but it soon became the unofficial anthem of the Union army and one of America's most stirring hymns.

After the war and for the remainder of her long life, Julia became a leader of reform causes, most notably women's suffrage and the campaign for world peace. No movement or "cause" in which women had an interest—from voting rights to pure milk for babies—escaped her notice and involvement. She was the president of the New England Woman Suffrage Association, the New England Women's Club, the Association for the Advancement of Women and the American branch of the Woman's International Peace Association, among her many civic posts.

True to her family's Rhode Island roots, she summered annually in Newport and became the center of a group of literati in that resort city that included the poets Whittier and Longfellow, historian George Bancroft, artists John La Farge and John Singer Sargent and philosopher Henry James.

Both in Boston and on Aquidneck Island, she wrote an impressive array of reform articles, poetry, essays and books that included *Sex and Education* (1874), a plea for coeducation; *Modern Society* (1881); *Margaret Fuller* (1883), a biography of the early advocate for women's rights; *Woman's Work in America* (1891); *Is Polite Society Polite?* (1895), a collection of essays; *From Sunset Ridge: Poems Old and New* (1898); and her *Reminiscences, 1819–1899.*

In 1870, she founded the weekly *Woman's Journal*, a widely read suffragist magazine, to which she contributed articles for twenty years. After her husband's death in 1876, she intensified her many reform activities. They continued unabated throughout the next three decades.

Julia died on October 17, 1910, in Portsmouth at her summer home, Oak Glen, not far from the spot where her grandfather and his black soldiers had beaten back a charge of Hessian troops in 1778 during the Battle of Rhode Island. Two of her daughters, Laura Richards and Maud (Howe) Elliott, wrote a revealing two-volume biography of their famous mother that they published in 1916. It preserved Julia Ward Howe's memory for future generations in the process of winning the first Pulitzer Prize for biography.

When Julia was buried at Mount Auburn Cemetery in Cambridge, Massachusetts, approximately four thousand people joined in singing the "Battle Hymn of the Republic." It had been the custom of audiences to sing that anthem at each of Julia's many speaking engagements.

SOPHIA (ROBBINS) LITTLE

When Sophia (Robbins) Little died in 1893 at the age of ninety-four, her obituary in the *Newport Daily News* noted, "The biography of such a woman with such connections would require a volume, and it will doubtless yet be written and given to the public." Unfortunately, no such volume has ever been written and most likely never will be, although Sophia deserved the honor. Today, her good deeds live on.

Sophia Louisa Robbins was born in Newport on August 22, 1799, the daughter of Asher Robbins. Her father was a prominent and conservative Rhode Island politician who was U.S. district attorney for Rhode Island from 1812 to 1820 and then a state legislator for five years before becoming a U.S. senator from 1825 to 1839 as a member of the Whig Party.

Not much is known about Sophia's early education, other than that she was educated in the local schools of Newport. Those who knew her said that she had deep and thorough religious convictions, being raised as a member of the Society of Friends. Later, however, she joined the Moravian Church because of its emphasis on personal sacrifice and service to humanity. In life, her religious convictions guided her and influenced her strong commitment to perform good deeds. As she once noted, "The missionary fervor and zeal of this church were prominent factors in the

preparation for what afterwards became my life work." In June 1824, she married William Little Jr., a lawyer from Boston.

A prolific writer, Sophia penned a number of poems along with several novels. One interesting and unsolicited testimonial to her writings is found in a letter from a young woman to her father in New Hope, Pennsylvania. Commenting on her stay at Newport in 1833, Caroline Corson noted, "Many of the ladies here have called on us—they are all *á la mode*— to play on the piano & dance, generally I perceive nothing remarkably intelligent in any of them except a Mrs. Little, daughter of Senator Robins [*sic*]. She is really a most agreeable and intelligent lady although a poetess."

Sophia's poems usually had a moral tale to tell. In her long antislavery poem "The Branded Hand," published in 1845, she wrote in its introduction, "This poem is founded on certain well known facts which have lately much affected the writer.…I have given to the slaves that exaltation of character, which though rare, is seen among them. I preferred the intelligent slave, because the world is full of exaggerated caricatures of the African as slavery has made him—and I wished to contrast it by what I have seen under favorable circumstances." Her prose was equally full of social commentary, as evidenced by her temperance novel, *The Reveille*, published in 1854.

Sophia's writings reflected her interest in a number of social causes—she was actively involved in the antislavery, temperance and women's suffrage movements—but prison reform was unquestionably her main interest. Early in life, Sophia began to visit prisoners in the Newport jail in order to provide them some solace. She also visited prisoners in other nearby states. During the height of the Dorr Rebellion, when many prisoners were brought from Providence to be held in Newport's Marlboro Street jail, Sophia made daily visits, providing them with food, news, reading material and good cheer. She even communicated with the rebellion's leader, Thomas Wilson Dorr, who was incarcerated in Newport in 1844 while standing trial for treason against the state.

As the nineteenth century was generally the age of great reform movements, it is not surprising that a wave of interest in prison reform took

hold in the United States. In Rhode Island, with Sophia playing a leading role, a Prisoner's Aid Association was incorporated in 1874. The association consisted of both men and women whose purpose it was to aid discharged prisoners by assisting them with making an honest livelihood and to adopt such measures that were conducive for the prevention of further crimes. As Sophia noted in the association's 1881 annual report, "During more than forty years of experience in visiting our prisons, I have been constantly impressed with the need of a shelter for discharged prisoners in the dark interval between the prison door and the difficult beginning of a new life. It is in vain to preach Christ to them if Christian care and sympathy do not meet and guide them as they come out into the world again." She suggested a plan for a "Temporary Industrial Home," but this idea ran into opposition from some members of the society who considered it unsafe to receive men into their industrial home.

An auxiliary society, the Women's Society for Aiding Released Female Prisoners, was formed by Sophia, Phoebe Knight and their associates in 1881. To accommodate recently released female prisoners, a property called the Eldorado House, located on Norwood Avenue in the Edgewood section of Cranston, was rented and aptly renamed the Sophia Little Home. Sophia was elected the new society's first president.

The group soon recognized that it was not practical to allow children to remain with their mothers for long periods in the industrial home. Therefore, in 1886, with Sophia again leading, a new home to care for such children was opened. Its name was the Rhode Island Nursery Association for Homeless Infants. When initially urged to abandon this project—she was in her late eighties at the time—she declared, "Do not hinder me. I cannot die until it is done, and you must not keep me much longer out of the Kingdom of Heaven."

Sophia died in Newport on August 26, 1893, at the age of ninety-four and was buried at Island Cemetery. Her obituary summed up her life's interest well when it stated, "Mrs. Little long since became known as the prisoner's friend through her sympathetic efforts in behalf of prison reform....Again and again have we seen her while bending under the weight of years, on her way to the Marlboro Street jail....Her heart was in the work."

During Sophia's life, the Sophia Little Home served as a halfway house, assisting released female prisoners. But during the twentieth century, the home took on a newer and equally important mission, becoming a sanctuary for unwed mothers. Unquestionably, Sophia would have been pleased by the good deeds the society performed after her passing.

TRANSITORY RHODE ISLANDERS

George William Curtis

George William Curtis owes his Hall of Fame status to his Rhode Island roots and birth. He was the maternal grandson of U.S. Senator, Chief Justice and House Speaker James Burrill Jr. through his mother, Mary Elizabeth Burrill. He was born in Providence on February 24, 1824. When he was four years old, his mother died.

In 1835, his father, George, a banker, and his stepmother, Julia Bridgham, moved first to New York City, where George received his basic education, and then to the Brook Farm community south of Boston. There, George and his elder brother, James Burrill Curtis, became acquainted with such literary giants as Ralph Waldo Emerson, Henry David Thoreau and Nathaniel Hawthorne. George and James then took an extended tour through Europe and the Middle East from 1846 to 1850.

After his return to America in 1850, George gained employment in New York as a travel writer with Horace Greeley's *New York Tribune*. Three years later, he left the *Tribune* to help start the short-lived *Putnam's Monthly Magazine*. Also in 1853, George took the momentous step that defined his career by writing columns for *Harper's Weekly Magazine*. Although the more sophisticated *Putnam's* failed in 1857, Curtis had by 1863 gone from *Harper's* columnist to its political editor. He maintained that powerful and influential post until his death in 1892.

Curtis was a prolific writer who became an opinion leader not only in New York, where he served on numerous boards and commissions, but

also nationwide. However, he failed to obtain the Republican nominations for New York's U.S. senator and governor despite earnest attempts in 1866 and 1870 respectively. Meanwhile, he declined the positions of New York secretary of state and editor of the *New York Times*.

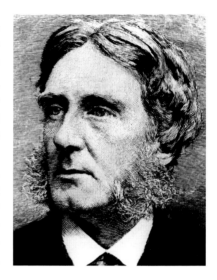

During the 1870s, Curtis teamed with cartoonist Thomas Nast to attack the political machine of Tammany Hall's infamous "Boss" Tweed, and he became a national spokesman for the cause of civil service reform. In this effort, Curtis was joined by like-minded Rhode Island congressman Thomas A. Jenckes. Under Curtis, *Harper's* also made another tangential connection with Rhode Island when cartoonist Nast depicted Santa Claus in the image described by Newporter Clement Clark Moore in his famous poem "A Visit from St. Nicholas."

In 1871, President Grant appointed Curtis to chair a federal civil service reform commission suggested by Jenckes, but its recommendation to replace the "spoils," or patronage, system by appointing government workers based on "merit" was ignored by Grant. Later, this reform was implemented by the passage of the Pendleton Civil Service Reform Act of 1883.

In the 1880s, Curtis deserted the Republican Party and led a group called the "Mugwumps" in support of the victorious Democratic presidential candidate, Grover Cleveland, who was regarded as a political reformer. Curtis's final major achievement came in 1890, when he was named chancellor of the University of the State of New York.

Curtis married Anna Shaw in 1856. She was the daughter of abolitionist Francis Shaw and the sister of Robert Gould Shaw, the commander of the famed Fifty-Fourth Massachusetts Volunteer (Colored) Infantry. Curtis made his home on Staten Island with Anna and their three children, and there he died on August 31, 1892, at the age of sixty-eight. He was buried at Staten Island's Moravian Cemetery.

In all, Curtis wrote a total of forty books and pamphlets, plus many poems and articles. He even edited historian John Lathrop Motley's correspondence. Much of this writing was done at his summer home in Ashfield, Massachusetts, a small Berkshire town about 122 miles from his birthplace in Providence.

"But better than any of Curtis's writings," observed one historian, "was his inspiring example. He willingly sacrificed a promising career in literature to serve his fellow citizens by writing and speaking out about the momentous issues of the day." The best book about Curtis is Gordon Milne's *George William Curtis and the Genteel Tradition* (1956).

DR. JOHN BATES CLARK

John Bates Clark was born in Providence on January 26, 1847, the son of merchant John H. Clark and Charlotte Huntington. In his early youth, his family moved to Minneapolis, where his father engaged in the business of selling farm machinery. Clark came east in the early 1860s to attend Providence High School and Brown University, but after a return to Minnesota to manage his ailing father's business, he concluded his American studies at Amherst College. Then, from 1874 to 1877, he spent considerable time in Germany studying economic theory with world-renowned scholars. Clark's European experience had a profound impact on his later economic writings.

During his long academic career, Clark wrote several seminal works: *The Philosophy of Wealth* (1886), *Capital and Its Earnings* (1888), *The Distribution of Wealth: A Theory of Wages, Interest and Profits* (1899, 1902), *The Control of Trusts* (1901, 1912), *The Essentials of Economic Theory* (1907), *Social Justice without Socialism* (1914) and *A Tender of Peace* (1935), this last a ringing but futile call for world peace.

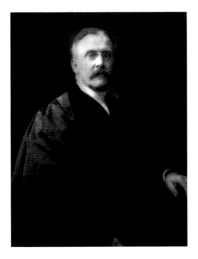

Clark's views shifted over his long academic career, but he was always an active participant in the debate over monopoly and business trusts. On this issue, Clark was forced to balance the belief of his German teachers, that increased corporate growth was inevitable and no bad thing *if* superintended by the state, against the prevailing view of the English classical economists, that all markets were naturally competitive if left alone by government. In 1912, in his revision of *The Control of Trusts*, which he wrote with the assistance of his brilliant son, John Maurice Clark,

the natural competitive model of the original book was modified and replaced by advocacy of several legal recommendations for controlling trusts. These suggestions became a blueprint for a governmental antitrust policy—namely restrictions on mergers, exclusive dealing, interlocking directorates and unfair competition. In 1914, both Clarks welcomed the Clayton Anti-Trust Act and the Federal Trade Commission Act.

In sum, Clark is described as a neoclassicist because he vigorously championed capitalism over socialism. However, he also allied with the "New Economists" in advocating some governmental regulation of the economic order such as implemented by Wilson's New Freedom and FDR's New Deal.

Clark taught at Carleton College in Minnesota (1877–81), Smith College and Amherst College in Massachusetts (1882–95) and eventually Columbia University (1895–1923). He was a founder (with New Economist Richard Ely) of the American Economic Association in 1885 and served as its president from 1893 to 1895. In 1911, he became the director of the history and economics section of the newly organized Carnegie Endowment for International Peace in New York City. In that capacity, until he left that post in 1923, he helped to launch the studies that became the *Social and Economic History of the World War* (1935).

In 1875, Clark married Myra Smith, one of the early graduates of Vassar College. John Maurice Clark, one of their four children, also became a leading economist and an associate of his father. Providence native John Bates Clark died in New York City on March 21, 1938, at the age of ninety-one and was buried at Lakewood Cemetery, Minneapolis, Minnesota. A useful account of his life and the impact of his thought is John F. Henry's *John Bates Clark*: *The Making of a Neoclassical Economist* (New York, 1995).

U.S. SECRETARY OF STATE JOHN MILTON HAY

John Hay, diplomat and author, was born in Salem, Indiana, on October 12, 1838, the son of Charles Hay, a physician, and Helen Leonard, a schoolteacher. When Hay was a youth, the family moved to Warsaw, Illinois. Hay attended Illinois State University (now Concordia College) in Springfield from 1852 to 1855. In the latter year, he transferred to Brown University, very likely because Providence was the early home of his mother and his maternal grandfather, Reverend David Leonard, who was a member

John Hay. Pictured here, *at right*, with Lincoln and his secretary, John Nicolay.

of the Brown class of 1792. At Brown, Hay was described as having "a retentive memory, a vivid imagination, and an ability to get along with the ladies." He graduated in 1858 with the distinction of class poet.

Upon his return to Illinois, Hay reluctantly but fortuitously joined his uncle's law office in Springfield. Next door was the office of Abraham Lincoln. The bright and affable Hay soon became Lincoln's protégé, and

when "Honest Abe" was elected president in 1860, Hay and a friend, John Nicolay, accompanied Lincoln to Washington as private secretaries.

During the postwar years, Hay held several minor diplomatic posts in Europe, had a brief fling with journalism and launched his literary career with *Pike County Ballads and Other Pieces*, *Castilian Days* and his collected *Poems*. Then Hay and Nicolay capitalized on their close personal relationship with Lincoln by writing a biography of the martyred president that they published in ten volumes from 1875 to 1890.

Using his Republican connections and his extensive travel experience, Hay returned to public life in 1878 as assistant secretary of state under President Rutherford B. Hayes. Later in life, he became a campaign adviser to President William McKinley, who made Hay ambassador to the United Kingdom, where he helped to generate an Anglo-American diplomatic rapprochement. His success earned him an appointment as secretary of state in 1898. McKinley's successor, Theodore Roosevelt, reappointed Hay, and both men, influenced by the lessons provided in the writings of Alfred Thayer Mahan, worked to enlarge America's role in world affairs. Secretary Hay's health declined during his seven-year state department tenure, and he died in office on July 1, 1905, at his summer home in Newbury on Lake Sunapee, New Hampshire, at the age of sixty-six. He was buried at Lake View Cemetery in Cleveland, Ohio. Hay left a record of solid diplomatic achievement. He forged closer Anglo-American ties; he presided over American imperialist ventures in the Caribbean and the Pacific that included the acquisition of Hawaii, the Philippines, Puerto Rico and the Panama Canal Zone; and he issued the "Open Door" notes to preserve the territorial integrity of China while protecting American economic interests in the Far East. Hay's "Open Door" notes (1899–1900), which advocated a free open market and equal commercial opportunity for merchants of all nationalities trading in China, became the official U.S. policy toward the Far East during the early twentieth century.

Shortly after Hay's death, his widow, Clara Stone Hay, gave her husband's personal library and papers to Brown. This gift was the catalyst for Brown to begin the construction of a long-anticipated modern library building. Hay's friend and great library supporter Andrew Carnegie offered the university $150,000 to build a library in honor of Hay if Brown would match that amount. Construction began in 1908, and the magnificent facility was completed in 1910 and dedicated to Brown's noted alumnus, with his papers preserved therein. The best biography of Hay is John Taliaferro's *All the Great Prizes: The Life of John Hay, from Lincoln to Roosevelt* (New York, 2013).

Dr. William W. Keen Jr.

Of Swedish and Dutch ancestry, William W. Keen was a man of stern principles and unwavering convictions and a diligent worker in the Calvinist tradition. He was born on January 19, 1837, in Philadelphia, the son of William Keen and Susan Budd. He saw active service during the Civil War as a battalion surgeon in the First Battle of Bull Run, was a consultant to the U.S. Army during the Spanish-American conflict and served as a commissioned medical officer in World War I.

He was one of the acknowledged founders of modern American surgery and America's first brain surgeon. His active friends and professional colleagues included Oliver Wendell Holmes, Weir Mitchell, Joseph Lister and William Osler. His patients included presidents from Grover Cleveland to Franklin D. Roosevelt.

Keen graduated from Brown University in 1859, and other than his years abroad, he attended every Brown commencement exercise until 1931. After leaving Providence, he received his MD degree from Jefferson Medical School in Philadelphia. He then studied abroad, principally in Vienna, learning the craft of surgery from the great European masters.

He taught the principles and rudiments of surgery at Jefferson Medical College to more than ten thousand American physicians. His rigorously disciplined operative skills set new standards for aseptic surgery. Dr. Keen published eight books and numerous medical essays. He served as president of the American Surgical Association (1898), the American Medical Association (1900) and the Congress of American Physicians and Surgeons (1903). He was awarded nine honorary degrees from American and European universities.

In his later years, Keen assumed the presidency of the American Baptist Missionary Union. In this position, he traveled the world in support of the many medical missions implanted by his church in Africa, Asia and Oceania. His greatest admiration was reserved for those professional colleagues who answered a higher call to labor as medical missionaries, bringing the precious gifts of anesthesia, vaccines and the

general principles of public health and sanitation to distant lands. He took pride in the 379 hospitals, 783 dispensaries and 533 orphanages established by the Union.

In 1867, Keen married Emma Borden of Fall River, Massachusetts. She died in 1886, leaving him with three daughters. Dr. Keen died in his native Philadelphia on June 7, 1932, at the age of ninety-five and was buried at Philadelphia's Woodlands Cemetery. In 1990, W.W. Keen James edited and published *The Memoirs of W.W. Keen, M.D.*

DR. BENJAMIN IDE WHEELER

Benjamin Ide Wheeler joins James Burrill Angell in the Rhode Island Heritage Hall of Fame as a significant contributor from the Ocean State to the world of university administration.

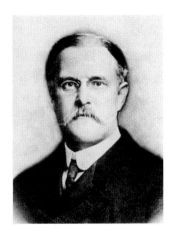

Wheeler was born in Randolph, Massachusetts, on July 15, 1854. His father, Benjamin, was a highly regarded Baptist minister who preached to a number of congregations in New Hampshire, Maine and Massachusetts. He also served in Pawtucket, the home of Wheeler's mother, Mary Elizabeth Ide, who had family roots in Rehoboth and South Attleboro. The family background in biblical studies pointed young Benjamin toward the classics, a field that he pursued during his high school years and then in his student days at Brown University from 1871 to 1875. At Brown, he was also an accomplished athlete.

Following graduation in 1875, Wheeler taught at the Providence High School, tutored at Brown and served for a year on the Providence School Committee. Then he went to Germany for graduate study in various universities during the years 1881 through 1885 and earned his PhD in classical literature summa cum laude.

Upon Wheeler's return to America, he embarked on a thirteen-year career teaching classical literature at Cornell University in Ithaca, New York. In 1899, he became president of the University of California. During his twenty productive years at Berkeley (1899–1919), he put this new western school on a steady path of academic excellence, leading it to become one of America's premier universities.

In the course of his life, Wheeler received honorary doctor of laws degrees from Princeton, Harvard, Brown, Yale, Johns Hopkins, Wisconsin, Dartmouth and Columbia. He was the author of various scholarly works in the field of philology (the study of literary texts). He also wrote a biography of Alexander the Great, as well as studies about higher education and democratic institutions.

Throughout his life, he occasionally left the lofty towers of academia and high-minded discourse to engage in the more muscular tussles of politics. This diversion first occurred while at Brown when Wheeler and some of his friends set out to topple the Rhode Island Republican political machine of Henry Bowen Anthony and Charles "Boss" Brayton. While at Cornell, he participated in the second presidential campaign of Democrat Grover Cleveland and continued in the political arena through his active friendship with Republican Theodore Roosevelt. In the aftermath of the great 1906 San Francisco earthquake and fire, he participated prominently in the emergency efforts to help the city recover.

Not only was Wheeler the recipient of numerous academic recognitions from collegiate institutions, but the University of California also named one of its major buildings in his honor, and a World War II Liberty ship also bore his name.

His Rhode Island connection was made stronger through his 1881 marriage to Amey Webb of Providence, the granddaughter of Jabez Gorham, founder of the Gorham Manufacturing Company. Wheeler died in Vienna, Austria, on May 2, 1927, at the age of seventy-two after a long illness. He was survived by Amey and a son and was buried at Sunset View Cemetery in El Cerrito, California.

DR. J. FRANKLIN JAMESON

John Franklin Jameson was a history professor at Brown University from 1888 to 1901; a vice-president of the Rhode Island Historical Society; first secretary of the American Historical Association and the longtime editor of its journal, the *American Historical Review*; director of historical research at the Carnegie Institution in Washington; and a founder of the National Archives.

Born in Somerville, Massachusetts, on September 19, 1859, the son of John Jameson, a schoolteacher and lawyer, and Mariette Thompson,

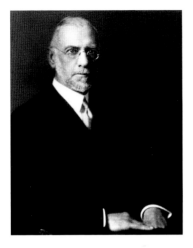

Jameson attended Roxbury Latin School and spent his college days at Amherst, graduating in 1879. After a year teaching school in Worcester, he studied for his PhD in history at the Johns Hopkins University in Baltimore, taking his degree in 1882 under Herbert Baxter Adams. His was the first doctorate in history awarded by Johns Hopkins and the first PhD in history granted by an American university. Jameson remained at Johns Hopkins as an instructor until 1888 before moving to Brown. One of his closest associates during this formative era was Woodrow Wilson, who was a Johns Hopkins student from 1883 to 1886.

Although unable to afford the desirable foreign graduate work in history then popular, he was one of a handful of American academics who adopted the new German-inspired seminar style of study, expounded by Leopold von Ranke, that touted a scientific and critical scrutiny of original texts as the most accurate approach to writing history. It was the seminar's dependence on original documents that propelled Jameson into a lifelong pursuit of perfecting documentary publications and improving archival collections. He spent most of his professional life in Washington promoting the establishment of a national archives. He is largely credited for its ultimate success.

While in Rhode Island, Jameson led an unsuccessful effort to retrieve a large cache of the papers of Major General Nathanael Greene that came up for public auction in New York. Although the Rhode Island General Assembly in the 1890s balked at spending $10,000 to acquire Greene's letters, successive, more recent General Assemblies spent nearly $1 million to publish those letters in thirteen volumes in the 1980s and 1990s.

During his stay in Providence, Jameson worked to improve the instructional resources at Brown by raising money for the acquisition of history books and serving as secretary of the library committee. He also instituted an historical seminar that produced several useful research papers on Rhode Island history still used by scholars in this area of study. His most substantial literary productions at Brown were *The History of Historical Writing in America* (1891), an edition of the papers of southern leader John C. Calhoun and his two-volume *Encyclopedic Dictionary of American Reference*. During the Andrews controversy, Professor Jameson vigorously supported the Brown president.

While in Providence, Jameson met a local schoolteacher named Sara Elizabeth Elwell, whom he married in April 1893. The couple resided at 196 Bowen Street. They became the parents of two children.

Following his Rhode Island years, Jameson became professor of history and department chairman at the University of Chicago, serving in those capacities from 1901 to 1905. Leaving Chicago, he went to the nation's capital to direct the history bureau at the Carnegie Institution, a post he held until 1928. Then, nearing age seventy, Jameson was appointed chief of the Division of Manuscripts of the Library of Congress, a position he occupied for nine more years until his death in 1937.

Jameson edited the *American Historical Review*, the profession's most distinguished journal, from its inception in 1895 until 1928, except for the years he spent in Chicago. He also played a major role in developing *The Dictionary of American Biography*. Other scholarly credits include his general editorship of the nineteen-volume *Original Narratives of Early American History*. He personally produced two of the volumes in this distinguished series. Jameson's most famous book was *The American Revolution Considered as a Social Movement* (1926), a concise yet pioneering effort to explain the impact of the War of Independence on American society and economic life. It has been hailed as a landmark in the historiography of the Revolutionary era.

Dr. Jameson was struck by an automobile in Washington in March 1937. Six months later, on September 28, just after his return to work at the Library of Congress, he died of a heart attack at the age of seventy-eight and was buried at Washington's Oak Hill Cemetery. He has been the subject of several biographies—testimony from their authors as to Jameson's lofty status in the American historical profession.

A very informative glimpse into Jameson's life and career is contained in the book *An Historian's World: Selections from the Correspondence of John Franklin Jameson*, edited by Elizabeth Donnan and Leo F. Stock (Philadelphia, the American Philosophical Society, 1956). Letters pertaining to Jameson's thirteen-year tenure at Brown (1888–1901) are printed at pages forty-four to seventy-seven. Ironically, the final letter in this lengthy volume was written from the hospital by Jameson on April 28, 1937, to the newly elected U.S. senator from Rhode Island, Theodore Francis Green, who had taught with Jameson at Brown in the 1890s. It was a response to Green's query about the constitutionality of President Roosevelt's controversial "court-packing" plan.

ABOUT THE AUTHOR

D r. Patrick T. Conley, Rhode Island's first-ever Historian Laureate, is president of both the Rhode Island Heritage Hall of Fame and the Heritage Harbor Foundation. Dr. Conley holds an AB from Providence College, an MA and PhD from the University of Notre Dame and a JD from Suffolk University Law School. He is the author of thirty books, most of which focus directly on Rhode Island's history, as well as dozens of similarly themed scholarly articles. He has served as chairman of the Rhode Island Bicentennial Commission, chairman and founder of the Providence Heritage Commission, chairman and founder of the Rhode Island Publications Society and general editor of the Rhode Island Ethnic Heritage Pamphlet Series. In 1977, he founded the Rhode Island Heritage Commission. He was also chairman of the Rhode Island Bicentennial Foundation, chairman of the U.S. Constitution Council and founding president of the Bristol Statehouse Foundation. He is a college professor in the subjects of history and law (Providence College, Salve Regina College and Roger Williams University School of Law), frequently gives lectures, writes an editorial column for the *Providence Journal* and publishes book reviews. In May 1995, Dr. Conley became one of a handful of living Rhode Islanders to be inducted into the Rhode Island Heritage Hall of Fame. Pat lives in Bristol, Rhode Island, with his wife, Gail, on an estate they named Gale Winds.

Visit us at
www.historypress.com